UNDERSTANDING EXPOSURE

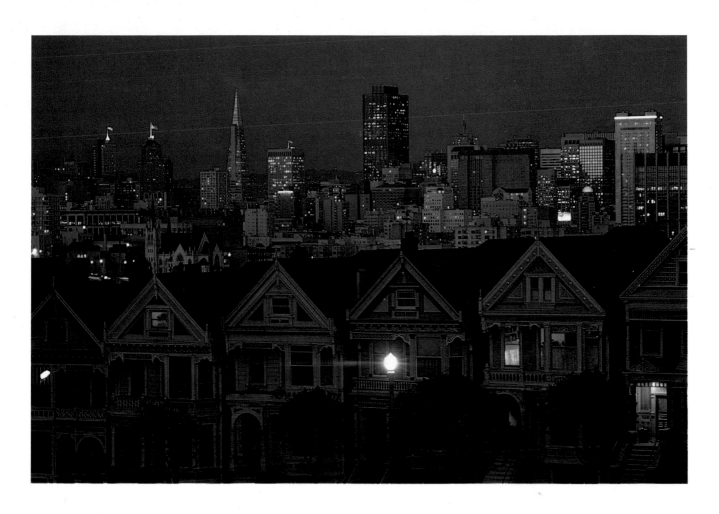

UNDERSTANDING
EXPOSURE

BRYAN PETERSON

AMPHOTO
AN IMPRINT OF WATSON-GUPTILL PUBLICATIONS, INC./NEW YORK

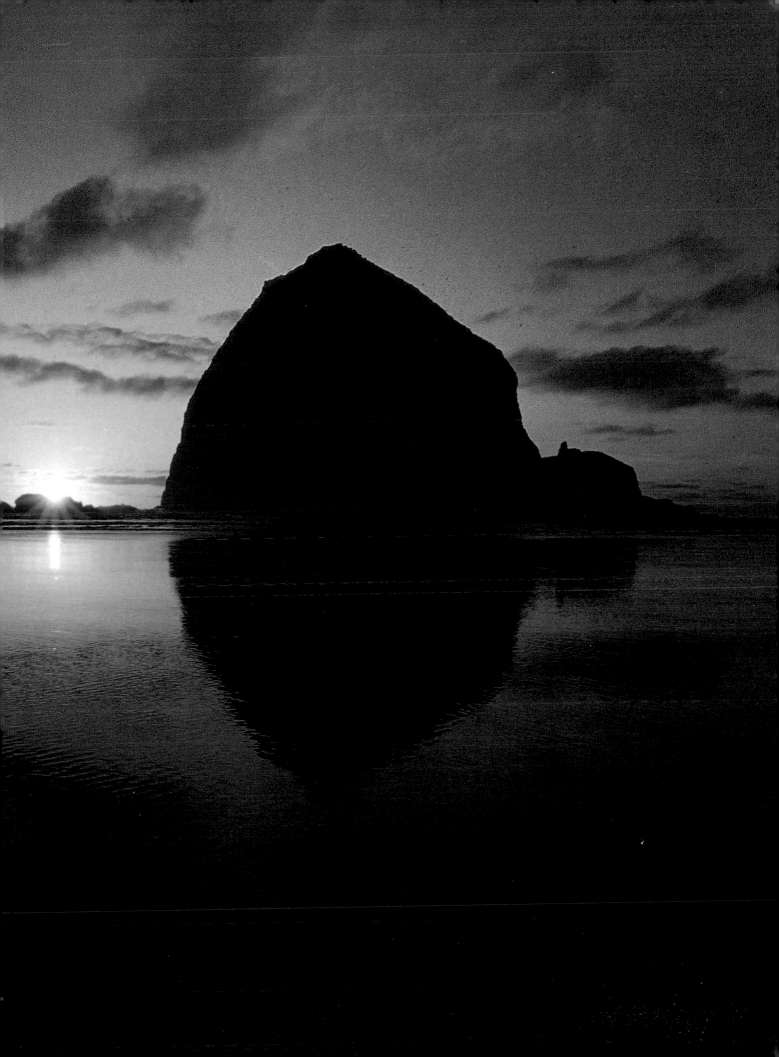

Bryan Peterson is a professional photographer who specializes in corporate and industrial annual reports. His popular photography column appears in *This Week,* the weekly Portland, Oregon, newspaper, and his photography seminars have brought his unique teaching methods to more than 5,000 students. Peterson's work has appeared in numerous magazines, including *Popular Photography, SLR, Pacific Northwest, Oregon,* and *Wine Country,* as well as various in-flight magazines, Northwest Airline's *Compass Readings* among them. He has received awards from the New York Art Directors' Club, Minolta Corp., and Nikon, Inc. Peterson's clients include: Amoco; the Army Corps of Engineers; Burlington Industries; Horizon Airlines; Manufacturers Hanover Corp.; Minolta Corp.; Nike, Inc.; Nikon; Pacific Telecom; Piedmont Airlines; Skies West, Inc.; Transamerica Corp.; US Fish and Wildlife; and Weyerhauser Corp.

Editorial Concept by Robin Simmen
Edited by Liz Harvey
Graphic Production by Ellen Greene

Copyright © 1990 by Bryan Peterson
First published 1990 in New York by AMPHOTO,
an imprint of Watson-Guptill Publications,
a division of BPI Communications, Inc.,
1515 Broadway, New York, NY 10036

Library of Congress Cataloging-in-Publication Data
Peterson, Bryan.
 Understanding exposure.
 Includes index.
 1. Photography—Exposure. I. Title.
 TR591.P47 1990 771—dc20 90-723
 ISBN 0-8174-3711-8
 ISBN 0-8174-3712-6 (pbk.)

Manufactured in Singapore

1 2 3 4 5 6 7 8 9/98 97 96 95 94 93 92 91 90

To my brother Bill, who put a camera in my hand

CONTENTS

INTRODUCTION

Looking back, I fondly remember that big day in my life when I bought my first 35mm camera. I had been saving like mad to purchase a Nikkormat camera and a 50mm lens, and on a warm June day I walked into the local camera shop and plunked down 200 dollars. Out on the street with a fresh roll of film, I began pointing my new camera at anything and everything. I was ever mindful of the store owner's advice: "Just make sure that the needle in the viewfinder is between the plus and minus before you shoot."

As the weeks and months passed, I found myself spending every spare moment thinking about and exploring my new hobby. Immediately following my daytime job, I rushed to the library, trying to absorb every ounce of information in the few photography books available. I vigorously wrote down the many ideas that popped into my head as I read about *f*-stops, shutter speeds, films, lenses, principles of composition, filters, and special effects. By looking at the photographs in these books as well as in countless magazines, I was soon able to "guesstimate" which aperture, shutter speed, and lens were used. I was becoming an expert on everybody's pictures—everybody else's, not my own.

But this business about apertures, lenses, shutter speeds, and film speeds didn't make complete sense until I started writing down exposure information. Then with each new roll of processed film, I sat down and reread my notes on each image: what *f*-stop, shutter speed, and film I had chosen. Soon I began to understand depth of field, and when and when not to use it extensively. I also became more and more familiar with the various shutter speeds and their creative effects on motion-filled scenes. For example, I learned when to freeze a subject as well as when to let it blur across the frame. And as I tried different color films with different grain structures and biases toward certain colors, I was better able to match a given film to a particular subject.

As a result, I developed a better understanding of photography as well as more effective techniques for recording what I saw. I came to realize that every camera is essentially just a lightproof box with a lens at one end and light-sensitive film at the other. Simply put, light enters through a hole in the lens (the aperture), and after a certain amount of time (the shutter speed), an image is recorded (the film). This recorded image is commonly referred to in photography as an exposure. I discovered that making an exposure wasn't an isolated technique but rather the result of combining the aperture, shutter speed, and film speed.

Throughout this book, I discuss the interrelationship between the film, aperture, and shutter speed. These three elements are at the heart of every exposure, and together they make up what I affectionately call *the photographic triangle*. The shortcoming of most other photography books on exposure is that they fail to tie all three elements together. Instead, these books treat each element as a separate unit independent of the others. Nothing could be further from the truth. Understanding the photographic triangle is what lets you make consistently strong, beautiful photographs.

Walking along Seal Rock on the central Oregon coast, I came upon this scene after sunset. To ensure sharpness throughout, I set my 50mm lens to *f*/22 and then preset the focus via the depth-of-field scale. ◆ The fuzzy image that appeared in the viewfinder became completely clear when I pressed the shutter-release button. This stopped the lens down to *f*/22, and the sharpness promised by the depth-of-field scale was rendered on film. ◆ To bring the exposure to a close, I took a meter reading off the foreground sand and adjusted the shutter speed until a one-stop underexposure was indicated.

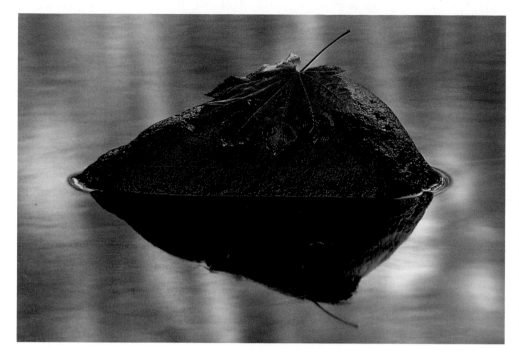

During the fall several years ago, a lone leaf sitting on top of a small rock in a stream near my farm caught my attention. ✦ With my 300mm lens and my camera mounted securely on a tripod, I was able to zero in on the rock and leaf. I set the aperture to $f/5.6$; I wanted an out-of-focus color as the background. ✦ Because the rock and leaf were under open shade yet were surrounded by the brighter tones reflecting on the water, I took a meter reading off a gray card. I then adjusted the shutter speed until the scene was correctly exposed.

Shortly after this important discovery, I realized that no matter what my exposure meter indicated as "correct," it was merely showing one of more than seven correct exposures I had to choose from. For example, with my camera loaded with ISO 100 film and my 50mm lens set at $f/2.8$, my meter indicated a shutter speed of 1/1000 sec. with the camera pointed toward the subject. Did I have to shoot at $f/2.8$ for 1/1000 sec? No! I could choose to shoot at $f/4$ for 1/500 sec., or $f/5.6$ for 1/250 sec., or $f/22$ for 1/15 sec. Because I was beginning to understand the interrelationship between f stops and shutter speeds, I knew that any of these exposures would prove to be "correct." However, I also knew that each f-stop-and-shutter-speed combination was capable of producing a different yet creative effect. If I wanted extensive depth of field, I certainly wouldn't achieve it by shooting at $f/2.8$. On the other hand, if I wanted to blur the subject, I certainly wouldn't shoot at 1/250 sec.

About this time, I became starkly aware that film choice played a major role in what aperture-and-shutter speed combinations were available. Slow films required longer shutter speeds, while fast films called for faster shutter speeds. Again, this was important because it enabled me to match a film's speed to my subject. If I wanted to be literal and freeze the action of a football game, I would load my camera with ISO 400 film. But if I wanted to create abstractions, I would use ISO 25 film, which would let me shoot the action at much slower shutter speeds. Such experiments usually added to my list of creative-exposure options. Nineteen years later, I still find myself trying new and different exposures on "tired and worn-out" subjects as well as on "fresh" subjects. When a student asked me if I ever felt burned-out, my answer seemed to surprise him: "I'm still trying to light the candle."

My goal in writing this book is to share with you my ideas about how to effectively use the photographic triangle—aperture, shutter speed, and film—to expose color film in available light. This light can be either daylight or the tungsten light found in many homes and offices. *Understanding Exposure* is about the color of light as well as its direction: whether it is frontlight, sidelight, or backlight. Unless you have a thorough understanding of light, your exposure options will be severely limited. I hope to show you how to exploit as well as to anticipate various lighting conditions in order to record some quite creative exposures. Of course, the exposure meter is the center of the photographic triangle; without it many exposures would be hit-and-miss propositions. I discuss exposure meters in depth, including how their interpretations of light and its value differ vastly from your own. Finally, I explain some special techniques that can increase your creative-exposure options tenfold.

This book has been "tested" in slide presentations by more than 5,000 students at my many workshops. Whether they had just graduated from high school or a four-year photography school, many of these students remarked that the workshops had finally cleared up their confusion about film speeds, apertures, and shutter speeds. My fondest wish is that after you spend time reading this book and begin applying the many techniques discussed here to your own photography, you will be able to clearly explain how you achieved a certain effect—rather than give a muffled, vague reply. I have only one request. As your confidence grows, please share your knowledge with and assist any less successful photographer you happen to meet. Perhaps this person will come up with a new creative exposure that you can add to your list. Enjoy!

METERING FOR A STARTING EXPOSURE

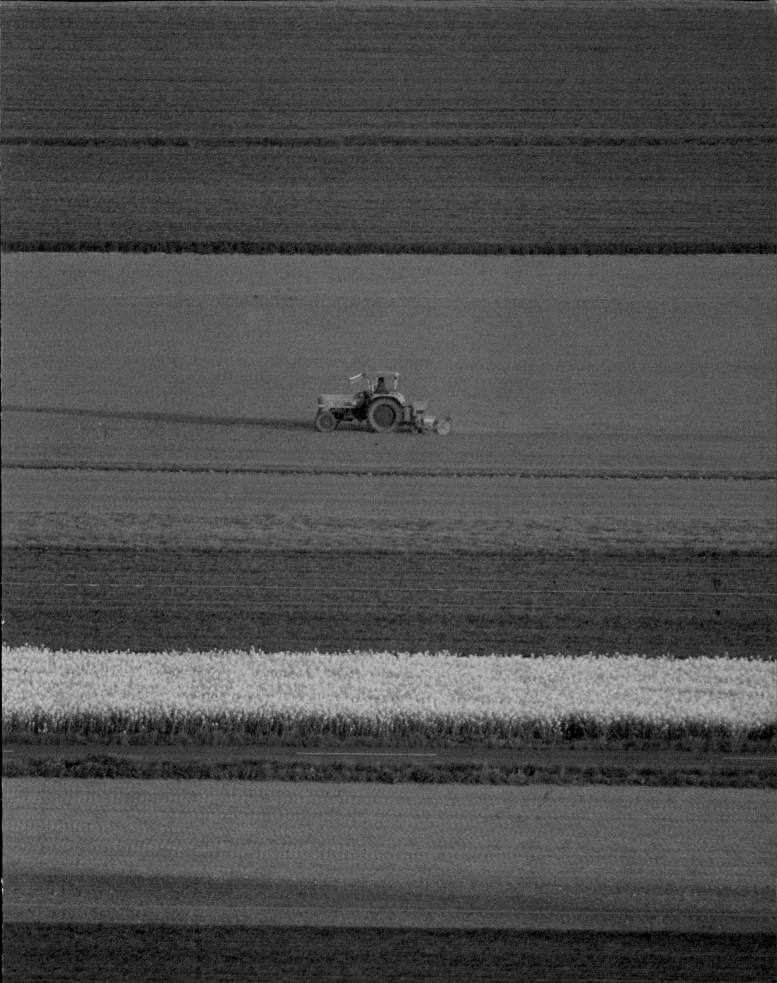

What is meant by exposure? Sometimes the work refers to a finished print or slide: "Wow, that's a nice exposure!" At other times it refers to the film: "I've got only one exposure left on my roll of film." But more often than not, exposure refers to a correct combination of three factors—film speed, aperture, and shutter speed—which I call "the photographic triangle."

How important is light in terms of your subjects? Experienced photographers often want you to believe that you can shoot only on clear days under low-angled lighting conditions. I am the first to agree that the quality of light during the early morning and late afternoon is truly dynamic for picture-taking. But the enthusiasm for these two times of day seems to eliminate the possibility that any other lighting condition can be favorable. ✦ While heading into my studio one morning, I noticed a bucket filled with sidelit tulips. With my 180mm lens and my camera mounted securely on a tripod, I set the aperture to f/5.6, and I adjusted the shutter speed to 1/500 sec. to bring the exposure on the right to a close. Several days later, I photographed the same bucket of tulips under an overcast sky. In the shot on the opposite page, you can see the vivid intensity of the colors of the flowers. ✦ Because overcast light is soft and produces little contrast, it is one of the easiest lighting conditions to expose for. (The only exceptions are white and black subjects.) Overcast lighting also enables you to photograph flowers, people, and forests without having to be concerned about your own shadow ruining the composition.

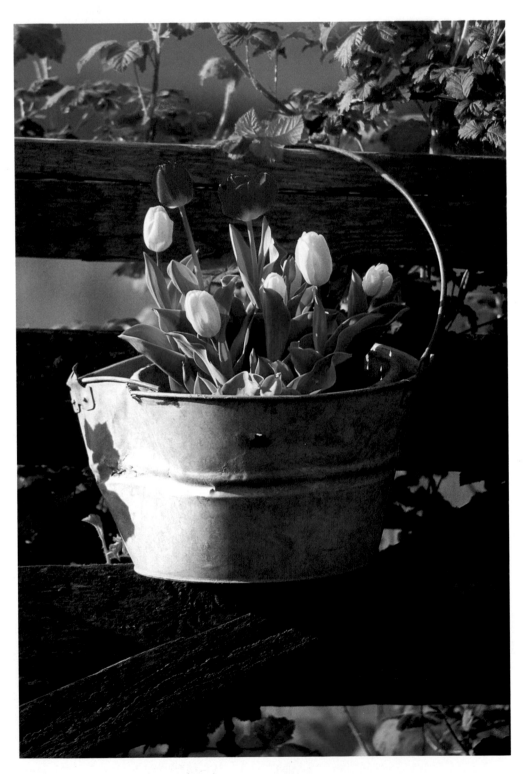

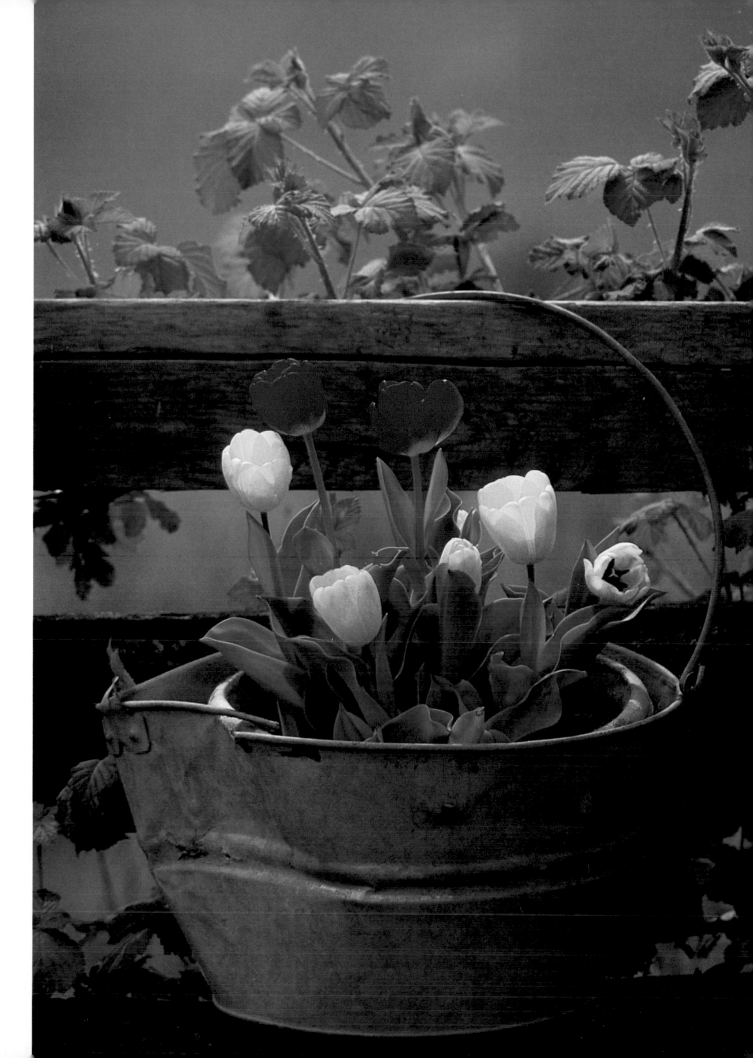

UNDERSTANDING F-STOPS

Before you can master exposure techniques, you need to learn some basic concepts. The first of these is the *f*-stop. Pick up your camera and find the serrated ring located on the outside of the lens; this is called the *aperture ring*. As you turn the aperture ring from one end to the other, the series of numbers (2.8 to 22) click in and out of position. Each of these "clicks" is called a *stop*. The number of each stop corresponds to a specific lens opening and is referred to as an *f*-stop. This opening controls the amount of light that enters the lens and passes onto the film. For the technical-minded among you, an *f*-stop is a fraction that indicates the diameter of the aperture. The "f" stands for the focal length of the lens, the slash "(/)" means "divided by," and the number represents the stop in use. For example, if you were shooting with a 50mm lens set at *f*/1.4, the diameter of the aperture would be 35.7mm. Here, 50 (the focal length of the lens) divided by 1.4 (the stop) equals 35.7 (the diameter of the lens opening). But all you must remember is that the *f*-stop determines how much light reaches the film.

THE HALVING AND DOUBLING PRINCIPLE

The primary function of apertures, also called *diaphragms*, is to control the volume of light that reaches the film during an exposure. This transmission of light can be compared to water flowing out of a faucet. If I were to open a faucet all the way and place an empty glass underneath it, the glass would fill with water in just a few seconds. On the other hand, if I were to open the faucet so that the water trickled out, the glass would take a longer time to fill. This same principle can be applied to light passing through an aperture. If you keep in mind that lens apertures are actually fractions—such as 1/2.8, 1/5.6, and 1/16—it should be easy for you to understand that an *f*/16 lens opening is smaller than an *f*/2.8 opening. Just as in the example of water coming out of a faucet, the volume or flow of light that passes through the lens openings is dictated by the aperture in use. Consider the following example. Imagine that the diameter of the faucet is equivalent to that of an aperture of *f*/2.8. The amount of water flowing out of this faucet, then, would clearly be greater than the amount of water coming out of a faucet whose diameter was equivalent to that of a lens aperture of *f*/22.

Interestingly enough, each time you descend from one aperture setting to the next, or *stop down*, such as from *f*/2.8 to *f*/4, the volume of light is cut in half. Conversely, when you turn the aperture ring from *f*/16 to *f*/11 to *f*/8 and so on, the volume of light is doubled with each change. For example, if I set my camera at *f*/2.8 and you set your camera at *f*/4, the amount of light reaching the film in my camera is twice as great. But if you leave your aperture ring at *f*/4 and I move mine to *f*/5.6, the volume of light entering my camera is now half as much as that entering yours.

This relationship is called *the halving and doubling principle* and can also be discussed in terms of the shutter speed. Remember that the shutter speed controls the length of time the volume of light enters the lens and stays on the film. Going back to the water-faucet analogy, it would take me twice as long to completely fill a glass as it would to fill another glass halfway. If I then were to fill a third glass a quarter of the way, this process would take half the length of time needed for the half-filled glass and one-fourth the length of time needed for the full glass.

This halving and doubling principle can best be understood by referring to the shutter-speed dial. The numbers located there denote fractions of a second. For example, "1000" designates 1/1000 sec., "500" designates 1/500 sec., and so on, all the way to 1 sec. Each shutter speed corresponds to a predetermined amount of time and dictates how long the light that enters the aperture remains on the film. For example, if I shoot a picture at 1/250 sec., the light that passes through the aperture and onto the film does so for exactly 1/250 sec. If I shoot another picture at 1/15 sec., the light that passes through the aperture and onto the film does so for exactly 1/15 sec. Note that each number represents a fraction that is twice as large as that of the number on one side and half as large as that of the number on its other side. For example, 1/250 sec. is twice as long as 1/500 sec. and half as long as 1/125 sec. To simplify this concept even more, consider another analogy: think of these fractions of a second as pie slices. A 1/250 slice is clearly twice as big as a 1/500 slice and half as big as a 1/125 slice.

Like the numbers on the aperture ring, each of these fractions is referred to as a stop. When you change from one shutter speed to the next, you are changing from one stop to another.

My students often say, "What difference does it make which aperture and shutter speed I use? All I care about is getting a good exposure!" For many photographers, exposure is simply the process of lining up the needles so that the diodes light up in the right spot inside the viewfinder. If a "correct" exposure is all you want, this approach is fine. But if you want a creative correct exposure, you'll need to choose the "right" *f*-stop and shutter speed.
◆ These three photographs are correctly exposed, yet each one has a different depth of field. In the image above on the left,

shooting at *f*/2.8 for 1/500 sec. produced an extremely shallow depth of field. I exposed at *f*/11 for 1/30 sec. for the picture above on the right; here, the green background is a bit more defined and the flower is sharper. Shooting at *f*/32 for 1/4 sec. produced a very sharp flower and even more background detail in the bottom photograph. ◆ The choice is yours as to which of these shots you prefer, but the point can't be overstated. Achieving a correct exposure is a task left to "snap-shooters," while achieving a creative correct exposure is a challenge welcomed by true photographers.

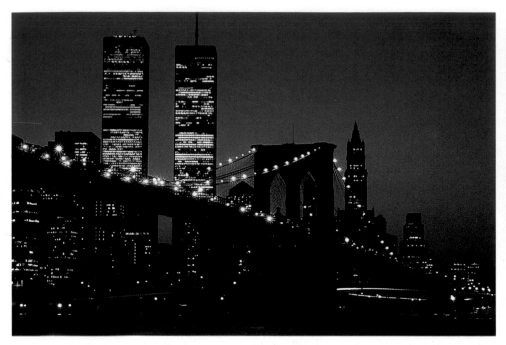

After several days of shooting in New York City, my assistant and I set aside an evening to head over to the Brooklyn Bridge to shoot the Manhattan skyline. For the photograph above, I first mounted my camera and 85mm lens on a tripod. Next, I set the aperture to *f*/1.8 (wide open) to achieve a starting exposure and began turning the shutter-speed dial until the correct speed of 1/15 sec. was indicated. Then, because I wanted to emphasize the distant motion created by the flow of traffic coming off the bridge ramp, I set the aperture to *f*/22. This reduced the light transmission by seven stops; in effect,

shooting at *f*/22 for 1/15 sec. resulted in a seven-stop underexposure. To compensate for this, I needed to increase the shutter speed by seven stops: 1/15 sec. to 1/8 sec. (one stop), 1/8 sec to 1/4 sec. (two stops), 1/4 sec. to 1/2 sec. (three stops), 1/2 sec. to 1 sec. (four stops), 1 sec. to 2 sec. (five stops), 2 sec. to 4 sec. (six stops), and 4 sec. to 8 sec. (seven stops). The correct exposure, then, was *f*/22 for 8 sec. ✦ The combination of the long exposure time and the small aperture produced the "stars" on the individual lights that were strung across the bridge. This is simply an optical phenome-

non that occurs when you photograph single-point light sources using small lens openings and lengthy exposure times. ✦ The full moon in the shot on the right was the result of a double exposure. To achieve this image, I patiently waited for the moon to rise in the night sky above the buildings. Following another exposure of the skyline, I pressed the double-exposure button without advancing the film. Then I switched from the 85mm lens to a 300mm lens and carefully framed the moon in the upper third of the image area. Finally, I adjusted the aperture to *f*/8 and the shutter speed to 1/125 sec.

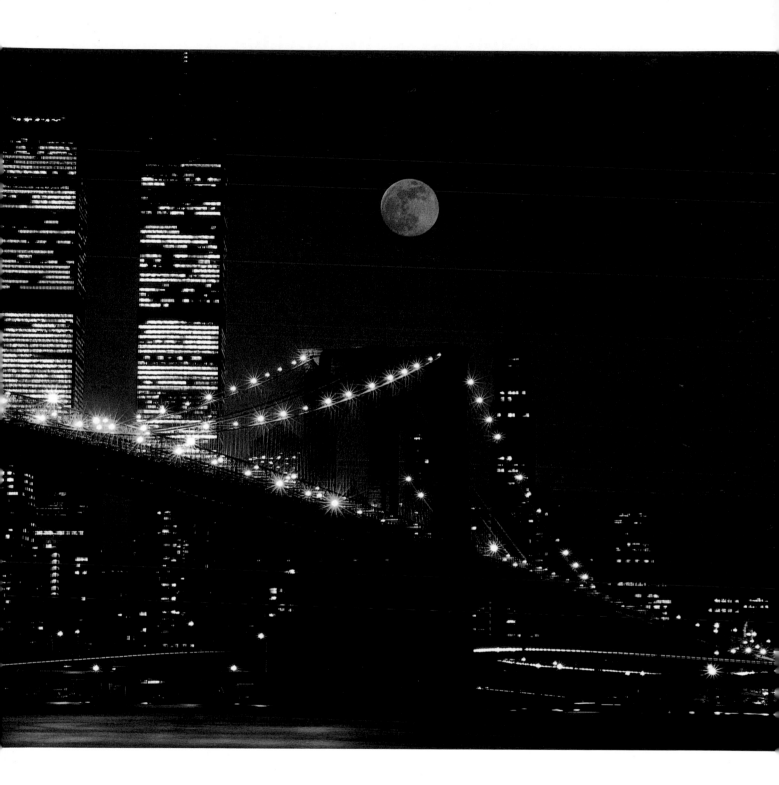

USING EXPOSURE METERS

At the center of the photographic triangle, which all three factors revolve around, is the exposure meter. It is the "eye" of creative exposure. Without the vital information the exposure meter supplies, many picture-taking attempts would be similar to throwing mud on a wall and hoping that some of it sticks. This doesn't mean that you can't take a photograph without the aid of an exposure meter. After all, a hundred years ago photographers were able to record images without one; however, they did have exposure tables or guides to head them in the right direction. Fortunately, today's exposure meters are quite reliable and sensitive. For example, while shooting at night was a hit-or-miss proposition not too long ago, photographers are now able to continue shooting well past sundown with the assurance of achieving a correct exposure. If there is a tool that eliminates any excuse for not shooting twenty-four hours a day, it is the exposure meter.

REFLECTED-LIGHT METERS

Exposure meters come in two forms. They are either separate units that you hang around your neck or hold in your hand, or, as with most of today's cameras, they are built into the camera body. Handheld meters require you to physically point the meter at the subject or at the source of the light falling on the subject and take a reading of the light. Once you do this, you set the camera and lens at an exposure based on this reading. Conversely, cameras with built-in exposure meters enable you to point the camera and lens at the subject while continuously monitoring any changes in exposure. This metering system is called through-the-lens (TTL) metering. These meters measure the intensity of the light that reflects off the metered subject. Like lenses, reflected-light meters have a wide or very narrow angle of view. Several less expensive SLR cameras have *av-eraging reflected-light meters* built into them. Such a meter is useful when a scene contains areas of light and shadow because the meter can measure both and give an average reading. This reading usually provides adequate data that enables you to successfully set an exposure. However, in picture-taking situations in which the scene contains much more shadow than light or much more light than shadow, an averaging reflected-light meter tends to give exposure data that results in either overexposure or underexposure.

Another type of reflected-light meter is a *spot meter*. This measures light at an extremely narrow angle of view, usually limited to one to five degrees. Seldom incorporated into the camera body, spot meters are separate units that look similar to a compact hair dryer. As a result, you can aim the barrel of the meter at a very small area of an overall scene and get an accurate reading. Unlike averaging meters, spot meters zero in on the primary subject and aren't influenced by surrounding light and/or dark areas of contrast. But because spot meters are expensive (prices begin around 150 dollars) and are rarely necessary for picture-taking situations, most amateurs and some professionals—myself included—forgo buying one.

The type of reflected-light meter located inside most SLR cameras is a *center-weighted meter*. Unlike averaging meters and spot meters, center-weighted meters measure reflected light throughout the entire scene but are biased toward the central portion of the viewing area. To use a center-weighted meter successfully, you must center the subject or subjects in the frame when you take the light reading. Once you set a manual exposure, you can then recompose the scene for the best composition. On the other hand, if you want to use your camera's autoexposure mode but don't want to center the subject in the picture, you can press the exposure-hold button and then recompose the scene so that the subject is off-center.

Portland, Oregon's skyline lends itself to early-morning frontlit compositions. One spring morning several years ago, I arrived in the city before the sunrise in order to photograph this western view. With my camera and 50mm lens secured on a tripod, I set the aperture to *f*/8. Depth of field wasn't a primary concern because much of the composition rested at infinity. ◆ As the sun came up behind my shoulder, I waited until it was high enough in the sky to cast its glow upon the buildings. When the light struck the buildings in the center third of the image and then was reflected in the water, I deliberately allowed this glaringly bright illumination to influence the camera's exposure meter. I proceeded to adjust the shutter speed, and the meter indicated a correct exposure of 1/500 sec. But as you can see in the top photograph, this was in effect an incorrect exposure. ◆ Because my camera's meter is center-weighted, I can almost always expect frontlit scenes to record on film as underexposures when I don't intervene. To achieve a properly exposed shot, I simply tilted the camera up and metered the sky. At the same time, I adjusted the shutter speed until 1/125 sec. was indicated. I then recomposed and fired, creating the correct exposure in the bottom shot.

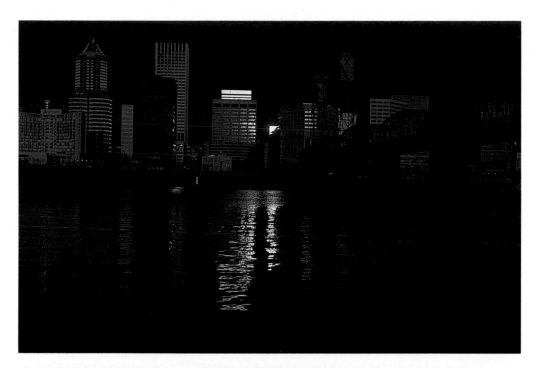

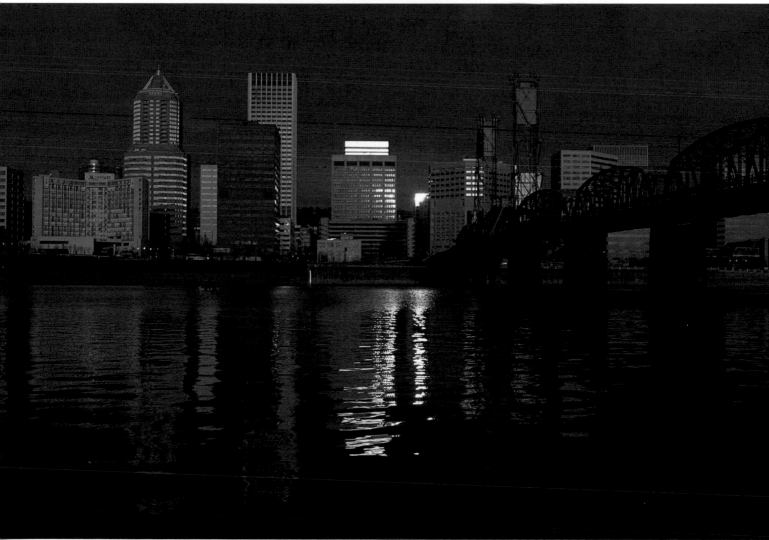

While on assignment in Cancún, Mexico, I met a shopkeeper who willingly agreed to be photographed for the magazine article I was working on. I purposely chose a spot near her shop that cast her in the low-angled light of the late afternoon. ✦ With my camera and 180mm lens mounted securely on a tripod, I set the aperture to *f*/5.6, thereby limiting the depth of field. I moved in closer to fill the frame with the light reflecting off the young woman's face and metered the scene. The correct shutter speed proved to be 1/250 sec. I moved back, recomposed, and pressed the shutter. The shopkeeper's expression and the warm illumination create an inviting composition.

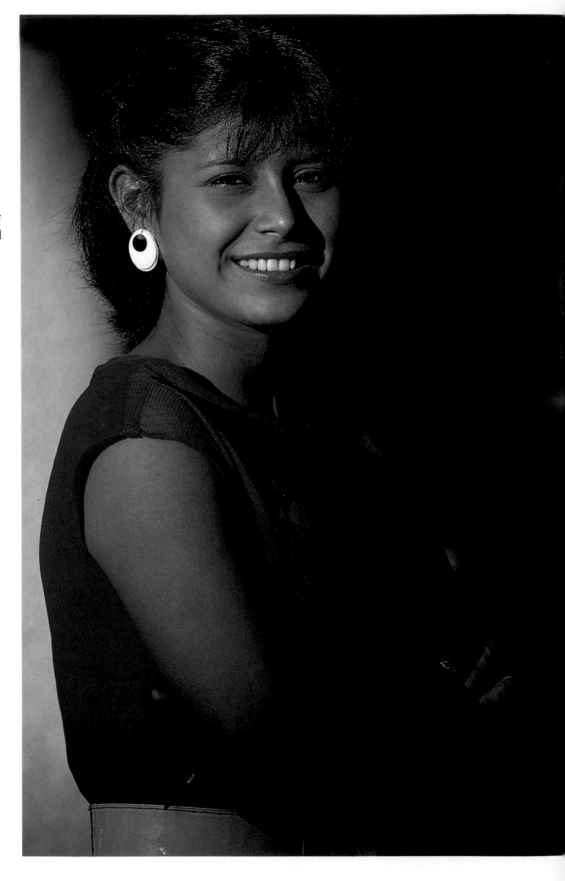

Whether you use an averaging, spot, or center-weighted meter, all three reflected-light meters are influenced by not only the amount and quality of light the subjects reflect but also the reflective characteristics, or *reflectance*, of the subjects themselves. More often than not, the reflectance of a given subject creates "bad" exposures, not the light that strikes the subject. As an illustration of this important point, imagine that you come across a black cat asleep against a white wall. Both the cat and the wall are frontlit by the early morning sun, illuminating them evenly. If you were to move in close and allow the meter to sense only the light reflected off the black cat, the meter would indicate a specific reading. If you were then to point the camera at only the white wall, the exposure meter would render a separate, distinct reading. This variation would occur because although the subjects are evenly illuminated, their reflective qualities radically differ. For example, the white wall would reflect approximately 36 percent of the light, while the black cat would reflect only 9 percent of the light.

Keeping this in mind, imagine that the world is completely neutral gray. Then, whether subjects are bathed in full sunlight or open shade, they always reflect 18 percent of the light falling on them. Although this is a fictitious description of the world, it is a very real scenario in terms of reflected-light meters. The built-in exposure meters in today's SLR cameras measure all reflected light as if it were bouncing off a neutral-gray surface. This is not a problem because most subjects—whether they are frontlit in full sun or open shade and whether they are red, orange, blue, or green—reflect 18 percent of the light, just as a neutral-gray surface does. Consequently, meter readings taken with an averaging, reflected, or spot meter under these conditions are usually correct.

The only two exceptions to this principle are white and black subjects. Because white subjects tend to reflect 36 percent of the light, the meter inadvertently interprets the light as excessively bright and suggests giving the subject less exposure time. Conversely, the meter suggests more exposure time when it reads black subjects. In effect, white subjects record on film as an underexposure, while black subjects record on film as an overexposure. Interestingly enough, if you were to set an exposure based on the way the meter "sees" white or black subjects, you would end up with gray subjects in your pictures instead. This would happen because reflected-light meters tend to want to make all subjects appear average in brightness.

How then do you successfully meter white and black subjects? Treat them as if they are neutral gray, even though their reflectance indicates otherwise. In other words, a white wall that reflects 36 percent of the light should be metered as if it reflected the normal 18 percent. Similarly, a black cat that reflects only 9 percent of the light should be metered as if it reflected the 18 percent standard. The halving and doubling principle can help determine a correct exposure for white and black subjects. A white wall might reflect 36 percent of the light, but you must expose for it as if it reflected 18 percent of the light. When the meter measures the wall, it will suggest one less stop of exposure because of the extra stop of bright reflectance. However, you must treat the white wall as having 18 percent reflectance and add one more stop of exposure to the meter reading.

A black cat, on the other hand, might reflect only 9 percent of the light, but you must expose for it as if it reflected 18 percent. When the meter measures the black cat, it suggests one more stop of exposure because of the one-stop reduction in reflectance. But once again, you must intervene and treat the black cat as having 18 percent reflectance; you must subtract one stop of exposure from the indicated meter reading.

When I first learned about the 18 percent standard, it took me a while to catch on. One tool that enabled me to understand it was a *gray card*. Sold by most camera shops, gray cards come in handy when you shoot bright scenes, such as white, sandy beaches of snow-covered fields. Gray cards can also be used effectively for metering dark subjects, such as black cats or shiny black cars. Rather than take a meter reading from such highly reflective subjects, you simply hold a gray card in front of the lens, make sure that the light falling on the card is the same light falling on the subject, and meter the light reflecting off the card.

Many cameras on the market today offer automatic exposure. Most of these have built-in meters that are center-weighted, although a few meters can function as a spot meter as well. But these "foolproof-exposure cameras" are not foolproof—as perhaps you've already learned—especially for scenes or portraits composed of white or black. Like a meter in a manual-exposure camera, an autoexposure camera's exposure meter is fooled by the 36 percent reflectance of white areas and 9 percent reflectance of black areas. As a result, without your intervention an autoexposure camera will record a bad exposure. This doesn't mean that you should never use an autoexposure camera in the autoexposure mode; it will perform well most of the time in straightforward available-light situations. But when you want to shoot excessively bright or dark scenes, you must alter the autoexposure.

You can do this one of two ways: either by switching to a manual-metering mode and measuring the light level with a gray card, or leaving the camera in the autoexposure mode and using the built-in autoexposure overrides that most autoexposure cameras offer. These overrides are designated as follows: +2, +1, 0, −1, and −2, or as 2X, 1X, 0, 1/2X, and 1/4X. So for example, to provide one additional stop of exposure when shooting a snowy scene in the autoexposure mode, you would set the autoexposure override dial to +1 (or 1X). Conversely, when shooting a black car in the autoexposure mode, you would set the autoexposure override to −1 (or 1/2X) to achieve one less stop of exposure.

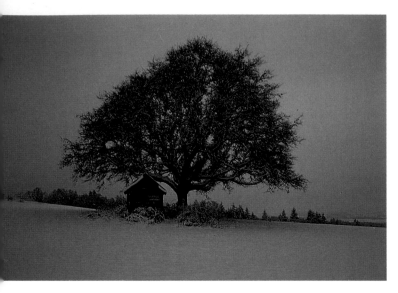

Heavy snowfalls in Oregon's Willamette Valley are uncommon, but last February a pristine blanket of white transformed an otherwise dreary landscape into a beautiful vista. I photographed this lone oak tree near my farm. Using a 50mm lens on a tripod, I set the aperture to *f*/8 and then found that a shutter speed of 1/30 sec. was necessary. But as the top shot shows, this produced a dark, underexposed snowscape. ◆ Why? Although white subjects reflect 36 percent of the light, they must be metered as if they were neutral-gray subjects; these reflect approximately 18 percent of the light. The meter understands this excessive reflectance to mean that less exposure time is necessary. The result recorded on film is an underexposed image. ◆ One of the easiest ways to overcome this problem is to use a gray card. When placed in front of the lens, a gray card enables the exposure meter to measure the normal 18 percent of the light reflecting off it. To achieve the bottom shot, I held a gray card in front of the lens, making certain to fill the frame with it, adjusted the shutter speed until 1/15 sec. was designated as the correct setting, and then removed the gray card. At this point, the meter responded immediately to the white landscape as an excessively bright scene and indicated that 1/15 sec. would produce an overexposure. But as you can see, *f*/8 for 1/15 sec. proved to be accurate.

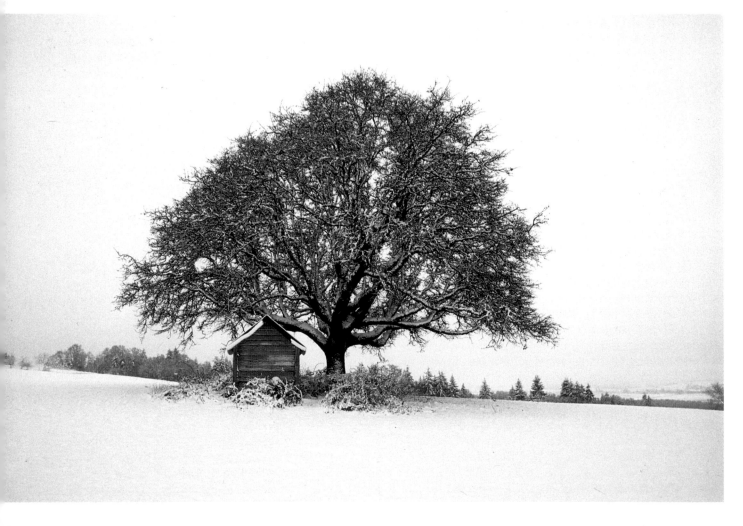

One August, I came across this solitary schoolhouse surrounded by acres and acres of golden wheat. I made a note in my calendar to return to this location during the winter. When I arrived at the scene after a snowfall, I was struck by the abandoned look of the schoolhouse and wanted to capture it on film. ✦ First, I mounted a 28mm lens and my camera on a tripod, positioning them in order to achieve a low shooting angle. I then set the aperture to *f*/22 and preset the focus via the depth-of-field scale. The camera's built-in exposure meter called for a shutter speed of 1/250 sec. But as the top photograph illustrates, the result was a severely under-exposed scene. ✦ To eliminate this problem when shooting both frontlit and sidelit snowscapes, you can either use a gray card or meter the blue sky above the horizon. In this situation, I tilted the camera up toward the sky above the building's roof and turned the shutter-speed dial until 1/60 sec. was indicated. I then composed the shot again. The correctly exposed photograph is shown below.

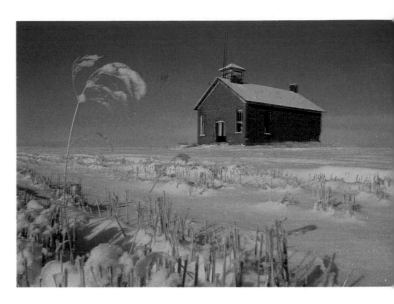

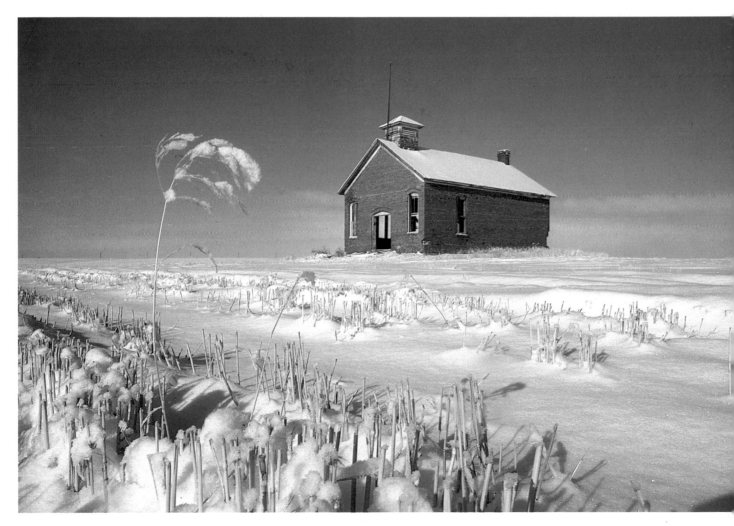

INCIDENT-LIGHT METERS

Unlike reflected-light meters, which measure the light reflecting off a subject, incident-light meters measure the light that falls onto a subject. To help you understand this distinction, think of an exposure meter as an arrow. A reflected-light-meter reading is achieved when you point the arrow directly at the subject, but an incident-light-meter reading is achieved when you point the arrow at the source of the light falling on the subject. For example, suppose you are shooting landscapes frontlit by the sun. As you compose, you decide to allow the camera's built-in reflected-light meter to measure the brightness of the scene, so you aim the meter (and, of course, the camera) at the landscape. If you then change your mind and decide to use an incident-light meter instead, you would point it toward the sun to measure the intensity of the sunlight falling on the landscape.

Incident-light meters have advantages and disadvantages. Small and compact separate units, they are easily handholdable. But incident-light meters can be expensive—good ones are priced about 150 dollars, and some cost around 500 dollars. Such an investment can seem unwarranted when you discover that these meters aren't needed for most picture-taking situations. I've never owned an incident-light meter, and only on the rarest of occasions have I used one. In fact, I've come to depend in large part on my camera's built-in exposure meter. The final decision, however, is yours.

EXPOSURE-METER SENSITIVITY

Every exposure meter on the market, whether it is built into the camera or is a separate unit, is capable of measuring the light on subjects that are bathed in daylight. This available light exists in various forms: full sun, open shade, and overcast conditions. But when your subjects are bathed in low light, you might think that your exposure meter isn't sensitive enough to record an accurate reading.

The easiest way to determine the sensitivity of your meter is to look at your camera's shutter-speed dial. If your camera offers slow shutter speeds of 8 sec. or longer, its exposure meter is quite sensitive. While photographic theory suggests that the more sensitive the meter is, the wider the range of picture-taking possibilities in low light, this doesn't necessarily mean that a less sensitive meter limits your options. With any long exposure, the primary goal is to record a starting exposure. So, using either a camera with a highly sensitive built-in meter or a precise handheld meter simply makes establishing a starting exposure a bit easier. (As I discuss in depth in the section on shutter speeds, long exposures are possible even with cameras that offer only 1 sec. as the slowest shutter speed. See page 88.)

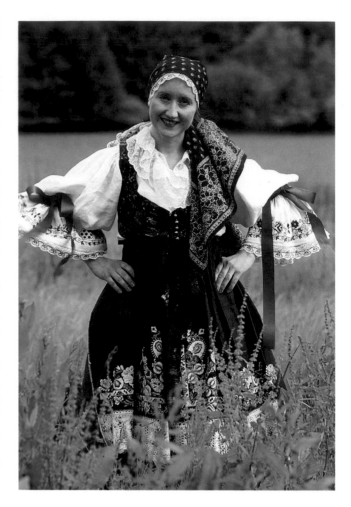

While photographing this woman, I realized that using an incident-light meter would be appropriate because the top half of her dress was white surrounded by a field of green and the bottom was dark blue. I knew that if I used my in-camera meter, I would end up bracketing this portrait of Daniela Sipkova-Mahoney, a Czechoslovakian artist. ✦ I borrowed my assistant's incident-light meter (I don't own one) and set my 180mm lens to f/5.6 to limit depth of field. With the ISO 50 film speed programmed into the meter, I pointed it toward the bright, diffused light in the sky behind me. The meter indicated that f/5.6 for 1/250 sec. was the correct exposure. The result is shown above. ✦ To satisfy my curiosity, I also took a reading with my camera's built-in meter. It indicated that an exposure of f/5.6 for 1/500 sec. was correct.

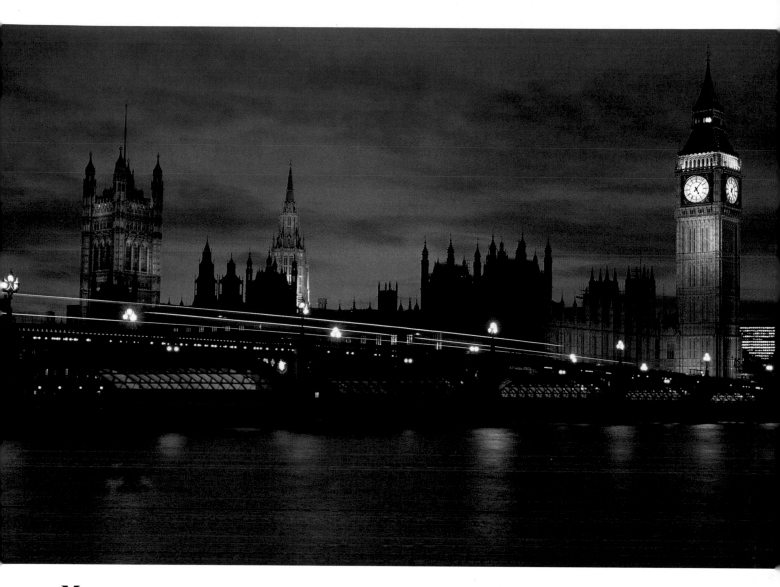

Many photographers forgo the opportunity to shoot at dusk because they aren't sure what part of a low-light scene to meter for. But determining exposure for such images is actually quite simple. The last traces of light in the sky 15 to 25 minutes after the sun sets require the same exposure time as the cityscape or rural landscape below. ✦ While on assignment in London, I photographed this classic scene that includes the Thames, Westminster Bridge, Parliament, and Big Ben. With my camera and 50mm lens mounted securely on a tripod, ISO 50 film, and the aperture set to *f*/2.8, I aimed the camera and lens at the darkening sky. At this point in the picture-taking process, the correct exposure was *f*/2.8 for 1/8 sec. ✦ Because I wanted to emphasize the motion of both the river and any traffic on the bridge, I had to shoot at the longest exposure time possible. Switching from *f*/2.8 to *f*/32 produced a seven-stop decrease in light transmission, so I knew that a corresponding increase in shutter speed was necessary for a proper exposure: from 1/8 sec. to 1/4 sec., to 1/2 sec., to 1 sec., to 2 sec., to 4 sec., to 8 sec., and finally to 16 sec. Then, by tripping the shutter via a locking cable release, I was able to achieve this appealing photograph of London at dusk.

Most picture-taking efforts begin with the question, "What should the exposure be?" To answer that question, you have to decide which creative tool is a priority: the aperture, which controls depth of field, or the shutter speed, which can freeze action or imply motion. Once you make this decision—which you must do every time you take a picture—all you have to do to achieve a successful exposure is determine where to take a meter reading. For example, during a trip to Hawaii I wanted to shoot Poipu Beach, a beautiful, palm-tree-lined stretch on the southwestern shore of Kauai. Within the first hour after sunrise, the early-morning frontlight contrasted the surf pounding against the rocks with the still, sandy shoreline. As I composed, I envisioned various images of the crashing surf. I could either freeze the action of the waves via a fast shutter speed or suggest their motion using a slow one. I also noticed a solitary shell resting on the smooth, golden sand, establishing a tranquil mood. I had two choices. First, I could shoot straight down on the shell with a 50mm lens set at $f/8$, an aperture whose area of focus begins and ends with the subject. My other choice was to lie down and using a wide-angle lens, place the delicate shell in the immediate foreground and the pounding surf in the background; this would result in an entirely sharp image.

Having explored several ways to creatively use the aperture and shutter speed, I was ready to think about exposure. To freeze the action of the pounding surf, I would have to rely on the aperture to achieve a correct exposure. On the other hand, to focus solely on the shell (shooting from either position), I would have to rely on the shutter speed in order to achieve exposure properly. Although the more common practice of simply lining up needles or diodes certainly can produce a correct exposure, it seldom leads to a striking image. Making a conscious effort when selecting an aperture and shutter speed brings creative exposure to a composition.

When you photograph backlit subjects or subjects in open shade that are surrounded by brighter light, it is a good idea to actually walk up to your subjects and take a meter reading off them. (Using a spot meter will, of course, accomplish the same result, but it requires an additional expense.) ◆ I had just finished mowing the lawn when my niece, Katie, came outside and announced that she wanted to model for me. Never one to turn my back on an opportunity to add to my stock-photography files, I asked her to wait while I went to my studio to grab my gear. With my 180mm lens set to $f/5.6$ to limit depth of field, I wanted to photograph Katie against a background of green. But because I didn't want the light meter to be influenced by the touch of backlight around Katie's head, I walked up to her and filled the frame with her out-of-focus face, as you can see in the shot above. Next, I adjusted the shutter-speed dial until 1/250 sec. was indicated as the correct setting. ◆ For the photograph on the opposite page, I set the exposure manually. I then returned to my original spot, which was about 10 feet away from Katie, focused, and recomposed.

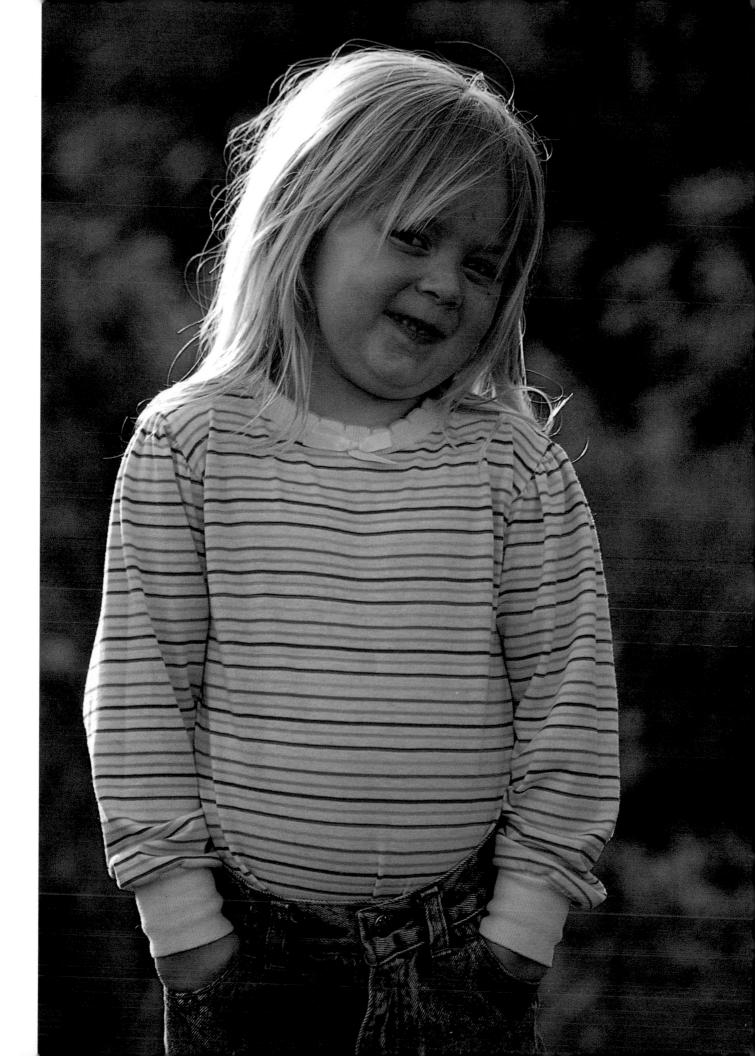

THE EFFECT OF FILM SPEED
ON METER READINGS

An exposure meter's functions are to sense the light that enters the camera's viewfinder and through the use of diodes or needles, to direct you to the best aperture and shutter speed for a creative exposure. But it is important to realize that the combination of aperture and shutter speed alone does not determine exposure. While this might surprise you, they are primarily tools that work together to bring the right amount of light for the right length of time to the film. Your choice of film speed also greatly influences your exposure meter. Because an exposure meter is a sensing device that measures the light reflecting off a subject, its response is directly affected by the number of light receptors a given film has; this in turn has a direct impact on which aperture-and-shutter-speed combinations you can use. So until you tell the meter what film speed you are using, it won't produce accurate readings.

To illustrate my point, I want you to go get your camera. Now set the film-speed dial to ISO 50 and the aperture ring on the lens to wide open (the largest *f*-stop). Next, point the camera at any subject, and adjust the shutter speed until a correct exposure is indicated.

Write down this shutter speed on a piece of paper. Now switch the film-speed dial to ISO 100. Without changing the aperture setting, point the camera at the same subject—notice that you have to change the shutter speed by one stop in order to get a correct exposure. Repeat this exercise, setting the film-speed dial to ISO 200, ISO 400, and ISO 800 and leaving the aperture wide open. You'll discover that you have to adjust the shutter speed by one stop each time you move the film-speed dial. You can also do this exercise using an ISO 50 film speed and a fixed shutter speed, such as 1/60 sec., and switching apertures until a proper exposure is established. You will also find that with every increase in the film speed, you'll need to change the aperture by one stop once again to ensure an accurate exposure. Both exercises graphically illustrate the impact of film speed on the exposure meter. Although it is true that exposure meters sense the light reflecting off every subject regardless of the film speed in use, a film's ISO rating directly influences the range of exposure combinations a given scene renders. You should keep this important principle in mind whenever you shoot.

As I prepared to photograph this tennis player jumping over a net, I asked myself why I make my work so difficult at times. With ISO 100 film in my camera and a 300mm lens, I determined the correct exposure to be *f*/5.6 for 1/500 sec. I was pleased about being able to shoot at such a fast shutter speed, but having to set the aperture to *f*/5.6 to achieve that speed left me feeling a bit annoyed with myself. If I had been smart, I would have brought along some ISO 400 film. It would have given me two extra stops, thereby enabling me to shoot at *f*/11 for 1/500 sec. The extra depth of field would have helped to render the subject sharp. ◆ After the tennis player made some trial jumps, I felt that I had preset the focus in the area of peak action. It took more than seven rolls of film, but I managed to make several compositions with exacting sharpness. My job would have been much easier if I had chosen ISO 400 film instead of the slower ISO 100 film.

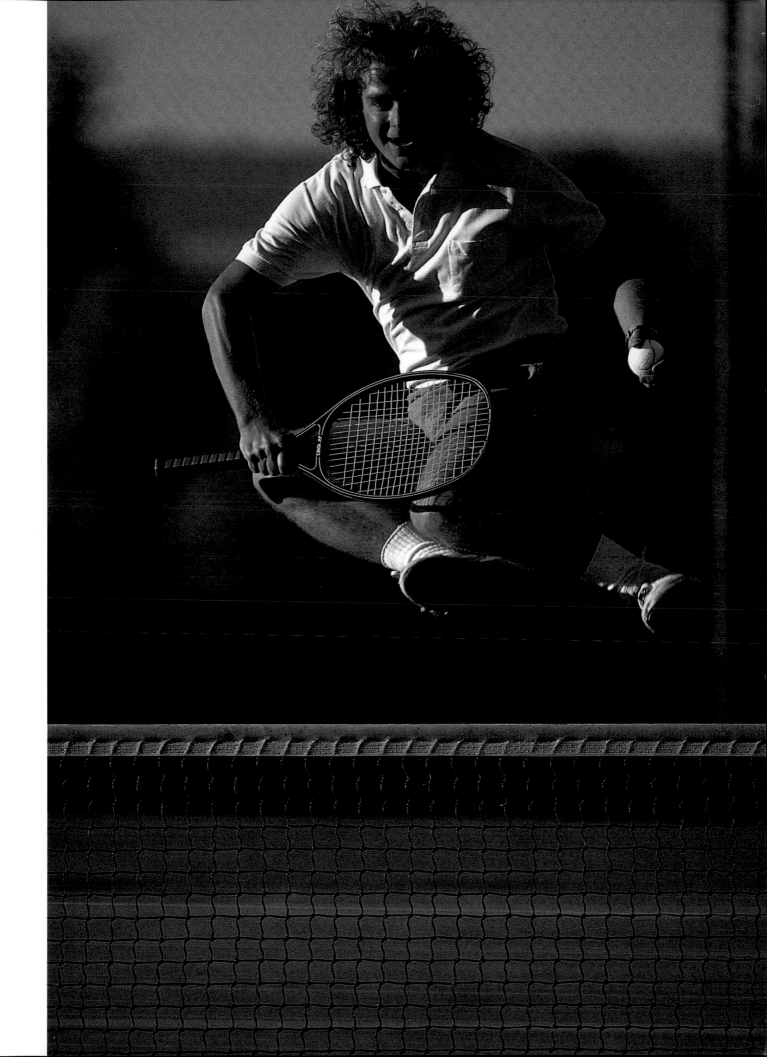

THE QUALITY OF LIGHT

Many amateur photographers today mistakenly assume that they can't capture light on film as well as professionals can. They seem to think that professional photographers have some special gift when it comes to capturing light. I've never understood this assumption because light is readily available to all who can see. Do waking up early and shooting the golden rays of morning light require a special gift? Do staying out after the sun sets and shooting the final orange-red glow on the western horizon require a special talent? Lighting, which more than any element establishes the tone of every composition, is the least exploited element in photography. Do your landscape compositions seem flat and lifeless? If so, to solve this problem you might be thinking about buying a 20mm wide-angle lens as soon as you can afford one. But unless you are willing to take advantage of early-morning or late-afternoon sidelighting as it slices across the landscape, thereby exposing textures and creating shadows to emphasize depth, your new 20mm lens will only magnify the contrasty light of midday in which you're accustomed to shooting.

Explore the changing light. On your next vacation, discover for yourself that frontlighting provides even illumination, sidelighting creates a three-dimensional effect, and strong backlighting produces striking silhouettes. After some experimenting, you'll reserve the midday sun for relaxing by the hotel pool.

You should also become familiar with the "color" of the light. Although early-morning light is golden, it is a bit cooler than the much stronger golden-orange light that begins to fall on the landscape an hour before sunset. Weather, especially inclement weather, also affects light quality. The soft, almost shadowless light of a bright overcast day can impart a delicate tone to many pastoral scenes as well as to flower closeups and portraits. Because snow and fog are monochromatic, they call attention to such an object as a long red barn or a pedestrian with a bright blue umbrella. Finally, you should follow light through the seasons. The harsh, direct summer sun differs sharply from the low-angled winter sun. During the spring, the clarity of the light provides delicate hues and tones for buds on plants and trees. The same clear light enhances the stark beauty of the autumn landscape.

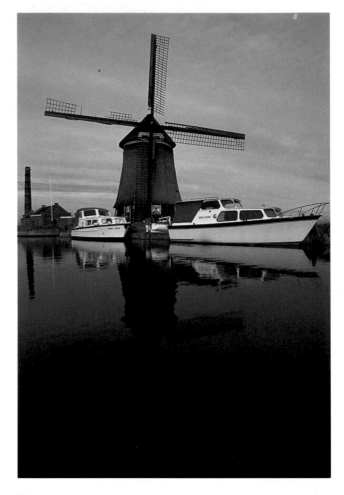

Pictures that showcase the gold and orange light of early morning and late afternoon always evoke a powerful response. These tones also create a pleasing sense of warmth. From sunrise until 45 minutes afterward, as well as the period between sunset and the preceding 90 minutes, low-angled lighting abounds. This illumination is important for shooting frontlit or sidelit subjects. ✦ While on assignment in Holland, I noticed this windmill at the edge of a dyke. I had wanted to photograph it in the golden light of the late-afternoon sun; unfortunately, a large layer of clouds moved in and dashed my hopes of shooting the windmill in low-angled light.

I returned to the same spot the next night, knowing that I would be able to achieve the desired effect because the sky was clear. With my camera and 105mm lens mounted on a tripod, I chose an aperture of f/22. The exposure meter indicated a correct shutter speed of 1/60 sec. To ensure maximum sharpness, I then preset the focus via the depth-of-field scale. ✦ During the final minutes of daylight, I shot more than five rolls of the frontlit windmill. As the difference between the earlier photograph above and the later one on the opposite page reveals, with each passing minute the quality—the color of the low-angled light—grew warmer.

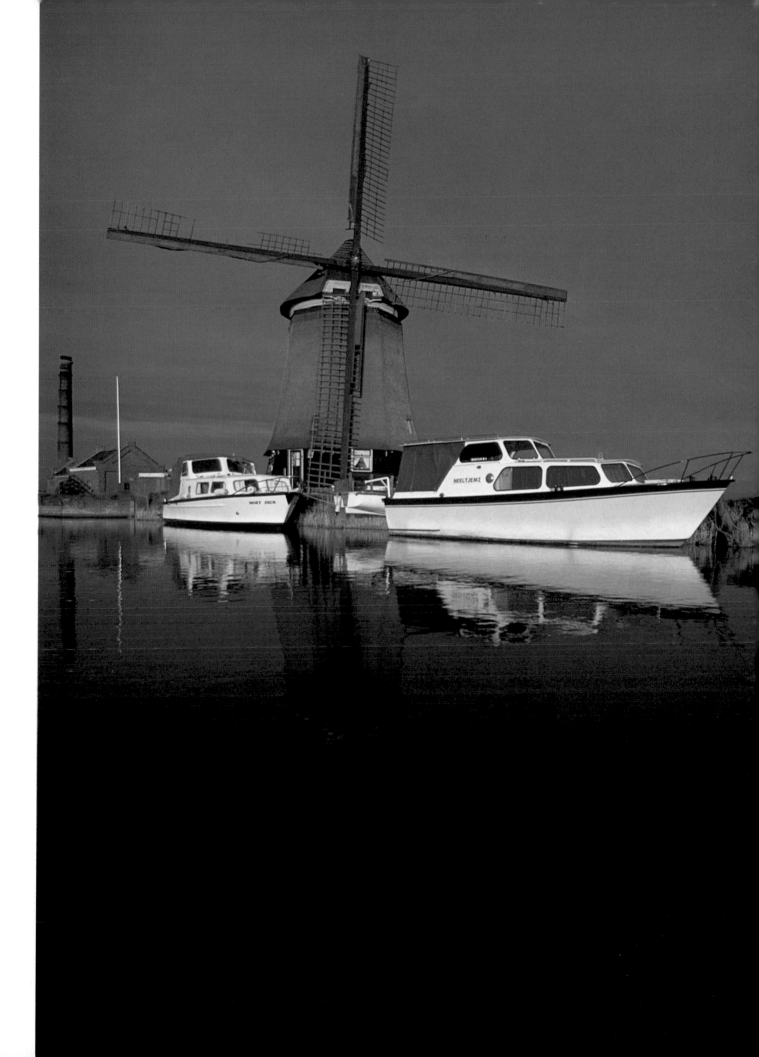

One of the best exercises I know can be done near your home. Select any subject: for example, the houses and trees that line your street or the city skyline. If you live in the country, in the mountains, or at the beach, choose a large, expansive composition. With a wide-angle or normal lens, document both the changing seasons and the continuously shifting angles of light throughout the year. At the end of your 12-month exercise, spread out the pictures on your desk or kitchen table; or if you shoot slides, place them in a projector. Then carefully study the seasonal changes in the light as well as the light's direction: frontlighting, sidelighting, and backlighting. I did this exercise several years ago in my own neighborhood. I took several pictures a week (usually on the weekend), shooting to the south, north, west, and east at different times of the day. I paid no attention to the photographs' content or to the weather, shooting whether it was sunny, foggy, raining, or snowing. Even before the year was over, I was miles ahead of other amateurs in my ability not only to see the light but also to predict its quality and tone on film. Was I gifted? No, the light itself is the gift. By putting myself in the position to receive and appreciate the quality of light, I gained a tremendous amount of understanding and improved my photography.

Tower Bridge is one of London's most famous—and most photographed—attractions. While on a corporate assignment for several weeks, I took advantage of the opportunity to shoot the bridge under different lighting conditions. ◆ My first attempt, shown above, was made at dawn on an overcast day. The illumination at that time was soft yet somewhat cool. I returned later that same morning after the sky had cleared and rephotographed the scene, shown in the top left shot on the opposite page. With the promise of a clear sky again at sunrise, I went back the following morning and recorded the same composition. As you can see in the top right shot, the scene was sidelit by the early-morning sun. When I returned at sunset, I decided to photograph the bridge from a different vantage point—50 feet east of my original position—with an orange filter (bottom left shot). I waited half an hour before I continued to shoot, knowing that the bridge lights would turn on just before the last light of the day disappeared into darkness. (bottom right shot). ◆ This experience taught me that different times of day, weather conditions, and lighting combine to produce different moods. Under the overcast light at dawn, the bridge appears cool and distant. On the other hand, the golden light at sunrise makes the bridge seem warm and inviting. In late morning, it appears cheerful and stable; at sunset, its graphic shape creates a sense of dignity; and right before nightfall, the bridge's artificial illumination makes it look quite regal. Because every subject is influenced by the quality of light, it is essential for you to explore the effects of various times of the day and the year.

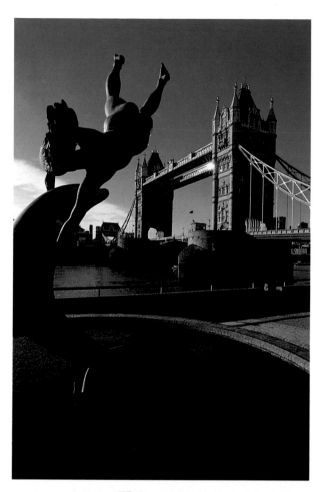
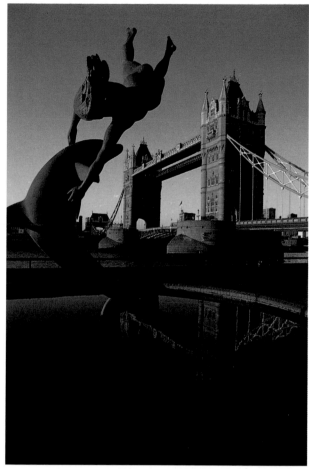
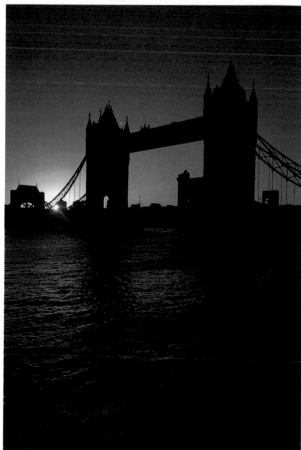
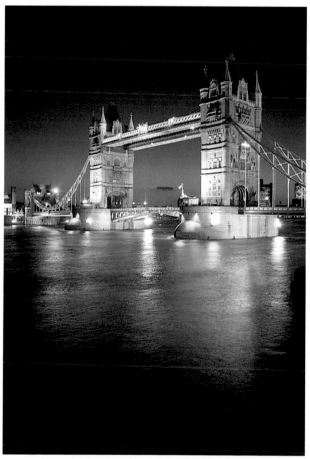

Of all the different lighting conditions that photographers are faced with, many consider an overcast sky and frontlighting to be the safest. This is because they illuminate most subjects evenly, making meter readings simple. These lighting conditions also enable autoexposure cameras to perform well. Despite these advantages, many photographers attach so much importance to the quality and color of light that they somewhat disdain overcast conditions. This is unfortunate because overcast lighting is ideal for photographing three popular subjects: people, flowers, and forests. (It is less than ideal for white and black subjects.) The softness of this type of light results in much more natural-looking portraits, richer flower colors, and eliminates the contrast problems that a sunny day creates in wooded areas. As such, I refer to overcast conditions as "aim-and-shoot lighting."

Frontlighting, on the other hand, poses a challenge—not in terms of metering light levels but in testing your endurance and devotion. The quality and color of frontlighting are best the hour before sunrise and after sunset. The warmth of this golden-orange light invariably elicits an equally warm response from viewers. Frontlighting makes portraits more flattering and enhances the beauty of landscapes. As a result, I approach frontlighting the way I do overcast conditions: using my "aim-and-shoot" method.

In addition, frontlighting offers slide shooters another creative possibility. They can increase the drama of their compositions by photographing a one-step underexposure of subjects that are both frontlit and set against a backdrop of an approaching storm. During the early morning and the late afternoon, I've often come across frontlit subjects set against a backdrop of dark thunderhead clouds. By shooting at a one-stop underexposure, I'm able to record the approaching clouds as even darker on film. This makes them seem even more threatening. The only exceptions to this are such highly reflective subjects as polished surfaces and windows, including much modern architecture. These subjects generally require a one-stop overexposure.

Frontlighting or overcast lighting are almost guarantees for perfect exposures every time you shoot. You don't have to be an exposure expert when shooting under these lighting conditions because they evenly illuminate the subject. Even first-time photographers can make successful exposures whether their cameras are in manual or autoexposure mode. This is a good time to try different films, f-stops, and shutter speeds. Make mistakes on overcast days or when shooting frontlit subjects, and learn from your mistakes. That way you'll be more prepared to master the challenge of setting exposures in sidelighting and backlighting conditions.

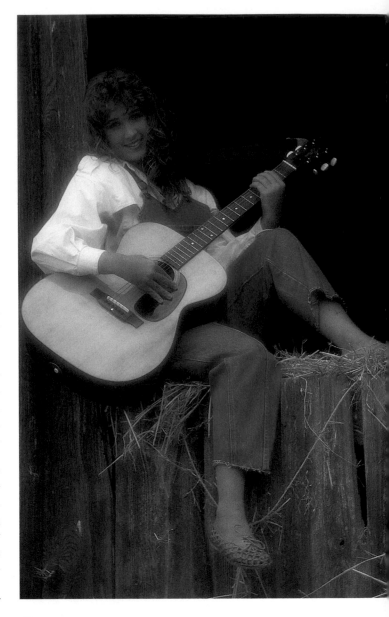

Over the course of several days, I shot more than forty rolls of Ranette Hastie, the daughter of one of my students. For this photograph, I asked her to pretend that she was playing a guitar as she sat in a large opening in my barn. ◆ With my camera and 180mm lens secured on a tripod, I chose an aperture of f/8; I didn't care about depth of field. The even illumination of the overcast sky made metering simple. The correct shutter speed proved to be 1/500 sec. I placed a soft-focus filter on the lens to enhance the composition.

Landscape photographers know that an overcast day is ideal for shooting in the woods or forest because of the even illumination. During the spring and summer, rich greens dominate; in the fall, yellows, reds, and oranges explode. ◆ While on assignment in Montana near Glacier National Park, I noticed an unusual bird foraging for food. With my camera and 300mm lens mounted on a tripod and the aperture set to *f*/5.6 to ensure a limited depth of field in the shot on the right, I simply adjusted the shutter speed until the correct exposure was indicated. Because overcast lighting is soft and poses no contrast problems, I was able to see details on the bird and to easily identify it as a scissor-tailed flycatcher. ◆ I took the bottom photograph along the Oregon shoreline on yet another overcast day. With my camera and 55mm macro lens mounted securely on a tripod, I decided to shoot straight down on this lone rock surrounded by different shades of gray and blue. Because depth of field wasn't important, I set the aperture to *f*/8. Once again, the even illumination created by the overcast sky enabled me to turn the shutter-speed dial until a correct shutter speed of 1/125 sec. was indicated. ◆ This image would have been impossible on a sunny day; because of my point of view, part, if not all, of the composition would have been cast in shadow.

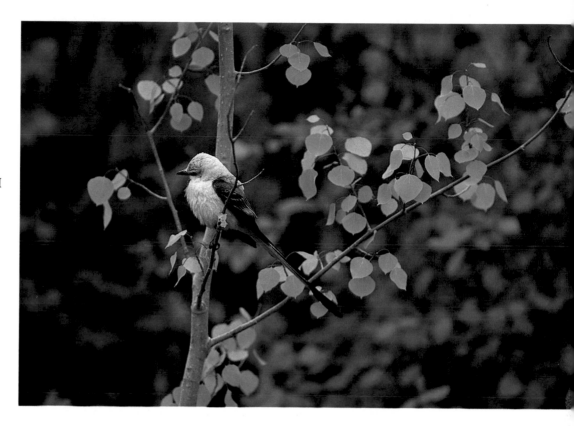

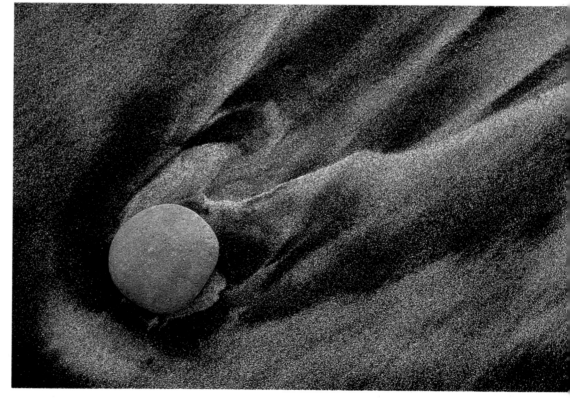

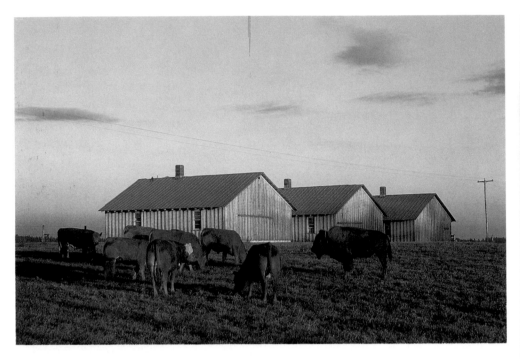

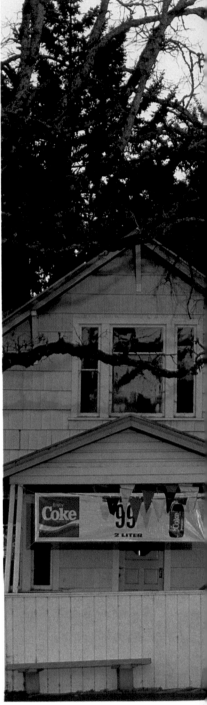

Driving along back roads near McMinnville, Oregon, I came around a corner and was immediately struck by the low-angled frontlighting bathing this rural farm scene. With my camera and 50mm lens securely mounted on a tripod, I proceeded to set the aperture to *f*/16. To maximize depth of field, I then preset the focus via the depth-of-field scale. The correct shutter speed for this shot was 1/60 sec. ◆ Although the golden illumination was beautiful and the cows and barns balanced well, what intrigued me most was the single buffalo in the right side of the frame.

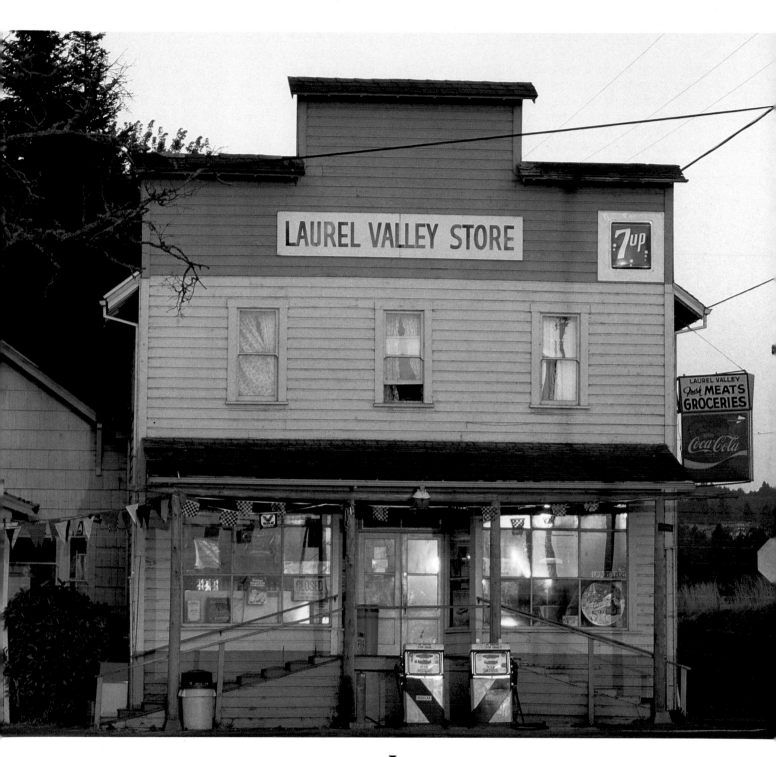

In this picture, low-angled frontlighting transforms an ordinary country store into an amazing work of art. Luckily, I happened to be in the right place at the right time. ✦ To prevent my camera's built-in exposure meter from being fooled into an underexposure—as a result of the intensity of the gold light reflecting off the storefront windows—I tilted the camera up on the tripod, above the front wall of the store, and metered the sky. I then set the exposure, recomposed, and shot. I used a 105mm lens at $f/8$ because depth of field wasn't a primary concern and a shutter speed of 1/250 sec.

SIDELIGHTING

How can the direction of the light affect the mood of the subject? Frontlit subjects and compositions photographed under an overcast sky often appear to be flat and two-dimensional even though your eyes tell you that the subject has depth. To create the illusion of a three-dimensional subject on film, you need subjects with highlights and shadows. Deliberately seeking sidelit subjects will reverse this three-dimensional effect. For several hours after the sunrise and several hours before the sunset, sidelit subjects abound if you shoot facing roughly north or south. If you are shooting slides, you'll want to favor the indicated meter reading in addition to underexposing by one and two stops. The shadows in any sidelit scene become excessively dark when underexposed, and this produces a wonderful illusion of three-dimensionality. Print shooters, on the other hand, should shoot at the indicated reading as well as overexposing by one stop to create the darker or black shadows. Textures are emphasized, and the subject shows both volume and depth. However, if important subjects are in the shadows, you'll want to shoot at the indicated reading as well as overexpose one and even two stops. This is true for both slide and print film.

Sidelighting is the most challenging of exposures because it combines highlight and shadow. But it is also the most rewarding picture-taking opportunity. As many professional photographers would agree, a subject that is sidelit rather than frontlit or backlit is sure to elicit a much stronger response from viewers because it simulates on film the three-dimensional world they see with their own eyes.

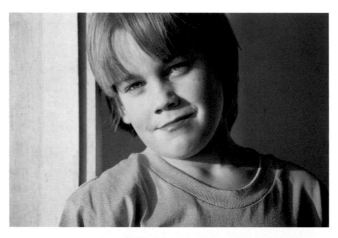

Unlike the human eye, which can see light and dark simultaneously and separate highlights, midtones, and shadows—as well as see detail throughout a scene—cameras can't. But you can exploit this inability for dramatic results. Sidelight provides the perfect opportunity. ◆ In the closeup on the right, I did my best to illustrate what I saw when I composed the shot. I saw my son, the gold light falling on him, and the area of open shade to the left of his face and behind him clearly. With my camera and 180mm lens secured on a tripod, I set the aperture to f/5.6 to limit depth of field. Exposing by two stops above the designated reading of 1/125 sec. (1/30 sec.) enabled me to record both the highlights and the areas of open shade. ◆ For the creative effect in the picture below, I exposed at f/5.6 for 1/1000 sec., one stop under the indicated shutter speed of 1/500 sec. The result: areas of open shade recording as dark if not black on film. The combination of light and dark provides a sense of depth and dimension in this sidelit composition.

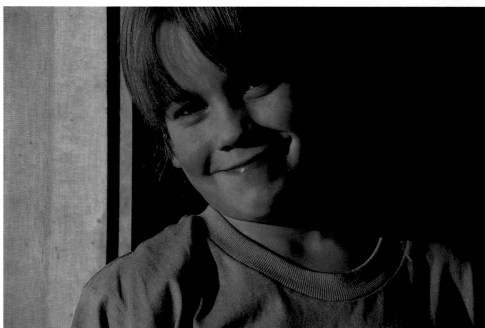

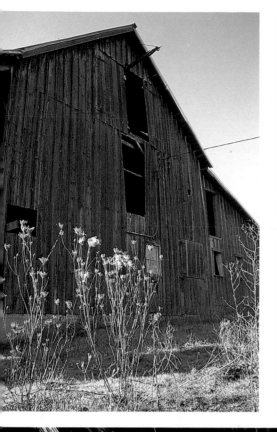

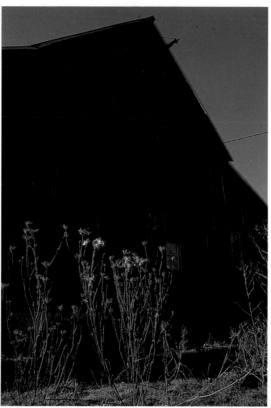

Shortly after sunrise, I noticed a group of sidelit seed heads snarled by Queen Anne's lace. In the shot on the far left, I deliberately photographed the scene to illustrate how it appeared to me. The seed heads, the barn, and the blue sky were all clearly visible. ✦ By exposing exclusively for the seed heads and then shooting at one stop under that indicated reading, for the shot on the left I was able to have background areas of open shade as well as the barn to record on film as very dark shapes. ✦ For the closeup of a single seed head below, I placed my camera and a 55mm macro lens on a tripod, moved in close, set the aperture to f/22, and, finally, adjusted the shutter speed until 1/30 sec. was indicated as correct. But rather than shoot for 1/30 sec., I decided to set the shutter speed to 1/60 sec., thereby creating a one-stop underexposure. This transformed the open shade into a black area of severe underexposure and contrast.

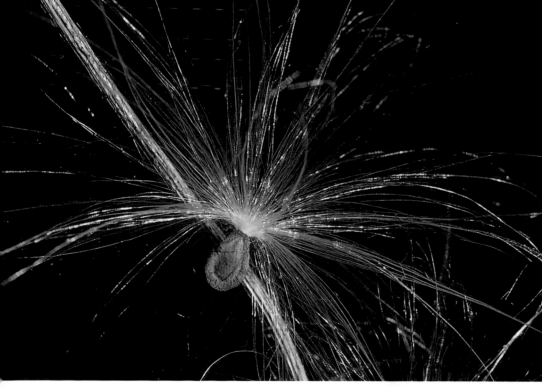

BACKLIGHTING

Backlighting, a photographic term used to describe a direction of light, can be confusing. Beginning photographers assume, as I did when I first started shooting, that backlighting means the sun is at your back. However, the opposite is true: the light, or the sun itself, is behind the subject in front of you. Of the three primary lighting conditions—frontlighting, sidelighting, and backlighting—backlighting continues to be the biggest source of both surprise and disappointment. Do you remember shooting your first silhouette? If you are like most other photographers, you probably achieved it by accident. During many assignments in the Hawaiian islands, I have watched countless bridegrooms shoot unintentional silhouettes. Rather than photograph a detailed portrait of his wife standing under a palm tree with backlighting from the setting sun, the well-meaning husband will in fact record a silhouette. (For those of you thinking that the groom might have intentionally shot a silhouette, please explain why he told the bride to smile before he pressed the shutter release.)

Although silhouettes are perhaps the most popular creative exposures, many photographers find them frustrating to shoot because they don't always turn out well. This inconsistency is usually a result of what lens is chosen and where the meter reading is taken. For example, when you shoot with a telephoto lens, such as a 100mm lens, you must meter carefully. The telephoto lens increases the image magnification of the very bright sunrise or sunset in the background. The exposure meter sees this magnified brightness and suggests an exposure accordingly. If you were to shoot at this exposure, you would end up with a picture of a dark orange or red ball of light, with the rest of the frame fading quickly to dark, if not black. Furthermore, whatever subject you want to silhouette would merge into the surrounding blackness. So whenever you shoot a silhouetted composition with a telephoto lens, *always* point the camera and lens to the bright sky to the right of, left of, or above the sun, and *never* include the sun in the viewfinder. Manually set the exposure or press the exposure-hold button if you are using an automatic camera in the autoexposure mode.

On the other hand, when you shoot scenes with a sunrise or sunset in the background with a wide-angle lens such as a 24mm, 28mm, or 35mm lens, you can simply point, compose, and shoot most of the time. Wide-angle lenses diminish the intensity of the sun's light: in effect, the angle of view of this type of lens merges the sun with the surrounding expanse of sky.

However, when you shoot sunrises or sunsets at the coast and wish to include the wet, sandy beach and small rocks in the foreground, you must take a meter reading from the light reflecting off the sand. This is because the wet sand, which reflects the colors of the sunset or sunrise in the sand, is about two stops darker than the sky. If you exposed for the large expanse of sky and sun, the wet, sandy foreground would record on film as a two-stop underexposure. In this situation, that is a bit too dark. In any effective storytelling photograph, foreground interest is essential (see page 52). When the foreground of a photograph isn't correctly exposed, it is like a book in which the print in the first few chapters is muddled and unclear. Although overexposing the foreground in a sunset shot by two stops means that the large expanse of sky and sun will also be overexposed, any foreground subject will remain colorful if perhaps a bit on the pastel side.

If you are photographing a backlit subject but don't want to make a silhouette, you can use flash to achieve a correct exposure. Because I'm not a fan of artificial light, I think that there is a much simpler way to both get a proper exposure and create a stunning effect. Returning to the honeymooners in Hawaii, if the groom wants a photograph that clearly shows his bride's face as well as her Hawaiian print dress, he must set an exposure exclusively for the light reflecting off her, regardless of his lens choice and composition. To do this, he should walk toward her and fill the frame with only her dress and face. She wouldn't even need to be in focus at this point. Then he should take a meter reading and either set the exposure manually or press the exposure-hold button if he were using an automatic camera in the automatic-exposure mode. Finally, he should return to his original shooting position, focus, recompose the scene, and shoot. The result will be a perfectly fine exposure, no matter what lens he uses.

To achieve a truly glorious image, he should use a telephoto lens and choose a viewpoint that places the bright sun directly behind the bride's head. Exposing for his wife's skin tones and dress will then create "a ring of fire" around her hair. This *rimlighting effect* is a type of backlighting; it is the result of an overexposure of the sun that in this situation illuminates the hair from behind.

Backlighting always provides two exposure options. You can either silhouette the subject or subjects against the backlight or meter for the light on the subject against the strong backlight. Although both choices require special attention, the results are always rewarding. Like so many exposure options, successful backlit scenes result from a conscious and deliberate metering decision.

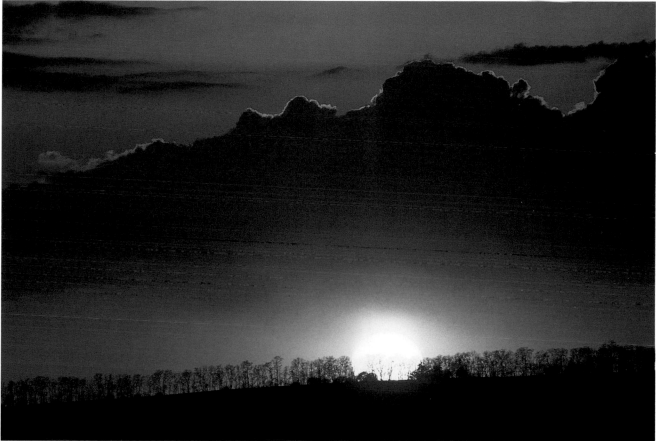

Shooting deliberate silhouettes is one of the most popular exposure techniques because the results are so dramatic. This is particularly true when subjects are photographed against a beautifully illuminated sky. Unfortunately, silhouettes look much easier to execute than they actually are. ✦ After photographing an assignment in eastern Washington for five days and witnessing an equal number of sunrises and sunsets, I had time to do some shooting for myself. Earlier in the week, I had spotted a hill lined with old locust trees and had planned to return there because I knew that the scene would make a wonderful silhouette. But I hadn't planned on numerous thunderheads—a stroke of luck. ✦ I mounted my camera and 400mm lens on a tripod, got into position, and proceeded to fill all but the bottom portion of the image area with this dramatic sunset. Because depth of field wasn't a primary concern, I set the aperture to f/8. Next, I allowed the meter to determine what the shutter speed should be: 1/500 sec. As you can see in the top left picture, however, this resulted in a too dark image. Because I was using a telephoto lens, the exposure meter interpreted the magnification of the sunlight as greater than it actually was. ✦ To prevent this problem, I find it beneficial to meter the area above or to the left or right of the sun. So I exposed for the sky above the sun, as shown in the top right shot, and adjusted the shutter speed until a correct exposure was indicated; this was f/8 for 1/250 sec. I then recomposed the scene. The bottom photograph is a far more pleasing silhouette.

Following a little-league game, I saw this boy sitting at the top of the bleachers staring at his baseball. With my camera and 200mm lens securely mounted on a tripod, I quickly framed him against the sunset. I allowed the camera's exposure meter to be influenced by the bright sun. The meter indicated that 1/500 sec. was the necessary shutter speed. I set the aperture to f/8—depth of field wasn't important—and proceeded to take the picture. As you can see in the shot on the right, the image recorded on film as a severe underexposure. ◆ For the next photograph, I moved to the left to eliminate the sun from the composition, adjusted the shutter-speed dial, found the exposure to be f/8 for 1/250 sec., recomposed the scene, and, finally, fired the shutter. The photograph below is a stronger example of using backlighting to achieve a silhouette.

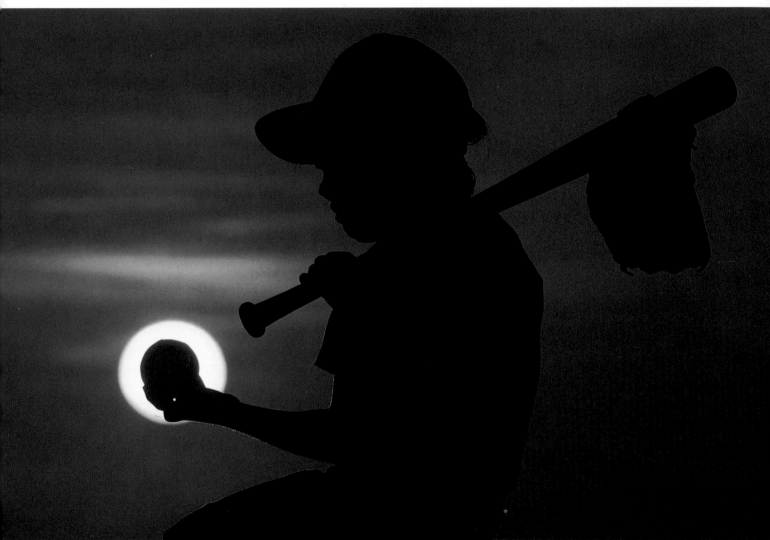

Along Oregon's central coast is Moolack Beach, which is a winter haven for hundreds of seagulls. I have successfully photographed the gulls against the strong backlight of late afternoon on more than one occasion. ◆ As you can see in the top picture, the sun's light is reflected in the water and wet sand directly below it. With my camera and 400mm lens securely mounted on a tripod, I walked slowly toward the seagulls until their relentless squawking made it clear that I was close enough. From a working distance of approximately 50 feet, I set the camera and tripod at waist level, knelt down, and began to focus on a few of the birds. ◆ Because I knew that I had to treat the backlighting as if it were the sun itself, I metered to the left of the reflected light. I then preset the aperture to *f*/22 in order to maximize depth of field. Next, I adjusted the shutter speed until 1/250 sec. proved to be correct. I swung the camera back to its original position (to the right). Although the meter indicated an overexposure, I proceeded to press the shutter anyway and, in fact, recorded the accurate backlit image (bottom picture).

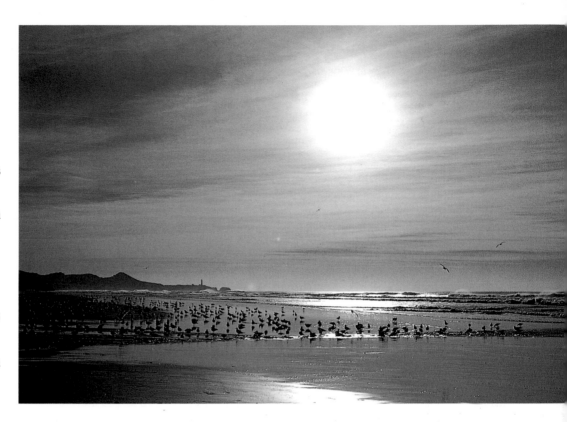

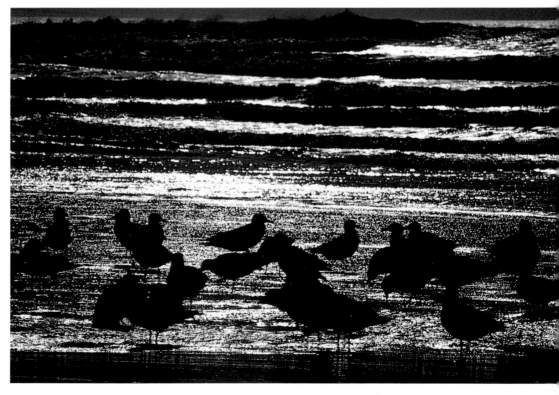

CONTRASTY CONDITIONS

Because the world is not completely neutral gray in color and because all picture-taking opportunities aren't composed solely of straightforward, existing-light scenes, photographers are faced with exposure problems. Can you recall the first sunset you photographed, whether you shot it in the city, in the country, or at the coast? Remember how you were able to see the blazing red sky as well as the subject matter below the horizon? As you composed the picture, you had every reason to believe that what you saw with your own eyes would in fact record on film exactly as it appeared because, after all, that same scene was also clear in the viewfinder. But when you picked up the film at the camera shop, what you saw and what the camera actually recorded were quite different. Chances are that the blazing red sky was exposed correctly while the subjects below the horizon faded to black. What went wrong? The exposure meter was more influenced by the bright sky than by the lower light value of the landscape.

Such scenes of high contrast pose the most common exposure problem for every photographer, amateur and professional alike. High-contrast situations abound. How many times have you noticed a bright sky behind a subject that is in open shade, or a solitary subject, illuminated by the sun, surrounded by shadows? The reason why what we see and what is captured on film varies so is simple. The human eye's ability to see and sense light differs quite a bit from an exposure meter's ability to do so. Translating vision into stops, the human eye can see approximately sixteen stops of light and dark simultaneously, whereas an exposure meter, in conjunction with aperture, shutter speed, and film speed, can "see" and record only a five-stop range.

Movie theaters provide a graphic illustration of this difference. Once you sit down and the movie begins, your eyes become dilated; in effect, their "apertures" are extremely wide open. As a result, you can simultaneously see the bright movie screen and the hair color of the person sitting in front of you. But if you were to photograph that person and include the much brighter movie screen in the frame, you wouldn't be able to record an acceptable exposure for both subjects. This is because the range of stops is too great. If you set the exposure for the light reflecting off the person in front of you, the much brighter movie screen would record on film as a severe overexposure. On the other hand, if you set the exposure for the light reflecting off the movie screen, the person would record on film as a pitch-black silhouette.

Because of this sharp contrast between human vision and photographic exposure, many photographers are often disappointed by their pictures—especially when they compare film results to their memory of what they actually saw. So in order to shoot high-contrast—in fact, all—scenes successfully, you must remember to "see" subjects the way an exposure meter does each time you look through the viewfinder and prepare to shoot.

The following exercise will help you feel comfortable with this approach. Find a scene that is composed of both sunlight and shadow. Load your camera with slide film, set the aperture to f/8, and adjust the shutter speed until a correct exposure for the overall scene is indicated. If, for example, this exposure is f/8 for 1/125 sec., shoot the same scene at two stops overexposed (1/30 sec.), one stop overexposed (1/60 sec.), correct (1/125 sec.), one stop underexposed (1/250 sec.), and two stops underexposed (1/500 sec.). When you get the film back, you'll notice that the highlights in the overexposed slides are not as "hot," or rich, as those in the underexposed slides. Deep reds, bright oranges, and vivid yellows are rendered as light pinks, soft apricots, and quiet yellows in the overexposed slides.

Also you'll probably favor one of the five exposures, the others being a bit too light or too dark for your taste. In many respects, exposure is a personal choice. But clearly, the saturated tones that resulted from underexposure and the delicate tones that overexposure provided were invisible to your eyes. While you could see the areas of highlight and the areas of deep shade simultaneously, you couldn't possibly see what was being captured inside the camera. On the film, a correct exposure for the highlights resulted in a very dark if not black exposure for the deep shade, and a correct exposure for the shade resulted in hot highlights. Even though a five-stop range might not seem like much, it is more than adequate since most picture-taking situations are seldom composed of light levels that vary by more than one or two stops. Furthermore, slide film's inability to cover a greater range of light and shadow can be utilized for many different creative effects. When you shoot contrasty subjects, make it a point to write down your exposure information. Did you underexpose the scene, shoot it at the indicated meter reading, or overexpose it by two stops? Then when you get your film back, go over your notes and pay special attention to the effects of varying degrees of exposure on the color and tone of your subjects. After keeping notes like this for several months, you'll begin to see and predict what and how the contrast will appear on film as you deliberately manipulate the exposure.

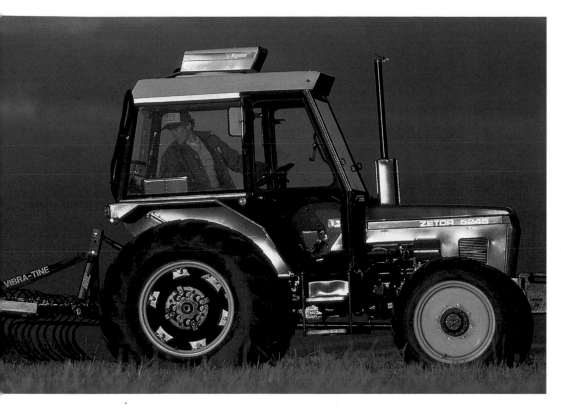

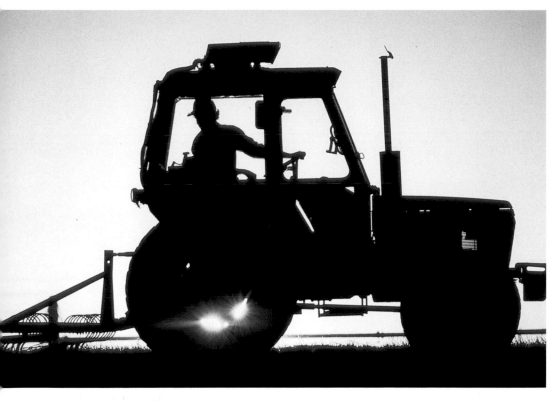

While on assignment for a tractor manufacturer, I had numerous opportunities to photograph this tractor under many different lighting conditions. One morning, my assistant and I arrived at a predetermined location before sunrise in order to shoot the frontlit tractor; the rising sun was behind our backs. The golden illumination of the early morning glinted off the tractor, and a storm to the west provided a dark backdrop. The resulting contrast produced a dramatic composition (top shot). To record it on film, I mounted my camera and 300mm lens on a tripod, chose an aperture of *f*/8 since depth of field wasn't a concern, and then simply adjusted the aperture until a correct shutter speed of 1/500 sec. was indicated.

◆ Later that same day, we returned to this location and shot the tractor against the strong backlight of the setting sun. I used the same lens-and-camera arrangement and aperture setting. I made a deliberate decision to photograph the tractor at the time when the sun reached a low point in the horizon. I knew that several of the sun's rays would pass through the rims of the rear tires, creating an image of high contrast. The result was a striking silhouette (bottom picture).

APERTURE

The aperture itself is really important for success-ful picture-taking, but even more important is the conscious selection of the "right" aperture. Before you can make smart choices, you need to be completely familiar with the aperture. First, the aperture is a "hole" located inside the lens. Also known as the *diaphragm*, this hole is formed by a series of six overlapping metal blades. When you turn the aperture ring, these blades change position and the size of the hole decreases or increases. This in turn transmits more or less light through the lens and onto the film.

For all lenses, the smallest number on the aperture ring—such as 1.4 on a 50mm lens, 2.8 on a 28mm lens, and 4 on a 200mm lens—always admits the greatest amount of light. Whenever you set a lens at its smallest numbered aperture, or *f-stop*, you are shooting "wide open." So when you shift from a small-numbered aperture to a much larger aperture number, such as 16 or 22, you are "stopping the lens down." Try to integrate these two photographic terms into your vocabulary. Then when you share your vacation pictures with co-workers, you can say, "Yes, I shot this sunset stopped all the way down, but this flower required me to shoot wide open." If you practice using these two phrases, you'll probably command a little more respect from friends as well as from salespeople at your local camera store. To select an *f*-stop, simply move the aperture ring until the desired lens opening is aligned with a central arrow or "hash mark."

Why would you possibly want to be able to change the size of the lens openings? Well, for years the common school of thought has been that because light levels vary from bright to dark, you can control the flow of light reaching the film simply by turning the aperture ring. This logic suggests that when you are shooting in the mountains surrounded by white snow, you should stop the lens down, which means make the aperture very small. Doing this will ensure that the brightness of the snow doesn't "burn a hole" in the film. This logic also implies that when you are in a dimly illuminated 15th-century cathedral, you should set the aperture to wide open so that your film can record the church's interior. Although these recommendations are well-intentioned, I emphatically disagree with them. They set up unsuspecting photographers for inconsistent results. Why? Because they give no consideration to a far more important function of the aperture: its role in determining depth of field.

Preparing for a trip to Vermont for an airline-magazine assignment, I planned for the riot of fall color. I packed more than 100 rolls of color-slide film. Once I arrived, I drove along the backroads. I was surprised by the number of fresh-produce stands. ✦ I watched several farmers unload pumpkins from large trucks behind one stand, arranging them in an almost orderly fashion on the ground. Excited by this picture-taking opportunity, I proceeded to shoot more than four rolls of film from varying points of view. ✦ I wanted this photograph to be sharp throughout, so I used a small lens opening, or *f*-stop. I set the aperture on my 20mm wide-angle lens to *f*/22. As a result, the depth of field is extensive.

DEPTH OF FIELD

No matter how well-composed a photograph is, if the wrong depth of field is employed, the picture won't be strong. But even the poorest of compositions can be commended when the right depth of field is used. So just what is *depth of field*? It is the zone or area of sharpness within a picture. Once you choose to focus on a particular subject, you'll notice that some sharpness exists in front of and behind the subject. As a general rule of thumb, this area of additional sharpness extends from one-third in front of and two-thirds beyond the in-focus subject. As you've undoubtedly noticed when looking at magazines, calendars, greeting cards, or large picture books, some photographs contain a great deal of overall sharpness while others have a very limited area of sharpness. You might be mystified by the "technique" professional photographers use to record extreme sharpness throughout an image—for example, from the flowers in the immediate foreground to the mountains in the distance. When you try to achieve overall sharpness with your camera, you may discover that when you focus on the foreground flowers, the mountains go out of focus; then when you focus on the mountains, the flowers go out of focus. In fact, one of my students felt quite confident that he couldn't render everything in a picture sharp because he did not have "one of those professional cameras."

What exactly influences depth of field? Three factors come into play: the focal length of the lens in use, the distance between you and the subject you want to focus on, and the aperture you selected. I think that choosing the right aperture is the most important yet most often overlooked element. In general, the shorter the focal length of the lens, such as 28mm (wide angle), and the larger the aperture number, such as $f/11$, $f/16$, or $f/22$, the greater the area of sharpness. Conversely, the longer a lens is, such as 200mm (telephoto), and the smaller the aperture number in use, such as $f/5.6$ or $f/4$, the narrower or more shallow the area of sharpness in the image. For example, if I were to set both the 28mm lens and the 200mm lens at $f/22$ and then focus both on a particular spot, the 28mm lens would render greater depth of field. Why would a longer lens produce less depth of field than a shorter lens when they are both adjusted to the same f-stop? The answer relates in part to the diameter of the lens opening. Even though both lenses are set at $f/22$, the actual diameter of the aperture in the 200mm lens is larger than that of the aperture in the 28mm lens.

Also, as the focal length of any lens increases, the amount of light that reaches the film decreases. As light enters through a long lens, some of it might scatter or become absorbed before it reaches the film. To compensate for this loss of light, lens manufacturers determined that the opening should be a bit bigger on lenses with long focal lengths so that the cumulative effect of light would be equal to that of lenses with shorter focal length. Because an aperture of $f/22$ is in fact a smaller opening on a 28mm lens than an $f/22$ opening on a 200mm lens, less depth of field is rendered.

Focusing on a given subject also affects depth of field. When you focus a lens by simply rotating the focusing ring, you are actually moving the lens closer to or farther from the film plane. To understand this concept, pick up any lens you have. As you focus on an object near you, notice that the lens appears to "grow" longer. In effect, the glass elements inside the lens are moving farther away from the film plane. Remember: with whatever lens you use, the closer an object is to you, the farther away the lens elements have to be from the film plane in order for you to focus.

CHOOSING THE RIGHT APERTURE

In theory, a lens is able to focus on only one object at a time; as for all the other subjects in a scene, the farther they are from the object in focus, the more out of focus they are. Because this theory is based on viewing a given scene through the largest lens opening, it is vital that you appreciate the importance of understanding aperture selection. Of course, the light reflecting off a subject makes an image on film, but the aperture in use dictates how well this image is "formed" on film. Optical law states that the smaller the opening in a given lens, the larger the area of sharpness or detail rendered on film. So a large lens opening, then, permits a huge blast of light to reach the film. In this case, the additional light in the scene—all the light except that reflecting off the single in-focus object—that passes through the lens splatters across the film, producing out-of-focus areas. Conversely, when the same object is photographed at a very small lens opening, such as $f/22$, the blast of light is reduced considerably. The resulting image contains a greater area of sharpness and detail because the light didn't splatter across the film plane but was confined to a small, narrow opening.

The following illustration will help you understand this idea. Using a funnel with a very small opening, imagine pouring a one-gallon can of paint through it into an empty one-gallon container. Compare this process to pouring a gallon of paint into an empty one-gallon container without the aid of a funnel. Of course, the paint being poured without the use of a funnel will fill the empty container much more quickly, but there is a good chance that some paint will splatter. Clearly, transferring paint through the funnel results in a cleaner, more contained job.

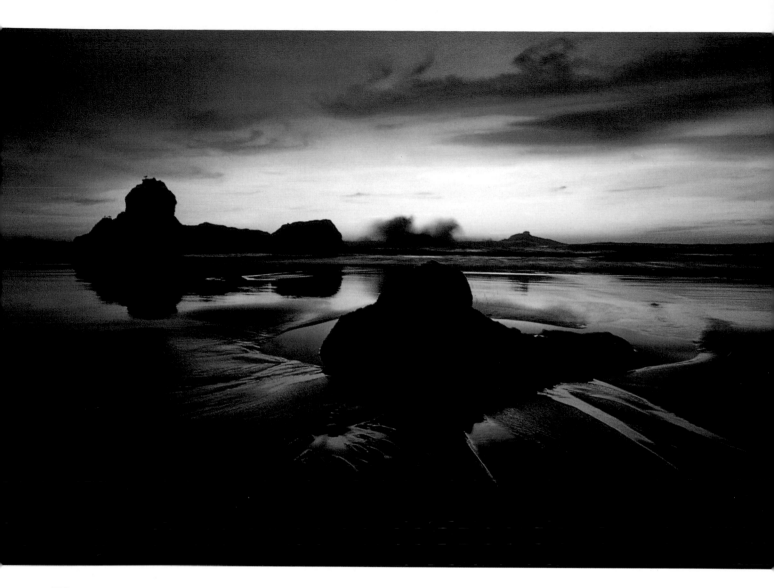

This beach in Lincoln City, Oregon, is aptly named Road's End. Even though it had been blustery and rainy all day, the weather forecast promised "partial afternoon clearing" and I decided to take a chance and drove out to the beach. Luckily, the skies began to clear about 45 minutes before the sun set. During the sunset and immediately afterward, I shot a 36-exposure roll of film of this vivid scene. ◆ To ensure an area of sharpness that extends from the foreground to the background, I set the aperture on my 20mm wide-angle lens to f/22. Because this coastal-sunset composition was backlit, I had to deviate from the normal "aim, expose, and shoot" approach. So, to successfully expose for the wet, reflective sand, I pointed the camera downward. This enabled me to completely eliminate the bright sky. I then adjusted the shutter speed until a one-stop underexposure was indicated, recomposed the image, and fired the shutter.

Keeping this in mind, you can see that when light is allowed to pass through small openings, a larger area of sharpness and detail always results. Does this mean that you should always use small, "neat" apertures rather than large, "messy" apertures? Definitely not! But if you don't appreciate and understand the creative uses of the aperture, producing compelling imagery will always be just beyond your reach. Although there are countless situations in which choosing the right aperture is a priority, I'll share with you some common examples.

The first aperture-priority image is what I call the *storytelling composition.* Like any good book, this type of picture has a beginning, middle, and end. The "beginning" is a foreground subject that clearly pertains to the rest of the scene. For example, such an image might contain stalks of wheat in the foreground that lead the viewers' eyes to the middle of the scene where they see a farmer's combine and then to the story's end where they see rolling hills in the distant background.

Because wide-angle lenses encompass sweeping angles of view, they are often called upon to tell visual stories more effectively. Also, when wide-angle lenses are combined with storytelling apertures, such as $f/16$ or $f/22$, an extensive sharpness, or depth of field, re-

sults. Although the 28mm lens is the most commonly used wide-angle lens, I prefer the 24mm and 20mm lenses. Because both of these lenses offer greater angles of view and a bit more depth of field from foreground to background, they can create storytelling compositions that include more information inside the frame. In effect, their "vision" enables these lenses to produce both a better "opening" and a somewhat longer "book."

Another kind of photograph that results in compelling imagery is the *isolation* or *singular-theme composition.* Here, sharpness is almost always limited to a single area, leaving all other objects in front of and behind the object in focus indistinct. Because a telephoto lens has a narrow angle of view, it is often called upon for single-theme photographs. Using small apertures on this type of lens, such as $f/4$ or $f/5.6$, renders a shallow depth of field. Portraits, whether candid or posed, are good candidates for telephoto composition in which the area of sharpness is restricted to the subject. Photographing just one or two blossoms in a wildflower meadow is another opportunity to isolate a subject. By shooting at eye level and focusing on the flower 10 feet away, you produce a blurred foreground and background. This in turn calls attention to the lone flower in focus.

Although compositions in which subjects are isolated or surrounded by a sea of out-of-focus color are relatively easy to understand, many photographers become quite frustrated when they go out and try to shoot such images. The problem usually stems from a misinterpretation of what the viewfinder is actually showing, not the subject matter. ✦ One day I came upon a row of orange and yellow lillies. With a 200mm lens, I close-focused on one large flower and clearly saw a blurry wash of color in the background. But just because I saw this out-of-focus background didn't guarantee

that it would remain out-of-focus on film. To capture this effect, I had to consciously select an appropriate lens opening. This aperture is almost always wide open or very near to it. ✦ For the more appealing photograph on the left, I deliberately chose $f/4$, an aperture that would isolate the single stem and render limited depth of field. Then I turned the shutter-speed dial until the correct setting of 1/1000 sec. was indicated. I exposed at $f/11$ for 1/125 sec. in the shot on the right. Here, the composition is so busy and the depth of field so extensive that the lone lily gets lost.

I photographed this 7-foot alligator in a Louisiana preserve. After shooting the overall view on the left, I decided to isolate the subject. With a 300mm lens and my camera mounted securely on a tripod, I moved a bit closer to the alligator. When I heard it hiss, I knew that I had gone close enough and began to focus on its large, imposing profile. ✦ To limit depth of field, I chose an aperture of *f*/5.6. Bringing the photograph below to a close was a simple matter of adjusting the shutter speed until a correct exposure was indicated. ✦ Isolation compositions like this one are almost always limited to a single area of sharpness. And because of the narrow angle of view of a telephoto lens, the lens is often called upon for such shots. Just keep in mind that you must use apertures of *f*/5.6, *f*/4, and *f*/2.8 with these lenses in order to be completely successful.

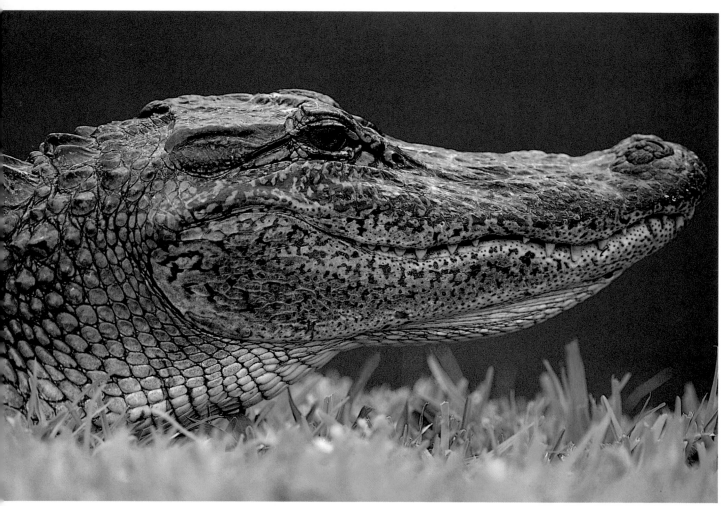

These three isolation pictures were taken with the same lens, a 200mm telephoto, and shot at the same aperture, $f/5.6$. In the photograph above on the left, only the single branch of cherries is in focus. I didn't want a shot of an entire cherry orchard with sharpness throughout. That impression could be conveyed just as easily by isolating one branch via an appropriate aperture. Because the light levels in the scene were even, I adjusted the shutter speed until a correct exposure was indicated. ◆ Every spring and summer, my wife and I plant literally hundreds of flowers. I have called upon my 200mm lens countless times because of its ability to selectively focus on several blooms while rendering the remaining flowers as a pleasing wash of out-of-color, shape, and tone. For the shot above on the right, I chose a viewpoint that placed me at the flowers' level. I then selectively focused on a small group of blooms about 10 feet down the row. To ensure that depth of field remained limited to those particular flowers, I set the aperture once again to $f/5.6$. ◆ The bottom photograph of the smiling oil-company employee was made in Lafayette, Louisiana. Here, too, I used a telephoto lens and a large lens opening to isolate my subject, Ray Matt. As he went about his work, I used a 200mm lens and focused through several stands of blue pipes. This created an out-of-focus frame of color in the foreground, drawing further attention to Matt. Once again, I found myself setting the aperture to $f/5.6$ and adjusting the shutter speed until the image was properly exposed.

THE DEPTH-OF-FIELD SCALE

When you shoot storytelling compositions, the question of focus always comes up. As you become familiar with wide-angle lenses, you'll find that once you get a subject, such as a landscape, into focus, everything appears sharp. This is particularly true when you photograph a subject at eye level. But this doesn't necessarily enable you to intuit the "right" aperture. Because most compelling storytelling compositions contain immediate foreground interest, you must choose apertures that render both the immediate foreground and the distant background sharp. Which apertures make everything sharp? As already discussed, the apertures with the smallest openings produce the greatest areas of sharpness. But even though you now know to use $f/16$ or $f/22$, do you know what to focus on? Probably not. Starting today, you can begin to employ the *depth-of-field scale*. Once you learn how to use it, which is an easy process, you'll never need to focus another storytelling composition.

When watching a major news event, have you ever noticed that many photographers who are apparently taking pictures of the event are doing so with their cameras raised above their heads? How do they know if the subject is in focus? They have preset the depth of field via the depth-of-field scale. Located on all single-focal-length lenses and even some zoom lenses, the depth-of-field scale enables you to preset the exact area of sharpness that you want rendered on film before the actual picture-taking. Take a look at one of your lenses. At the front of the lens is the *distance scale*; note that the distance measurements appear in both feet and meters. Behind that scale is the depth-of-field scale, and behind this is the *aperture ring*. Finally, there is a central *hash mark*, which usually takes the form of a black dot, a straight white line, or a small triangle. Now look at the depth-of-field scale again. The number "22" appears on both the far left and far right, as do the numbers "16," "11," "8," and "4." Directly above these numbers are small engraved marks. I want you to think of these marks as prison walls that extend vertically into the distance scale and are designed to work in pairs.

For example, when I shoot a storytelling composition, I always want a sharp horizon and the greatest depth of field that allows me to include the immediate foreground. To achieve this, I rotate the focusing ring until the middle of the infinity symbol, (∞), is split by the $f/22$ prison wall on the right. Presto!—I just preset the depth of field. The foreground distance captured is indicated above the $f/22$ setting on the left. Here, that distance is 2 feet. So the area of sharpness captured within the

prison walls is 2 feet to infinity. All that I must now do to capture this extensive depth of field is to set the aperture ring to the f-stop number of the two prison walls, which is $f/22$.

If you own a single-focal-length or zoom lens with a depth-of-field scale, take it out now and repeat the step-by-step process just described. Once you've done this, I want you to look through your camera. What do you see? Chances are you'll notice that the image in the viewfinder is far from being in focus. In fact, it looks so out-of-focus that you may feel compelled to refocus the lens so the image in the viewfinder appears sharp to your eye. Stop! The reason the image appears fuzzy and unsharp is because you are viewing the scene through a wide-open aperture. Simply put, even though the picture-taking f-stop of 22 is preset on the aperture ring, the lens itself remains wide open at the smallest aperture number, such as $f/2.8$, until you press the shutter-release button. At that point, the expected depth of field promised by the depth-of-field scale will be rendered in its entirety on film.

On assignment to shoot a corporate brochure for a utility company based in Bullhead City, Arizona, I was so impressed by the vastness of this desert region that I was compelled to stop on more than one occasion and shoot some pictures. ✦ When I photographed this graphic scene, I decided to use the depth-of-field scale. First, I set the aperture on my 20mm wide-angle lens to *f*/22 and preset the depth-of-field scale. However—as is always the case when you preset the depth of field—the scene in the viewfinder wasn't sharp. The fuzzy image on the opposite page is what I saw through the viewfinder because I was viewing the scene at the largest lens opening, *f*/2.8. The picture-taking *f*-stop of 22 wasn't employed until I pressed the shutter release. ✦ At that time, the sharpness promised by the depth-of-field scale was recorded on film, as you can see in the shot on the left. I obtained the desired depth of field not by refocusing the lens but by combining a storytelling wide-angle lens with a storytelling aperture of *f*/22 and a preset depth-of-field scale.

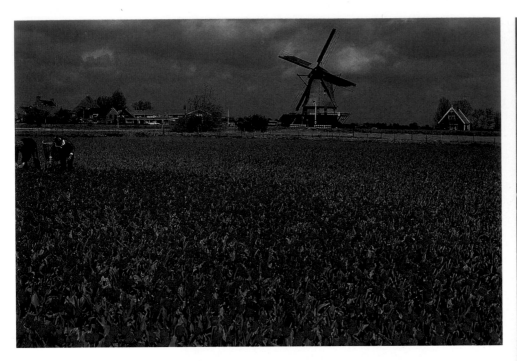

I photographed these lush fields of blooming red tulips in Holland. While talking to a farmer, I received permission to enter his property and photograph this charming scene. ✦ I quickly realized that an eye-level composition wasn't adequate here, as you can see in the above picture of the countryside. ✦ To create the more effective image on the right, I mounted a wide-angle lens on my camera, dropped to my knees, and shot the tulips at their "eye level." At this point, I set the aperture to *f*/22 and pre-set the focus via the depth-of-field scale. Taking the meter reading was simple because the scene was evenly illuminated by front-lighting. I merely composed the image and adjusted the shutter speed until a correct exposure was achieved.

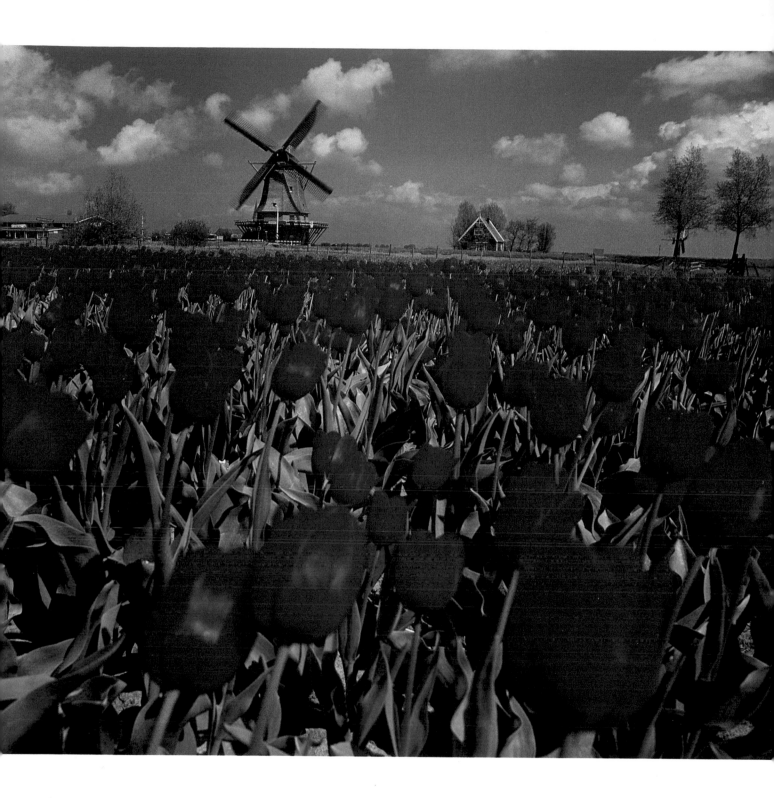

THE DEPTH-OF-FIELD PREVIEW BUTTON

Because the depth-of-field scale is an invaluable aid when you shoot storytelling pictures, you might be wondering if there is something that can simplify shooting singular-theme compositions. The answer is yes, but unfortunately, the *depth-of-field preview button* is one of the most misunderstood features on a camera. Depressing this button stops the lens down to whatever aperture you have selected, offering you an advance look at the actual depth of field you are about to record. This enables you to make any necessary depth-of-field corrections before permanently capturing depth-of-field mistakes on film.

As simple as the depth-of-field preview button is to use, it initially confuses many photographers. "I press it, and everything just gets dark" is typical of the comments I hear. But eliminating this confusion is not difficult. First, if you aren't sure whether your camera has a depth-of-field preview button, or if you don't know where it is located, refer to your camera manual. If and when you find the preview button, try this exercise. With a 50mm or longer lens, focus on an object close to you, thereby turning the background into a blur. Next, set the aperture at the smallest number—1.4, 1.8, 2, 2.8, or 4—and depress the preview button. Nothing happens as you look through the viewfinder, right? Now, with the button still depressed, begin rotating the aperture ring toward the bigger numbers until you get to the smallest f-stop: 16, 22, or 32. As you do this, note what is happening behind the in-focus subject. (I realize that the image seen through the viewfinder is getting progressively darker. This is simply the result of changing the size of the aperture; as the diameter of the opening decreases, less light passes through the lens to the viewfinder.) Each time you stop the lens down, these objects become more well-defined—in other words, the area of sharpness is extended.

Unlike the depth-of-field scale, which is useful when you shoot storytelling pictures, the depth-of-field preview button is much more valuable for isolation or singular-theme images. For these compositions, you have to decide how much definition you want in the background as well as how far out-of-focus you want to keep the foreground. Suppose, for example, that I'm photographing a meadow filled with flowers using a 200mm lens. As I focus on a lone daisy, I can see the out-of-focus colors in both the foreground and background. However, I want to increase the depth of field just slightly to achieve a bit more sharpness around the daisy. So with the preview button depressed, I begin to stop the lens down ever so slowly from its wide-open position. I then discover, with the aid of the preview button, that setting the aperture to just a hair beyond $f/5.6$ produces the desired effect.

I have become spoiled by my depth-of-field preview button because it comes in handy for isolation pictures. While shooting this cluster of cherries, I felt that an aperture of $f/5.6$ would enable me to both render the fruit sharp and leave the background out-of-focus. However, when I pressed the depth-of-field preview button, I noticed a small but jarring spot of high contrast peering out from under the two cherries in the image on the left. ◆ So with an 180mm lens, I found myself slowly increasing the size of the lens opening until this highlight disappeared. Not surprisingly, the new aperture was between $f/2.8$ and $f/4$. I then simply turned the shutter-speed dial until a correct exposure for this evenly illuminated, frontlit scene was indicated.

OUT-OF-FOCUS CIRCLES OF LIGHT

You've undoubtedly seen your share of movies, including some that contain night scenes shot on well-illuminated streets. Have you ever noticed that when the camera focuses in close on a character, the background lights appear as out-of-focus circles of color? This is another optical phenomenon. To put it simply, any out-of-focus spot or spots of light appearing inside the viewfinder will record on film in the shape of the aperture in use. The farther away that the subject is from the light source and the brighter or more intense the light is, the larger and more diffused the spot or spots of light become. This means that when you focus on a subject close to you, any background lights that are part of the composition, such as the Las Vegas Strip or sunlight glistening on a lake, will record on film as out-of-focus shapes. These can be either circular or hexagonal. To produce circular shapes, you must use a wide-open ap-erture. So whether you are using a macro lens whose wide-open aperture is *f*/3.5, the "macro" setting on a zoom lens whose wide-open aperture is *f*/4 or *f*/4.5, or extension tubes with a normal lens whose wide-open aperture is *f*/1.7 or *f*/1.8 (depending on the brand), you must physically set the aperture at wide open to record circles. This can be a source of confusion. When you look through the viewfinder, you can see circular, out-of-focus spots of light, regardless of the aperture setting. But today's cameras offer "wide-open viewing," which means that you always see in the viewfinder what the scene will look like if photographed through a wide-open aperture. Any other aperture renders hexagons when you shoot out-of-focus spots of light because it is hexagonal in shape. This is true of any lens when it is focused as close as possible to a subject, but this effect is most apparent with the use of closeup equipment.

I photographed these images of the setting sun while standing in my barn following an afternoon rain shower. When I noticed that the skies cleared after the rain had stopped, I grabbed my camera and began to shoot the sunset through the barn's rain-splattered window. Using a 55mm macro lens, I took several pictures of the wet window and frame; the top photograph is my favorite from that group.
✦ I then proceeded to move in much, much closer and shot only the raindrops on the glass against a background composed of a large ball of orange light, as you can see in the bottom shot. This circular shape was a direct result of the wide-open aperture, *f*/2.8, as well as my shooting in the direction of the out-of-focus light from the setting sun.

Much of the impact of this image comes from the creative use of an out-of-focus spot of light: the setting sun in the distance. I deliberately set out to achieve this effect. First, I gathered several stalks of wheat from a neighboring farmer's field. I then arranged the wheat in a vase and placed it on top of a 4-foot stepladder. I knew that within minutes the sun would be setting and that I would have an unobstructed view from my hilltop farmstead. ✦ With my camera and 100mm macro lens mounted securely on a tripod, I began to focus on the stalks of wheat against the background of the setting sun. I was careful not to include the vase in the image. Because I wanted to record a ball of yellow-orange light, I set the aperture to wide open; this was *f*/4 here. Next, I pointed my camera into the sky above the bright sun and turned the shutter-speed dial until a correct exposure was indicated. ✦ Then I recomposed the shot so that the bright yellow-orange circle would appear behind the wheat. At this point, I was confident that I would get the desired effect. And I wasn't disappointed. This particular sunset image has been one of my best-selling stock shots.

CLOSEUPS

Closeup photography continues to enjoy great popularity, for both amateurs and professionals. While such obvious subjects as flowers, butterflies, and insects are ideal for beautiful images, so are more unusual subjects. Recently, I judged a photography contest in which several closeups had been shot in a neighborhood junkyard; they were pleasant surprises. But I seldom see closeups that incorporate out-of-focus spots of light. Before you can master this technique, however, you need to be familiar with closeup photography and equipment.

First, working at closeup distances differs greatly from working at "normal" ones. When you shoot closeups, you almost always need a tripod or a steady pair of elbows because even a slight shift in point of view changes the focus. Because the depth of field always decreases as you focus closer to a subject, it becomes quite shallow when you shoot closeups; as a result, critical focusing is always essential in these situations. The depth of field is distributed differently, too. In closeup photography, the depth of field extends one-half in front of and one-half beyond the in-focus subject. But in "normal" photography, the depth of field extends one-third in front of and two-thirds beyond the in-focus subject.

Various photographic accessories make closeup photography possible. Macro lenses, extension tubes, macro converters, and closeup filters are designed to get you close to the subject. In addition, the limited area of sharpness of closeup photography makes using a tripod a must. Trying to handhold a camera and lens while shooting most closeups makes about as much sense as driving a car at 100 miles per hour and steering with your feet. Of all these tools, the most versatile—and most expensive—are macro lenses. Not to be confused with the many zoom lenses on the market that offer a so-called macro image, a true macro lens offers you the opportunity to view subjects so closely that they are rendered on film life-size. Thus, the image recorded on a piece of 35mm film is the same size as the actual subject. Most zoom lenses set at the "macro" length are able to offer only a quarter-life-size image on film. Macro lenses are available in two focal lengths, 50mm or 100mm, but one manufacturer offers a 200mm lens as well. Most 50mm macros lenses cost between 170 and 230 dollars, and the price of 100mm macro lenses ranges between 270 and 430 dollars.

Extension tubes are hollow metal tubes that fit between the lenses and the camera body, and they are sold in sets of three. The combination of the lens and the number of tubes you use determines the image magnification you will achieve. With three tubes, a life-size reproduction is possible when they are combined with a standard 50mm lens; when they are combined with a wide-angle 28mm or 35mm lens, image magnification quickly increases beyond life-size.

Gaining increasing popularity are macro converters. Unlike extension tubes, these are operated by an internal helicoid that enables the unit to move in and out with a simple turn of a focusing ring. Magnification levels increase or decrease as you turn this ring, thereby eliminating the need to stop and switch extension tubes.

Both extension tubes and macro converters are wonderful additions to a camera system, especially when coupled with a telephoto or a telephoto-zoom lens. These tools enable you to shoot closeups of, for example, bees, butterflies, and grasshoppers, without having to be so close physically to the subjects that you frighten them off. Macro converters cost around 80 dollars and extension-tube sets a little less. You will find, however, that locating camera stores that carry extension tubes is becoming increasingly difficult because of the increasing popularity of macro converters. Closeup filters, on the other hand, are inexpensive, costing about 30 dollars for a set of three. Because they thread into the front of a lens, you can get quite close to your subjects. But be aware that closeup filters tend to produce unsharp images, particularly around the edges.

Try this exercise. Grab a string of Christmas-tree lights and plug them into a wall outlet in a dark room. From across the room, look at the lights through the "eye" of your closeup lens. You will see a colorful display of out-of-focus circles. Next, place your hand in front of the closeup lens and move it in or out until your hand looks sharp. You'll now see a sharply focused hand against a background of out-of-focus circles. To record these circles on film, you must set the aperture to wide open (use the smallest number on the lens). Now stop the lens down to f/8 or f/11. If your camera has a depth-of-field preview button, press it; you'll see a multitude of hexagonal shapes. The circles become hexagons because the shape of the aperture changed from, of course, circular to hexagonal. In addition, as you stop the lens down from one f-stop to the next, these hexagonal shapes decrease in size because they pass through a smaller lens opening.

You can practice this technique shooting at night—at any time of the year—in a city. Theater marquees, building lights, and even car headlights and taillights can be viewed as out-of-focus spots of light. Simply look at any of these subjects with your closeup equipment from a distance of 10 to 20 feet and enjoy the "light show" of out-of-focus circles. Try shooting these scenes as a single exposure or as a double exposure with their in-focus counterparts.

Finally, don't forget to photograph the sun. I've arrived in countless meadows at dawn or just before sunset and focused my closeup equipment on a single blade of grass, wheat stalk, or seed head, framing it against a large, looming out-of-focus "ball" of light. What actually appeared on film was a circular record of the distant rays of light provided by the rising or setting sun.

Clearly, choosing the "right" aperture affects the overall depth of field in an image. The three basic approaches to selecting an aperture—storytelling, isolation, and who cares?—can be used for shooting close-ups, but in "miniature" format. Remember, the closer you focus to a subject, the shallower the depth of field is. Of course, this is never more true than when you shoot closeups, whether you use a macro lens, extension tubes, closeup filters, or a macro feature on a zoom lens. So when a subject is composed of curves, twists, creases, or bends, you must call upon a storytelling aper-

ture, such as *f*/22 or even *f*/32 if your lens offers such a choice, to ensure adequate sharpness throughout the image. ◆ Note the difference in depth of field in these two photographs of grapes. I shot the picture on the right at *f*/2.8. Even though the distance from the nearest grape to the farthest grape is less than 1 inch in the composition, I was forced to shoot at a storytelling aperture to make the image sharp throughout. To achieve the depth of field in the shot below, I mounted my camera and 55mm macro lens on a tripod and then set the aperture to *f*/32.

The deliberate isolation of a subject via a large aperture is almost always associated with a telephoto lens, and rarely with a macro lens. In fact, a number of photographers want to shoot all closeups at $f/22$ or $f/32$, thereby producing maximum sharpness throughout. I don't agree with them. I think that opportunities to dramatically isolate a subject abound—and should be taken advantage of. ✦ For this closeup of a rose, I first securely mounted my camera and 55mm macro lens on a tripod. I decided to shoot straight down into the flower. Rather than opting for an aperture of $f/32$ that would render the entire rose sharp, I wanted to use the wide-open aperture of $f/2.8$. This resulted in an exquisite composition, enhanced by the softness of the out-of-focus petals. ✦ I photographed the shot on the opposite page in my greenhouse one morning. As soon as I noticed this cabbage moth perched on a sweet sultan flower and realized that it wasn't warm enough yet for the moth to be active, I seized the opportunity to shoot this scene. ✦ With my camera and 55mm macro lens securely mounted on a tripod, I carefully chose a viewpoint that made the moth parallel to the film plane. This ensured a sharp moth, regardless of the aperture. Then, to render the background flowers in muted tones in order to isolate my primary subject, I shot at $f/4$.

"WHO CARES?" APERTURES

Suppose you find yourself staring at a subject and draw a blank about how to approach it. You know that it isn't a storytelling composition so using *f*/16 or *f*/22 isn't important. You also realize that it isn't a singular-theme composition or a composition that allows for selective focusing, so that a large lens opening isn't that critical. So what is it? I affectionately refer to such an image as a "who cares?" composition. Does it really matter what aperture you use when you shoot straight down on a seashell at the beach? Does the choice of aperture really matter when you shoot graffiti on a wall? You can safely disregard the "right" aperture when you approach compositions like these because there are no real depth-of-field concerns. (In both of the instances mentioned above, the area of sharpness needed begins and ends at approximately the same spot.) As a result, additional depth of field is unnecessary.

For example, as you walk along the shore, you may come across a lone starfish on the smooth, textured sand. If you shoot with a 50mm lens, the starfish and sand remain parallel to the film plane as you shoot straight down on them—whether the distance between you and the subject is 2 feet or 5 feet. Here, both the starfish and sand are within the plane of focus, so you can photograph them at any aperture. This principle applies to any composition in which the subjects are at the same focused distance. To put it simply, when nothing but air exists in front of or behind the subject or subjects, you can use any aperture. But rather than randomly choose an aperture, I recommend using the *critical aperture*. This aperture, *f*/8, offers critical focus: sharpness so rich and defined, that the image on the film seems sharper than the way you saw it with your own eyes through the viewfinder.

To understand why *f*/8 is so sharp, you need to know a little bit about lens construction and the way light enters a lens. Most lenses are constructed of elliptically shaped glass elements. Imagine for a moment that within the central area of these elliptical elements is a magnet—which is often called a *sweet spot*—designed to gather a specific amount of light and then to funnel it through to the waiting film. The approximate diameter of this sweet spot is equivalent to the diameter of any *f*/8 aperture. So for example, when light enters a lens through a wide-open aperture, such as *f*/2.8, the amount of light exceeds the area of the sweet spot and in turn scatters across the entire elliptical range and eventually onto the film. The effect is similar to pouring milk onto an upside-down bowl—only a little milk remains on the center while most of the milk spills off to the sides. Because of the light scattering, a wide-open aperture doesn't provide edge-to-edge sharpness on most lenses. But when the light passes through *f*/8, it becomes confined to the sweet spot on the elliptical glass. As a result, a sharply defined image is recorded on film. (If you are wondering why all lenses don't have a sweet spot throughout the entire element, it is because the cost is prohibitive for most photographers.)

The importance of the aperture can't be overstated. Whether you want to tell a story, to isolate a subject, or to compose a "who cares?" image, consciously and deliberately choosing an aperture is essential.

Wouldn't it be great if you could sometimes choose any aperture you wanted and not be the least bit concerned with depth of field? When shooting compositions that don't rely on a storytelling or isolation theme, you can treat aperture selection with some indifference. ✦ These two photographs have only one thing in common; they were shot at an aperture of *f*/8. I affectionately refer to this lens opening as a "who cares?" aperture. For the most part, *f*/8 is a middle-of-the-road aperture that seldom provides enough depth of field for effective storytelling compositions and usually provides a bit too much depth of field for compelling isolation images. So when you're presented with a picture-taking opportunity that doesn't rely on very small or very large lens openings, use the "who cares?" aperture, *f*/8. ✦ That is precisely what I did when shooting down on the footprint in the sand in the shot above. Here, the area of sharpness begins and ends with the footprint. With my camera and 50mm lens securely mounted on a tripod, I set the aperture to *f*/8 and adjusted the shutter speed until the meter indicated a correct exposure. ✦ I used the same approach for the shot of a shipyard worker on the right. With my camera and 105mm lens securely mounted on a tripod, I set the aperture to *f*/8 and shot straight down on my subject. To bring the exposure to a close, I allowed the exposure meter to indicate the necessary shutter speed.

Early one morning when the temperature was 24 degrees, I awoke to find a covering of heavy frost. Following a quick breakfast, I drove along many country roads and came across numerous picture-taking opportunities. I photographed an overall view of a field as you can see in the shot above. Dissatisfied with this composition, I searched for a more compelling image.

◆ I soon discovered one that enabled me to call upon the "who cares?" aperture, *f*/8. With my camera and 50mm lens mounted securely on a tripod, I focused close and straight down on a single frost-covered walnut nestled among frost-covered leaves. The exposure meter determined the shutter speed required for the even illumination provided by the overcast sky.

I photographed model Tamara Clark in different spots around my farm; she wanted some pictures of her taken outdoors for her portfolio. One composition enabled me to use the "who cares?" aperture. ✦ As you can see in these photographs, I decided to position the model off center in the frame. I took the shot on the right but wasn't satisfied with the result. For the picture below, I moved in a bit closer to the subject in order to eliminate the unsightly mess at the foundation of the barn. With my camera and 105mm lens mounted securely on a tripod, I set the aperture to *f*/8. I was able to use the "who cares?" aperture here because depth of field wasn't a concern.

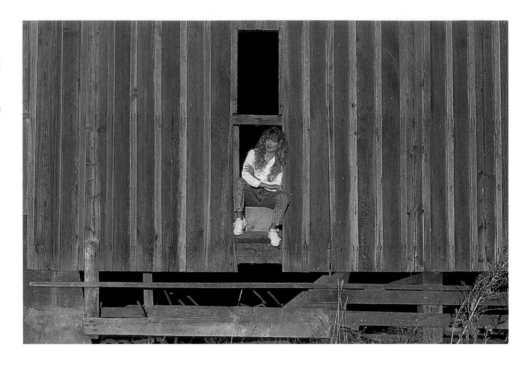

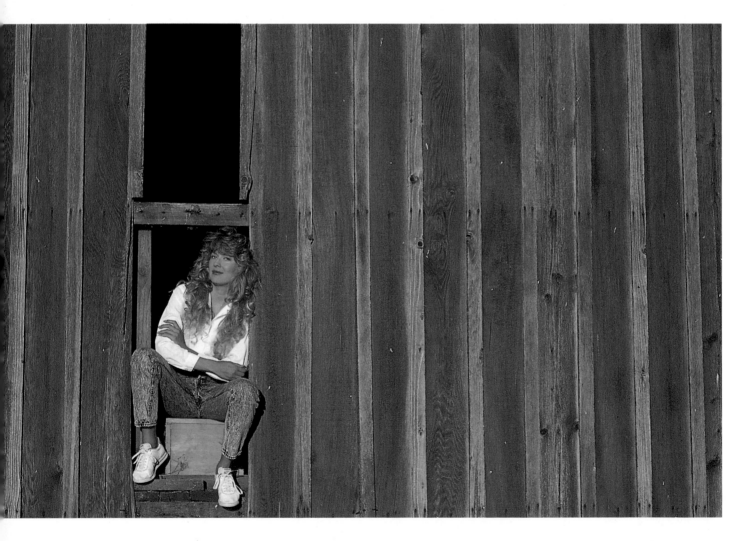

While on assignment for a coal company in Decker, Montana, I questioned my decision to become a free-lance photographer as I stood in an open pit waiting for the sun to rise—and to warm up the −33-degree temperature. After what seemed like an eternity, the sun came up 20 minutes following my arrival. ◆ Having mounted my camera and 400mm lens on a tripod, I proceeded to compose this graphic scene of an im- mense dragline bucket and the small shape of an em- ployee. The early golden light provided a perfect background for a silhouette. Because the subjects were at the same distance from the camera (infinity), I was able to call upon *f*/8, the "who cares?" aperture. Then in order to bring the exposure to a close, I adjusted the shutter speed until a correct exposure of the strong backlight of the sky was indicated.

SHUTTER
SPEED

All SLR camera bodies contain a *shutter*, another element vital to the creation of certain effects as well as correct exposures. The shutter controls the effects of motion on your pictures, whether it results from your shaking the camera or from your subjects moving as you photograph. Fast shutter speeds freeze action while slow shutter speeds blur it. When you handhold the camera, I recommend using a shutter speed of at least 1/60 sec. At speeds of 1/30 sec. or slower, even the slightest camera shake results in a blurred image. And when you handhold both a camera and a long telephoto lens, you should shoot at speeds faster than 1/60 sec. As a guide, use the approximate inverse of the focal length of the lens. For example, if you're shooting with a 200mm lens, you can safely handhold the camera at 1/250 sec. Similarly, with a 28mm wide-angle lens, you can safely handhold at 1/30 sec. If, however, you must shoot at shutter speeds slower than the inverse of the lens' focal length, steadying the camera and lens on a tripod or some other firm support is almost a must. (This does not apply to *panning*, a creative technique discussed on page 86.)

Your camera contains either a *focal-plane shutter* or a *copal-square shutter*. To find out, open the camera back—first make sure there is no film in the camera—and push the shutter-release button. If the shutter curtains move horizontally, you have a focal-plane shutter. If the shutter curtains move vertically, you have a copal-square shutter. Although most cameras have focal-plane shutters, copal-square shutters do offer several advantages. First, because the up-and-down distance that these shutters must move is shorter than the side-to-side distance focal-plane shutters must travel, copal-square shutters usually provide a higher *sync speed*. This is the maximum shutter speed allowed when you use electronic flash. Sync speed is an important consideration, particularly when you are shooting fast-moving

subjects, such as a dancer leaping across a stage. While most focal-plane shutters reach a maximum sync speed of 1/125 sec.—which is more than adequate for general flash pictures—several cameras now have copal-square shutters that offer a sync speed of 1/250 sec. Also, the vertical motion of the copal-square shutter curtain enables optional winders and some motor drives to advance the film at 3.5 frames per second versus the usual 2 frames per second. Despite these benefits, when buying a camera you should keep in mind that a copal-square shutter is a primary concern only if you anticipate shooting a great deal of action, with or without flash.

Shutter mechanisms can be constructed of cloth, metal, or titanium. Whatever the material, never touch the shutter curtains with your finger or any other instrument. The slightest alteration of the shutter curtains can adversely affect a correct exposure. For example, although your exposure meter indicates a correct exposure of 1/60 sec. at $f/8$, a malfunctioning shutter curtain may in fact be firing at 1/38 sec. or 1/76 sec. If the shutter curtains need to be repaired, take the camera to an expert. So hands off the shutter curtains!

The function of the shutter mechanism is to admit light into a camera and onto the film for a specific length of time. Although shutter speeds are indicated on the shutter-speed dial as whole numbers, such as 250, 500, and 1000, they are actually fractions of time: 1/250, 1/500, and 1/1000. In addition to these numbers, there is a capital letter "B" on the shutter-speed dial. "B" stands for "Bulb," but it has nothing to do with flash; it is a remnant from the early days of picture-taking when photographers made an exposure by squeezing a bulb that was part of a cable release attached to the camera. Squeezing the bulb released air through the cable, thereby locking the shutter in the open position until the pressure on the bulb was released. Today, "B" is used when exposures longer than 1 sec. are hoped for.

Trafalgar Square in London is famous for its pigeons. This little boy caught my attention because he seemed so bored with the flurry of activity. Children are usually anxious about, if not frightened by, the onslaught of the birds. ✦ Because the sky was bright but overcast—a typical London sky—getting an exposure was easy. With my camera and 180mm lens mounted securely on a tripod, I set the aperture to $f/5.6$ to limit depth of field. Then, since the illumination was even, I simply adjusted the shutter speed until a correct exposure was indicated. This proved to be 1/60 sec. for the slow ISO 50 film I was shooting. This shutter speed provided a bonus: the implied motion caused by the rapid fluttering of several pigeons' wings.

CHOOSING THE BEST SHUTTER SPEED

Obviously, the goal of every picture-taking effort is a successful exposure. This requires both the right aperture and shutter speed. But the old rule of thumb, "Set your camera to 1/125 sec. and adjust your aperture until a correct exposure is indicated," just doesn't work. It leaves absolutely no room for the many creative uses the shutter speed can offer. Because the aperture controls both the amount of light reaching the film and even more important the creative depth of field in an image, some photographers choose a shutter speed first, leaving the final determination of exposure to the aperture. Of the various good reasons for selecting a shutter speed before an aperture, I believe that you should do this for three—and only these three—reasons: the scene offers motion or action opportunities, you find yourself shooting in low light without a tripod, or you need to use a shutter speed that will enable you to handhold the camera and lens. And of these three reasons, I think that photographing motion or action is the primary motivation for giving the shutter speed priority over the aperture.

Motion-filled scenes abound. One of the most common is the waterfall in the forest. In this situation, you can creatively use the shutter speed two ways. You can either freeze the action of the water with a fast shutter speed or make the water look like cotton candy by using a much slower shutter speed. The cotton-candy effect seems to be more popular, perhaps because it turns the rushing water into a wispy, white blur.

Consider other action-filled scenes. As you drive through the country on a beautiful autumn day, you see several horses frolicking in a pasture up ahead. Here, you can *pan*, or follow, the horses with your camera as you shoot. The result will be a streaked background that clearly conveys the action yet renders the horses relatively sharp (see page 88). Next, suppose that you are watching a soccer game on a Saturday afternoon and you want to freeze the action of your son or daughter kicking the game-winning goal. Finally, imagine that you are on the Las Vegas Strip at night. However, you forgot your tripod, so you need a shutter speed that is fast enough for you to safely handhold the camera. These are simply a meager sampling of situations in which you can creatively use the shutter speed. You must be imaginative as you explore other ways to freeze or imply motion and to pan subjects.

Contrary to popular belief, most action-filled compositions in which the subjects' movements are frozen aren't accomplished by a single exposure, but rather by a number of successive exposures that whirl through the cameras. This is due in part to fast shutter speeds, but more often it is the result of automatic film winders or motor drives.
◆ A blustery winter day at Shore Acres State Park on the central Oregon coast always provides spectacular wave action. While I was preparing to shoot this series, my first step was to securely mount my camera and 300mm lens on a tripod. Next, I set the shutter speed to 1/500 sec. Because of the white water and the bright overcast sky, I decided to use a gray card. With my outstretched arm, I held the gray card in front of the lens, making certain that it reflected the sky. With my other hand, I turned the aperture ring until a correct exposure was indicated. ◆ Now I was ready to shoot the next group of waves. The combination of the 1/500 sec. shutter speed and the five-frame-per-second motor drive captures the wave motion in all of its sequential beauty. So as each new wave broke upon the rock, I had ample time to focus. While all of these photographs are appealing, I think that the image on the top left best conveys the drama and power of the wave and effectively incorporates the lighthouse.

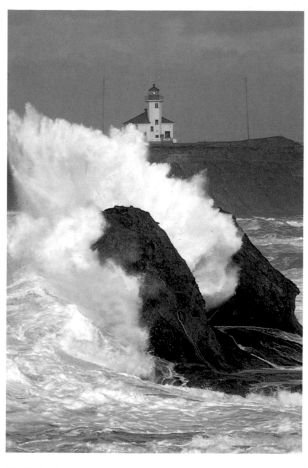
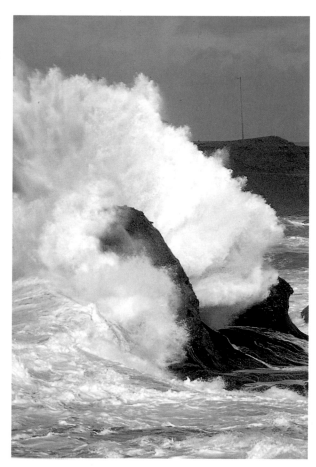
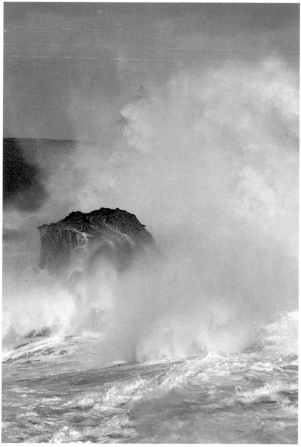
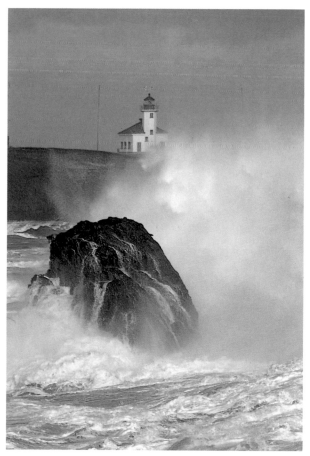

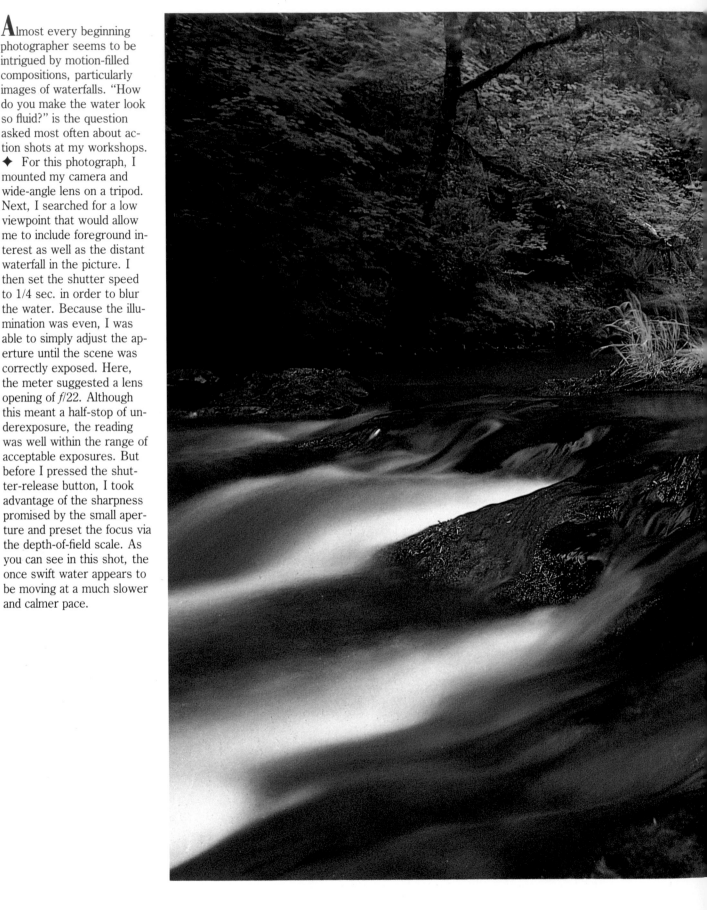

Almost every beginning photographer seems to be intrigued by motion-filled compositions, particularly images of waterfalls. "How do you make the water look so fluid?" is the question asked most often about action shots at my workshops.

✦ For this photograph, I mounted my camera and wide-angle lens on a tripod. Next, I searched for a low viewpoint that would allow me to include foreground interest as well as the distant waterfall in the picture. I then set the shutter speed to 1/4 sec. in order to blur the water. Because the illumination was even, I was able to simply adjust the aperture until the scene was correctly exposed. Here, the meter suggested a lens opening of *f*/22. Although this meant a half-stop of underexposure, the reading was well within the range of acceptable exposures. But before I pressed the shutter-release button, I took advantage of the sharpness promised by the small aperture and preset the focus via the depth-of-field scale. As you can see in this shot, the once swift water appears to be moving at a much slower and calmer pace.

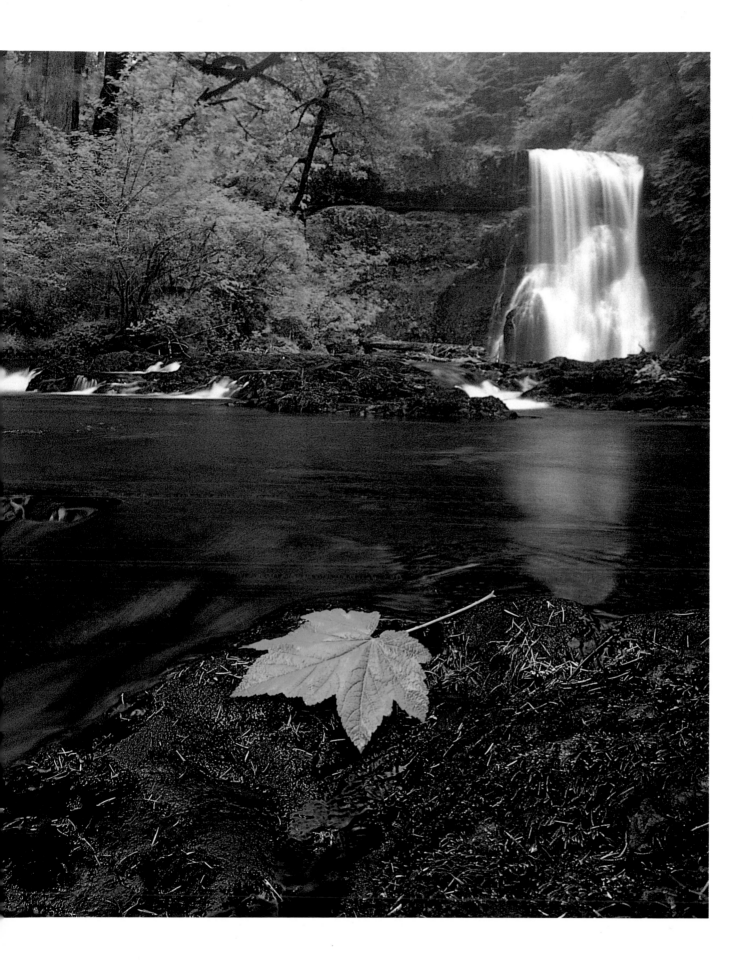

FREEZING ACTION

The first photograph I ever saw in which the technique of freezing action was employed showed a young woman in a swimming pool throwing back her wet head. Clearly, the image was "frozen" because each drop of water and the woman's flying hair were recorded in crisp detail. Because the visual world seldom slows down enough to give us time to study its fast-moving pace, pictures that freeze action are often looked upon with wonder and awe. In fact, since that photograph of the woman appeared in a popular photography book many years ago, I have seen numerous others like it. (This is often the outcome when one photographer creates something "new"; many others rush out and try to repeat it. While trying a technique perfected by another photographer can lead to new and sometimes even more exciting discoveries, duplicating the image exactly is going too far.)

When freezing action is the desired effect, you wish to literally freeze a moment or slice of time for a much closer inspection later. More often than not, to freeze action effectively you must use fast shutter speeds. This is particularly critical when the subject is moving parallel to you, such as when a speeding race car zooms past a grandstand. In general, these subjects require shutter speeds of at least 1/500 sec. or 1/1000 sec. Besides race cars on a track, many other action-stopping situations exist. For example, the San Diego Zoo provides an opportunity to freeze the movement of killer whales as they propel themselves out of the water from the depths below. Similarly, rodeos enable you to freeze the misfortunes of falling riders, and on the ski slopes, "hot-doggers" soar above the snow into the crisp air.

When you wish to freeze any moving subject, you need to consider three factors: the distance between you and the subject, the direction in which the subject is moving, and your lens choice. First, determine how far are you from the action. Is the distance 10 feet or 100 feet? The closer you are to the action, the faster the shutter speed must be. Next, is the action moving toward you or away from you? Finally, which lens is the most appropriate? For example, if you were shooting at a distance of 10 to 20 feet with a wide-angle or normal lens, you would have to use a shutter speed of at least 1/500 sec. to freeze the action of a bronco rider. If you were then to photograph him from a distance of 100 feet with a wide-angle or normal lens, his size and motion would diminish considerably, so a shutter speed of 1/125 sec. would be sufficient. But if you were shooting at a distance of 50 feet and using the frame-filling power of a 200mm lens, a 1/500 sec. shutter speed would work (just as if you were 10 feet from the action). Finally, a shutter speed of 1/1000 sec. would be needed if the bronco rider were moving parallel to you and filled the frame, either through your lens choice or your ability to move in close.

Whatever effect you want to achieve—freezing the action, panning, implying motion, blurring a subject, or making long exposures—it is imperative that you deliberately choose the "right" shutter speed. ✦ While on vacation in Maui, I heard several voices screaming with delight. They were coming from six boys launching themselves and their bicycles off a home-made ramp. I rushed inside and grabbed my camera and 80–200mm zoom lens. I hoped to record the action even though I knew that the sun would be setting soon. Fortunately, I was able to shoot a number of exposures that captured the action at its peak. Like this image, many of the shots were backlit by the setting sun. ✦ Here, I deliberately chose a fast shutter speed of 1/500 sec. With my zoom lens set at approximately 100mm, I took a meter reading of the bright sky above the sun. I then began to adjust the aperture until a correct exposure was indicated. I recomposed and told the boy to start up the ramp. Within a second or two, he soared through the viewfinder, and the fast shutter speed froze him in midair.

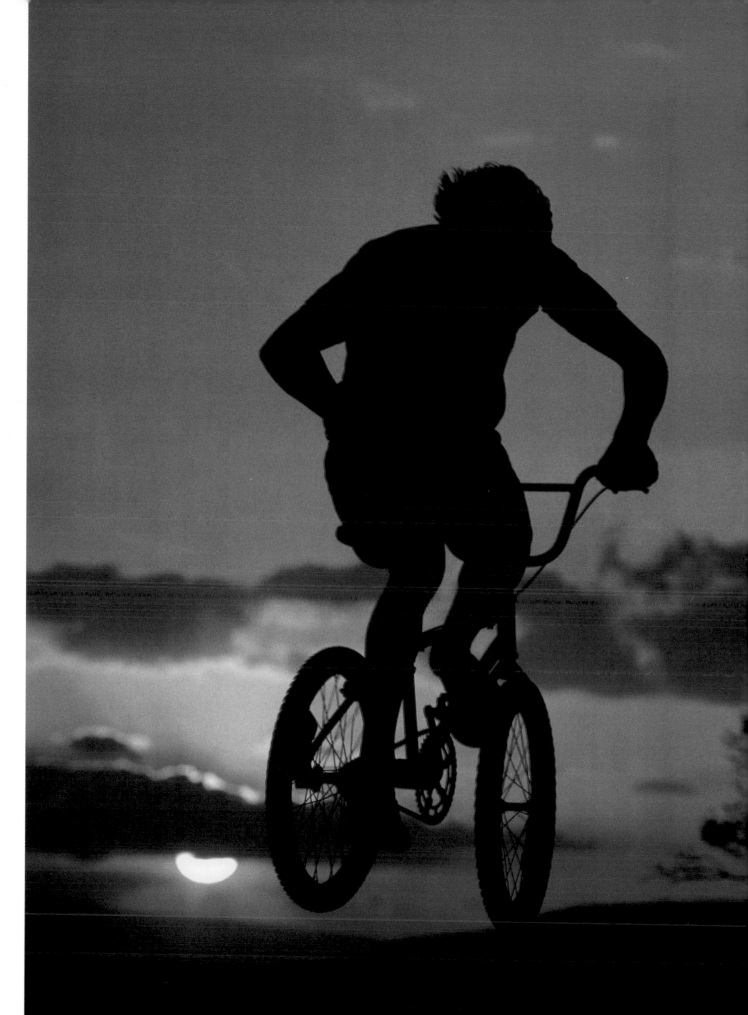

BLURRING THE SUBJECT

When you intentionally blur a subject, the camera remains stationary—usually on a firm support, such as a tripod—and the moving subject passes through the frame while you trip the shutter. The resulting image shows the moving subject as a blur, while stationary objects in the composition are recorded on film in sharp detail. Generally, slow shutter speeds, such as 1/30 sec. and 1/15 sec., are called upon to create this deliberate blurring effect. However, objects that are moving very quickly, such as a race car, blur at 1/125 sec.

I deliberately wanted to create the blur effect when shooting an advertisement for an umbrella manufacturer. On the sixth floor of a parking structure, I mounted a 105mm lens on my camera, steadied them on a tripod, and pointed the lens straight down on the sidewalk. The two models were standing on the street, one holding a bright yellow umbrella, the other a bright red one. As the models stood very still, several cars turned the corner right in front of them. I shot a few exposures at a shutter speed of 1/4 sec. The resulting composition showed two sharply focused and brightly colored umbrellas in the lower third of the frame, while the top and middle thirds were filled with a curvilinear, streaked blur; this blur was a turning car.

Another blur-effect opportunity presented itself when I discovered my son and niece jumping off several bales of hay about 3 feet high onto a bed of loose straw. As the late-afternoon light filled this area of the barn with light, I positioned my camera on a tripod and set my shutter speed at 1/15 sec. The resulting image showed a blurred, almost ghostlike shape of a small child against the in-focus bales of hay.

Because most shooters still prefer sharply focused images, they seldom intentionally blur a subject. This is unfortunate since new discoveries can be made only when you are willing to experiment. Consider just for a moment the creative possibilities when you deliberately blur subjects. Suppose you were shooting with your camera on a tripod at a shutter speed of 1/15 sec. Imagine how these subjects would look: a person who uses hand gestures, a dog shaking itself dry after a dip in a lake, a large Vermont sugar maple assaulted by a 30-mile-per-hour wind. Intentional blurring is one technique in which many waters remain uncharted.

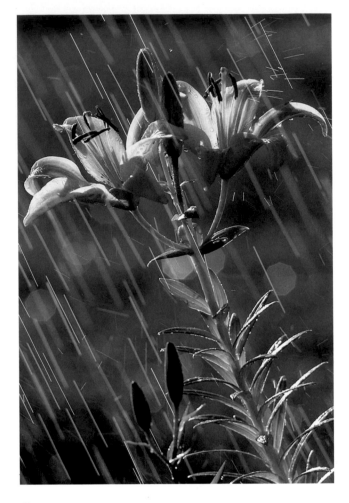

Of all the discoveries I have made during my twenty years of shooting, my favorite is creating "rain"; it has provided me with hours of joy-filled photography. This technique has also resulted in numerous stock sales with calendar and greeting-card companies. ✦ The effect is easy to achieve. On clear mornings in the spring and summer, I set up an oscillating sprinkler so that the water is backlit as it cascades down. I then select and arrange the blossoms. I use a small vase for single stems and a large narrow vase for bunches of flowers.

To effectively produce the look of falling rain, I set the shutter speed to 1/60 sec. Next, I move in close to the backlit flower and adjust the aperture until the meter correctly exposes for the light reflecting off the subject. At this point, I back up, recompose, and shoot. ✦ I almost always choose a 200mm or 300mm lens for "rain" shots, not so much because they have a shallow depth of field, but because they enable me to fill the frame with the flower from a distance that allows me to keep dry. I photographed all of these images at f/11 for 1/60 sec.

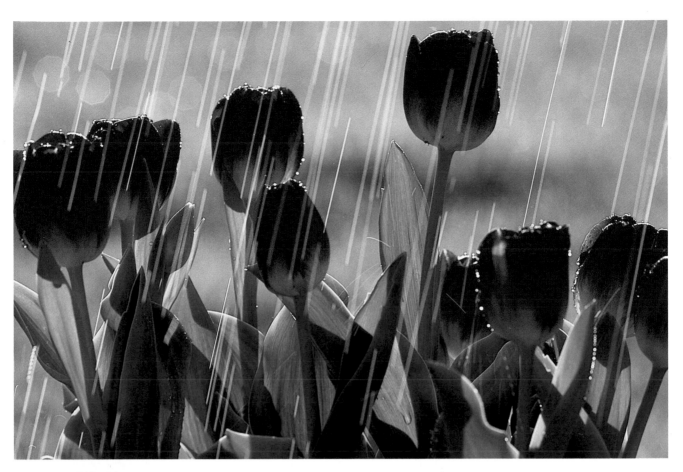

I have a particular fondness for the 70-year-old black-walnut tree that grows near the studio on my farm. In the fall, the leaves turn vivid yellow. Because my travel plans called for me to be out of town during the tree's peak-color period, I was forced to try a deliberate blur technique while the leaves were changing. ◆ Standing directly underneath a branch, I looked up at it with my 20mm wide-angle lens. The view was perfect for what I had in mind. With my shutter speed set to 1/4 sec., I turned the aperture ring until the correct exposure of *f*/22 was indicated. Although I actually photographed the scene for a mere 30 seconds, I managed to shoot an entire roll at this 1/4 sec. shutter speed while I twirled a full 360 degrees. As you can see in the shot on the right, this approach resulted in some dizzying yet wonderfully distinct compositions.

With all of the zoom lenses available on the market today, I am surprised that the "zooming-during-the-exposure" technique hasn't been revived. Recently, I used this effect while photographing an oak tree. ✦ To achieve this effect, I deliberately zoomed in on the tree during the short exposure time of 1/8 sec. After setting the shutter speed, I adjusted the aperture until a correct exposure was indicated for this frontlit scene.

With my camera and 35–70mm lens mounted securely on a tripod, I was ready to start zooming. I began with a focal length of 35mm and immediately zoomed to 70mm after I pressed the shutter-release button. ✦ Not all of the exposures worked out; I zoomed too slowly for some and too fast for others. The bottom photograph is one of the seven good shots I managed to record on a roll of 36 exposures.

PANNING

Unlike intentional blurring in which the camera remains stationary, *panning* a subject is a technique in which you deliberately move the camera parallel to and at the same speed as the action. Panning is similar to blurring in that it also calls for slow shutter speeds. This technique is most often used for photographing racing cars at the track. Consider this situation. From your spot in the grandstand, you begin to follow a race car's movement as it enters the frame. Next, while pivoting the camera on an axis, you gently trip the shutter release. You then want to follow through smoothly after tripping the shutter release; any sudden stop or jerking motion could adversely alter the effect.

Panning results in a relatively sharp subject against a background of total blur. The importance of the background in panning cannot be overstated; without an appropriate background, no blurring can result. One of my first attempts at panning involved photographing my brother and a friend tossing a frisbee in the air. With the shutter speed set at 1/30 sec., I shot more than 20 exposures as the frisbee streaked across the sky. Twenty pictures of a single subject seemed almost nightmarish to me back then, but I wanted to be sure that I got at least one good image. Unfortunately, none resembled the panning technique that I had recently seen in an article. I learned that you can't effectively pan a frisbee against a clear, blue sky. Since then, I have deliberately sought out subjects that have the potential to be exciting blurs of colorful backgrounds.

Intentional blur or pan, the choice is yours. Nowhere are there more opportunities to try your hand at either technique than at a park—think of the swings, merry-go-round, and teeter-totters for starters. Try the following exercise; I promise that it will help you to discover many more motion-filled situations. As you sit in a swing with your camera and wide-angle lens and your shutter speed set to 1/30 sec., point and focus the camera at your outstretched legs and the grass below. Now adjust the aperture to get a correct meter reading. All

set? Start swinging. Once you reach a good swinging action, raise the camera to your eye—either horizontally or vertically—with one hand, while holding on to the swing with the other hand. Gently press the shutter-release button while swinging upward and then with both arms carefully wrapped around the chains of the swing, advance the shutter release with one hand while holding onto the camera with the other. Now take another exposure as you swing downward. (If your camera has a winder or motor drive, use it here to eliminate the clumsiness of trying to manually advance the shutter.) The result: sharp legs surrounded by a sea of movement.

Next, walk over to the merry-go-round where a parent and three-year-old son are spinning at a good pace. Hop on the ride, use the same shutter speed of 1/30 sec., and focus on the parent and child from a viewpoint directly opposite them. Now adjust the aperture until a correct exposure is indicated. Fire away. The end result is a sharply focused parent and son against a swirling background. Finally, move over to the teeter-totter. If you are alone, ask someone to ride with you. With your wide-angle lens mounted on your camera, set the shutter speed at 1/4 sec., adjust the aperture until a correct exposure is rendered while pointing the camera at your partner. Now place the camera so that its base rests flat on the teeter-totter, about a foot or so in front of where you will be sitting, and focus on the other person. Next, climb on, start teetering, and as you go up and down, gently fire the shutter release. Even though you can't see through the camera, don't worry: remember, you focused and framed your partner before you started photographing. Shoot at least a dozen or so shots at different intervals. On your finished slides or prints, you'll notice the bold line of the teeter-totter's board created by the camera resting on it. This will lead the viewers' eye into the scene so that they immediately feel the up-and-down motion of the background—the trees, grass, fences, houses—which the creative and deliberate use of the slow shutter speed created.

Panning is simple to explain but difficult to master. This technique calls for you to focus on a subject that is moving parallel to the film plane, to deliberately choose a shutter speed of either 1/60 sec. or 1/30 sec., and to press the shutter-release button while following the subject. As a result, the subject will record sharp on film, while the background will record as a streaked blur. ◆ I photographed this scene in downtown Antwerp, Belgium. More than 200 cyclists rode past me in 20 minutes. With a shutter speed of 1/60 sec. and my camera and 100mm lens securely mounted on a tripod, I was almost ready to pan. Before I began, however, I had to bring the exposure to a close. So with my camera pointed at the gray sidewalk—to meter the overcast light reflecting on the ground—I adjusted the aperture until a correct exposure was indicated. I then continued to move the camera in the direction of the cyclist as I pressed the shutter-release button. This follow-through is essential when you pan; a sudden stop or a jerking motion could ruin the effect.

IMPLYING MOTION

Not to be confused with panning, implying motion is also quite the opposite from freezing action. Here, even slower shutter speeds are necessary because light levels are considerably lower and/or smaller apertures are used. Most of the time, compositions that convey a sense of implied motion require subjects that remain stationary within an action-filled scene. One of the most popular photographs is a waterfall surrounded by rocks and evergreen trees. Shutter speeds beginning at 1/4 sec. and longer—upward of even four hours—open up an array of creative possibilities. The motion of the common yet beloved waterfall is best implied at shutter speeds of 1/4 sec., 1/2 sec., or 1 sec. The pounding ocean surf at midday can be reduced to an angelic calm with shutter speeds of 8 sec. or longer, and stars on a moonless night streak across film when the shutter remains "locked" open for several hours.

Most photographers have little difficulty determining the right combination of shutter speed and aperture for most action-filled pictures—as long as the range of shutter speeds remains within those found on most cameras: from 1/1000 sec. down to 1 sec. When it comes to determining exposures longer than 1 sec., however, most photographers end up randomly "throwing darts," hoping against hope that at least one of their attempts was on target. But calculating longer exposure times actually is not at all difficult if you keep in mind the simple law of *progressive exposure* as you shoot. This is merely the continuation of an already established starting exposure that provides you with additional options. For any low-light situation, determining a starting exposure is essential. You must do this long before you address depth-of-field concerns or attempt to creatively capture motion-filled scenes.

Of all the creative compositions that are possible via a deliberate choice of shutter speed, I find that long-exposure-time images are the most compelling and satisfying. For example, a 2-minute exposure enables me to shoot rush-hour traffic moving through the dark on a cold winter night, and a 2-hour exposure permits me to capture a moonlit landscape. ✦ On assignment for the Bonneville Power Administration, I was asked to shoot landscapes filled with power lines. Several concepts posed challenges, but I was most intrigued by the composition of a single tower against a star-filled sky. ✦ Arriving at the location right after sundown, I first mounted my camera and 28mm wide-angle lens securely on a tripod. I then chose a viewpoint just below the looming tower and pointed my camera toward the North Star. About 45 minutes later, with the aperture set to *f*/8 and the shutter-speed dial set to "B," I began the exposure. I used a locking cable release in order to lock the shutter open. The exposure would continue for more than 4 hours. This photograph proves that shooting images with long exposure times is worth all of the effort and patience required.

SHOOTING IN LOW LIGHT
OR AT NIGHT

Suppose I am standing on a hotel balcony several hours after sunset, looking down on the strip in Las Vegas, about to start shooting. With my camera and 85mm lens securely mounted on a tripod, I am ready to establish a starting exposure. The first "rule" is to set the aperture at wide open. For my 85mm lens, that is $f/2.8$. Next, I adjust the shutter speed until a correct exposure is indicated. In this situation, I find that 1/30 sec. is needed. So my starting exposure is $f/2.8$ for 1/30 sec. But this is merely one of the many different exposure options. When I glance quickly at the scene below, I see the moving headlights and taillights of many cars and realize that this is an opportunity to convey motion. The only trouble is that I'll never succeed if I shoot at $f/2.8$ for 1/30 sec. The starting exposure won't produce the creative effect I am seeking: streaking headlights and taillights surrounded by the bright, colorful stationary signs on the strip.

To achieve this effect, I know that the exposure time must be at least several seconds. If I stop the lens down one stop to $f/4$, I must increase the shutter speed by one stop to 1/15 sec. to maintain a correct exposure. From $f/4$ I switch to $f/5.6$, then to $f/8$, $f/11$, $f/16$, finally ending up at $f/22$. How many stops did I reduce the lens opening? Moving from $f/4$ to $f/5.6$ is one stop, $f/5.6$ to $f/8$ is two, $f/8$ to $f/11$ is three, $f/11$ to $f/16$ is four, and $f/16$ to $f/22$ is five. Now, once again, in order to maintain a correct exposure, I must increase the shutter speed five stops: from 1/15 sec. to 1/8 sec. to 1/4 sec. to 1/2 sec. to 1 sec. and finally to 2 sec. But my shutter-speed dial does not provide a setting of 2 sec. What can I do? Use the "B" (Bulb) setting. When shooting at "B," I take out my trusty old cable release and count: 1001, 1002. By doing this, I am sure that I am recording this motion-filled cityscape on film.

There are other scenes that call for revealing motion through long exposures and enable you to make some creative images. Along many coastlines in the United States, the pounding surf releases its fury against large rock outcroppings. During the day, photographers have many chances to freeze this thunderous action. On countless occasions, however, I've seen many photographers put their equipment away immediately after sunset. This is unfortunate because exposures of the smashing waves made after the sun goes down seem calm and ethereal.

Unlike shooting a city scene from the safety of a balcony, photographing such landscapes requires you to seek out a location to shoot from before the sun goes down. Obviously, you don't want to begin to hunt for an ideal spot in the dark. After hiking through some rather rough terrain, I arrived an hour before sunset on a bluff along the Oregon coast. As I shot to the south, my camera and 105mm lens recorded the surf pounding against large boulders. During this hour, the sidelighting imparted not only great contrast but also a golden glow on the water and wet rocks. I shot most of my exposures at shutter speeds of 1/250 sec. and 1/500 sec. to freeze the action of the surf. Once the sun set, the light level began to diminish rapidly. As a result, my interest shifted to implying the motion of the crashing surf. For a starting exposure, with my camera and 105mm lens mounted on a tripod, I set the aperture to wide open at $f/2$. I then began adjusting the shutter speed until a correct exposure was indicated. At 1/4 sec., the meter "said" to take the picture. So in this situation, $f/2$ for 1/4 sec. is my starting exposure—and merely one of many different exposure options.

Although it was possible that $f/2$ for 1/4 sec. would have revealed some motion, I wanted an extreme effect. I stopped the aperture down one click at a time, remembering to double the shutter speed each time to keep the exposure constant. The exposure settings changed from $f/2$ for 1/4 sec., to $f/2.8$ for 1/2 sec., to $f/4$ for 1 sec., to $f/5.6$ for 2 sec., to $f/8$ for 4 sec., to $f/11$ for 8 sec., to $f/16$ for 16 sec., and finally to $f/22$ for 32 sec. Because the amount of light was cut in half with each f-stop reduction, I had to get that light back to maintain a correct exposure. I did this by doubling the amount of time with each click. Then I set the shutter-speed dial to "B" and with the locking cable release, tripped the shutter for a count of 16 seconds.

I hope that you can now appreciate why the road to photographic boredom is paved with the shutter speed of 1/125 sec. Choose any subject, animate or inanimate, and you can make a great photograph through the creative and deliberate use of different shutter speeds. Even a building, which is obviously stationary can be "moved" with a creative shutter speed. When you combine a zoom lens with a shutter speed of 1/4 sec., you can "explode" the building; while firing the shutter at 1/4 sec., zoom the lens from its widest focal length to its narrowest focal length. Why not stop right now and just look at motion-filled opportunities around you? Make a list of scenes starting with the motion created by your putting this book down. From there you can add the motion created by coffee being poured from the pot as you refill your cup. Now as you look outside, you can add the wind as it moves through the branches of an elm tree, and then you can add

While long exposures can seem intimidating, they can also open the door to exciting and rewarding—and, I'll admit, challenging—photography. The question my students always ask is, "How long should I expose the scene?" I remind them that first they need to establish a starting exposure. ◆ I photographed this lighthouse near Heceta Head on the Oregon coast. Following a day of heavy rain, I waited for the storm to pass in order to make this long exposure. I mounted my camera and 105mm lens securely on a tripod and then composed the scene at dusk, minutes after the rain stopped. Next, I set the aperture to $f/2.5$ (wide open) and tapped the shutter-release button to activate the exposure meter. As I adjusted the shutter-speed dial, I found that 1/2 sec. was the correct exposure. ◆ But because I wanted to render the distant, pounding surf on film as a calm sea, I simply started to stop the lens down. I doubled the shutter speed with every f-stop decrease. By the time I got to $f/32$, the corresponding exposure time was 1 minute. Realizing that this wasn't long enough, I placed a two-stop neutral-density filter on the lens and added two full stops of exposure time to compensate for the two-stop decrease in light transmission. This took me to 4 minutes at $f/32$. Then I added another full stop of time to allow for the sky getting progressively darker during the 4-minute exposure. I was now at 8 minutes at $f/32$. Finally, I added another full stop of time to correct for reciprocity failure; all films suffer a one-stop underexposure when the exposure time exceeds 4 sec. Now the exposure was $f/32$ for 16 minutes. With the shutter-speed dial set to "B" and the aperture set to $f/32$, I locked the shutter open with the locking cable release. ◆ The last concern: how to render the light from the lighthouse on film correctly? It is much brighter than the surrounding sky and water, so if I expose it for the full 16 min-utes it will "burn a hole" in the film. To solve this problem I took a reading of my car headlights from a distance of about 50 feet at $f/2.5$ and determined that a shutter speed of 1/30 sec. was adequate. I then estimated that $f/2.5$ for 1/8 sec. was correct for the light-house illumination 1000 feet away. This two-stop differ-ence enabled me to proceed with the first 4 minutes of the exposure time as in-tended but caused me to put my hand in front of the lens (for less than a second) every time the roving light swung around into the view-finder during the last 12 minutes. My patience paid off. This image has sold quite well as a stock shot.

For any low-light situation in which you wish to use slow-to-medium-speed films and want to achieve overall sharpness, using a tripod is essential. The following features are a must on any tripod. First, the tripod head is the most important because it supports the bulk of the weight of your camera and lens. When looking at the many different styles of tripod heads, always practice mounting your heaviest camera-and-lens combination. Once you secure the camera and lens on the head, check to see if it tends to flop or sag a bit. If so, you need a much sturdier head. Next, see if the tripod offers, by a simple turn of a handle, the ability to shift from a horizontal format to a vertical format. Can you also lock the tripod head at angles in between horizontal and vertical? Finally, does the tripod head offer a "quick release"? Many tripods require you to mount the camera and lens directly onto the tripod head by way of a threaded screw. A quick release, on the other hand, is a metal or plastic plate that you attach to the camera body; you then secure the camera and plate to the head via a simple locking mechanism. When you want to remove the camera and lens, you simply flick the locking mechanism and lift the camera and lens off the tripod.

Before buying any tripod, you should also spread out its legs as wide as possible, regardless of the height of the legs at that point. The wider the base, the greater the stability. Each leg of the tripod is composed of three individual lengths of aluminum or some other metal. You can lengthen or shorten the legs and then tighten them by a simple twist of hard plastic knobs, metal clamps, or a threaded metal sleeve. I've found that the metal-clamp locks tend to break easily and that the threaded-metal-sleeve locks are difficult to turn when tightened down—much like getting the lid off a well-sealed pickle jar. I prefer locks made of hard plastic because they seldom break or get stuck.

The height of a tripod at full extension is another important consideration. Obviously, if you are 6'2", you don't want a tripod with a maximum height of only 5 feet—unless you won't mind stooping whenever you use the tripod. All tripods have a center column that is designed to provide additional height; this can vary from 6 inches to several feet. Some center columns extend via a cranking mechanism, while others require you to pull them up manually. Keep in mind that you should adjust the center column only when it is absolutely necessary. This is because the higher the center column is raised, the greater the risk of wobble—which defeats the purpose of using a tripod.

Finally, when shooting long exposures with a tripod, you are trying to achieve sharpness. So when the exposure time exceeds the slowest possible shutter speed on your camera, use a locking cable release. When you shoot at the slow shutter speeds on the shutter-speed dial, use your camera's self-timer to trip the shutter.

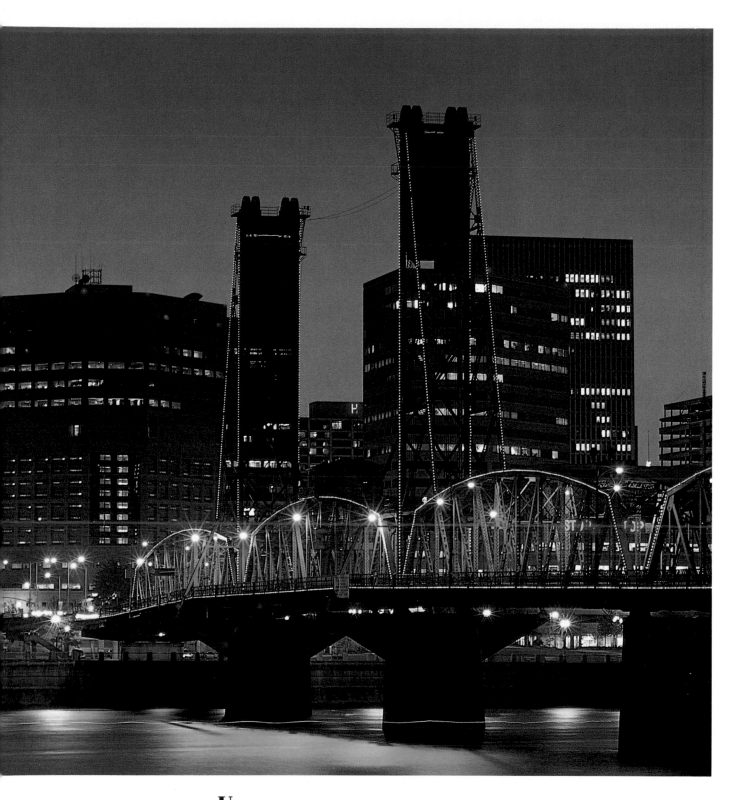

Using a tripod is a must by night, if not by day. One evening after sunset, the Portland, Oregon, skyline took on a lavender glow. With my camera and 35–70mm lens mounted on a tripod, I set the aperture to wide open to get a starting exposure. Next, I pointed my camera to the part of the sky just above the buildings and adjusted the shutter-speed dial until the correct reading of 1/2 sec. was indicated. I stopped down to *f*/22 and then increased the shutter speed by a corresponding five stops to keep the exposure constant. ✦

This final exposure of *f*/22 for 16 sec. resulted in a tack-sharp image because I used a tripod. Also the lengthy exposure time enabled the motion of the river to record on film as a colorful sheen. If any tool can improve the quality of your images, it is a tripod.

FILM

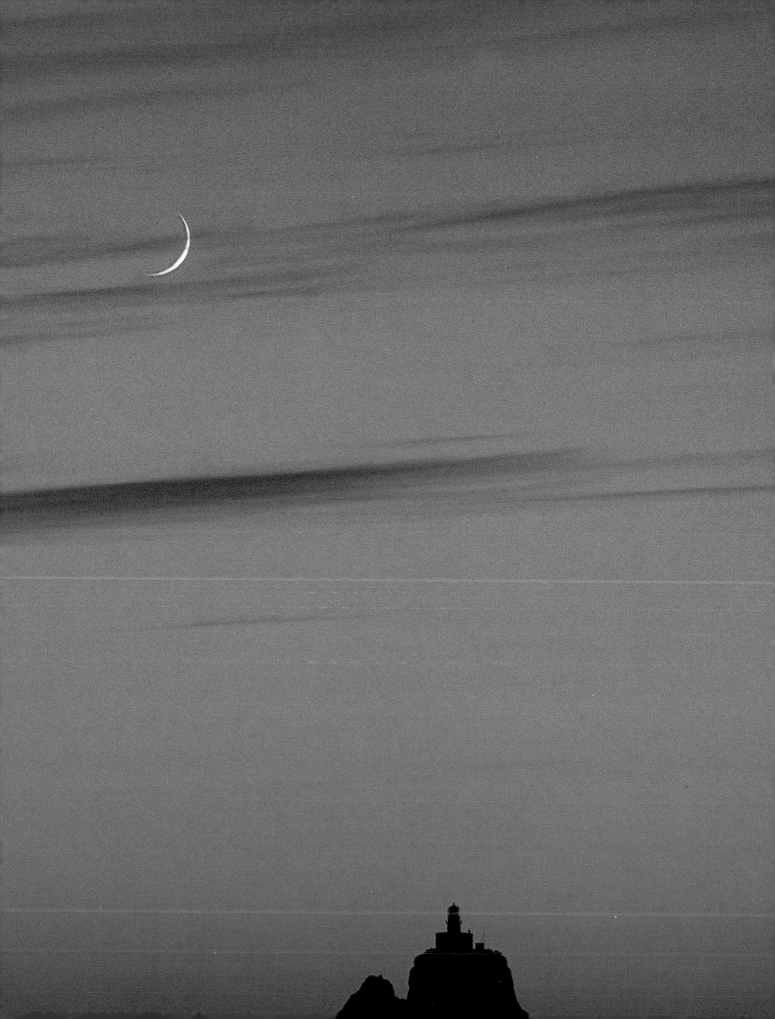

Within seconds of glancing at the film counter in any camera shop, beginning photographers experience sweaty palms, a rapid heartbeat, and a tightness around the forehead. They are confronted by neatly stacked rows upon rows of different types of film: green boxes, orange boxes, yellow boxes, and blue boxes. Overwhelmed, they ask themselves the following questions. Why are there so many choices? Why are there so many brands? Is one film really better than another? Is slide film better than print film? What is meant by "film speed?"

To narrow down your choices, thereby alleviating some anxiety, follow a few basic guidelines. First, you have to decide between black-and-white or color film. Assuming that you select color film, your next choice concerns the final result. Do you want prints or slides? You can readily identify both kinds of film. Regardless of the manufacturer, all color-print films end in the word "color:" for example, Kodacolor, Agfacolor, and Fujicolor; and all color-slide films end in the word "chrome:" Kodachrome, Agfachrome, and Fujichrome.

Quite often, the question of which brand of film is best comes up in my workshops. One good rule of thumb is to match the color of the film box to the subject or subjects you expect to be shooting. For example, both Fujichrome and Fujicolor come in green boxes, so these films are logical choices for photographing rich green forests and deep blue skies. Kodachrome and Kodacolor, on the other hand, come in yellow boxes and are logical choices for shooting the intense reds, oranges, and yellows of a Vermont autumn. In essence, Fuji's green-boxed film favors cool colors while Kodak's yellow-boxed film is best suited to warm colors.

Additionally, film boxes also provide much-needed information about the film's number of exposures, speed, and format. All 35mm films begin with a designation of 135, followed by the number of exposures possible: 135-12, 135-24, or 135-36. When buying film, keep in mind that slide film is available in only 135-24 or 135-36. In big, bold letters, the film's speed is shown on the box, such as Fujichrome 50, Agfachrome 100, or Kodachrome 200. These numbers refer to the film's sensitivity to light. This treatment of the film speed differs greatly from the small print used on packaging just a few years ago. Finally, the film box indicates the film format. The most popular type of color film—for both prints and slides—is *daylight-balanced*. Simply put, "daylight" refers to natural light, whether it is the deep shade under a willow tree, the strong midday sun, or the light filtering through a skylight into a room.

For many photographers, film choice is a personal decision. Seasoned professionals and serious amateurs often have a favorite film and insist that it is the best. Only after trying several brands and comparing the results can you make an informed decision about the film that is right for you. I always recommend to my students that they shoot landscapes, portraits, and closeups using at least three different brands, all with exactly or approximately the same film speed. This type of comparison shooting will clarify which film is best for your own personal tastes and your goals.

I also strongly recommend sticking with the major brands. Whether you shoot with Kodak, Agfa, or Fuji film, you'll seldom have trouble getting the film processed even if you're in a remote region of the world. Speaking of film processing, don't return from an outing and throw the exposed rolls into a dresser drawer. Over time, the film begins to break down, which affects both its density and color. This is especially true when it remains stored in high heat and humidity. If for some reason you can't have your film processed right away, place the exposed rolls in the refrigerator.

One of the most enjoyable trips I have ever taken was to the Gulf of Mexico to spend several days on an offshore oil rig. The employees on this rig work two weeks nonstop for 12 hours a day, so you can imagine how happy they were to see a new face. And when I promised all of them at least one 8 × 12 print, I had their complete cooperation. Most of them expressed interest in getting the photograph so that they finally could prove to their wives or girlfriends that they actually did work such grueling hours. ◆ Of all the workers I photographed on the rig, none was more memorable than Eric the Red. With my camera and 300mm lens securely mounted on a tripod, I set the aperture to *f*/8. Depth of field was of little importance for this portrait. Because of the even illumination created by the overcast sky, metering was a simple task. I adjusted the shutter speed until a correct exposure of 1/500 sec. was indicated. ◆ Eric's spontaneity was largely due to my assistant, who was conversing with Eric out of the camera's view. This gave me the opportunity to record a variety of candid expressions.

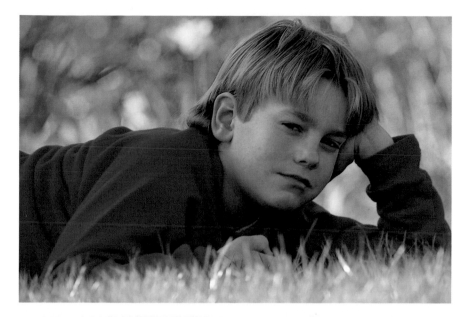

All photographers have a favorite film that they measure others against. When a new film comes on the market, they usually test it and compare it to "old reliable." Doing such a test convinced me to switch from Kodachrome 64 to Fujichrome 50 more than two years ago. Even though other films have been introduced since then, none seems to compare to the rich, saturated colors and warm skin tones that Fujichrome 50 offers. Keep in mind that I based my decision to shoot Fujichrome solely on my picture-taking needs. Other photographers firmly believe that Kodachrome is best, while others insist on Ektachrome or Agfachrome. So it is important that you shoot the same subject with three or four different films and find your own favorite.

◆ As you can see here, Fujichrome (top shots), Agfachrome (middle shots), and Kodachrome (bottom shots) do a fine job covering the color spectrum. For this film test, I simply placed a number of felt pens on black paper near a south window and exposed for the available light that fell on them. But when I photographed my son, Fujichrome produced much warmer skin tones than Agfachrome or Kodachrome. This is important to me because I often photograph people.

PRINTS VERSUS SLIDES

Choosing between print and slide film involves many variables. For some photographers, price is a primary consideration. Which film is cheaper, slide or color-print? Processing a 36-exposure roll of slides costs around 6 dollars while processing a 36-exposure roll of color-negative film costs an average of 12 dollars. So if you adhere to a ruthless editing ethic, it is clearly much less expensive to shoot slide film. To the surprise of many beginning photographers, you can also make color prints from slides. On the average, a 3½ × 5 print costs about 50 cents. Suppose you have four really great slides in a roll of film and decide to have prints made, bringing the final processing cost to 8 dollars. This price is still 4 dollars less than the cost of processing the print film. But most beginners and many amateurs shoot color-print film because the processed film can be easily seen and shared. Slides, on the other hand, are smaller than prints, are more convenient to store, and can be shown to large groups via a slide projector.

Another difference you should think about when buying film is its ability to compensate for errors in exposure. Color-print film is a bit more forgiving when you accidentally overexpose it than color-slide film is; it records rather pale colors when overexposed. However, color-slide film responds to underexposure better than color-print film does. When you underexpose slide film a bit, the colors are usually more vivid and contrast increases. With color-print film, on the other hand, underexposure results in a dense negative. This makes it difficult to pull the color out and onto the printed paper. In general, color-slide films allow for both a one-stop-overexposure and a one-stop-underexposure margin of error, while color-print films allow for a two-stop-overexposure margin of error. Finally, you should realize that color-slide films record permanent images, but the negatives of color-print film can be altered in the darkroom to correct for exposure errors. It is important to note, however, that these exposure corrections are made in the darkroom of a custom lab, not in a lab that processes film in an hour.

If all of this sounds like I prefer slide film to print film, it is meant to. And there is yet another reason why I think that you should shoot slides. I have frequently taught advanced compositional fundamentals and exposure techniques to serious amateur photographers. Like me, they were bitten by the photography bug as beginners and soon found themselves hoping not only to shoot the way a professional does but also to become a "weekend warrior." This is a term I use affectionately to describe serious amateurs who spend their weekends shooting up a storm and dream about marketing their images to greeting-card, calendar, and textbook companies. These weekend warriors are often deeply disappointed when they discover that most if not all publishing houses want only slides, not the color prints that they have been shooting. For proof, look at the latest edition of *The Photographer's Market*, a book that lists more than 800 markets for photographic work.

While professional photographers usually shoot slide film, you may find that you want to shoot print film for certain situations—or that you prefer it in general. Both types of film have advantages and disadvantages. Although slide film provides richer, sharper images, it has less exposure latitude; this means that you must be more precise or you will end up with unwanted over- and underexposures. On the other hand, print film is more forgiving and can be successfully push and pull processed, but its faster speeds produce grainier images. ✦ Here, I used slide film for the top image and print film for the bottom image. As you can see, the colors in the slide are more saturated.

FILM SPEED

After solving the slide-versus-print dilemma, you need to consider film speed. Simply put, a film's speed determines its sensitivity to light. When the "right" amount of light strikes the film, a picture is recorded. While the "right" amount of light (the aperture) and the "right" length of time, (the shutter speed) are essential for determining an exposure, film speed is an even more critical variable because it influences the aperture and shutter speed. Selecting the appropriate film speed is far more important than choosing the right brand or deciding between print and slide film. The "right" film speed can ensure a multitude of creative effects via the creative use of the aperture and shutter speed. Conversely, a "wrong" film speed can leave you floundering.

CHOOSING THE RIGHT FILM SPEED

On every box of film, color or black-and-white, the speed of the film is indicated by a number after the brand name, such as Fujichrome 50, Kodacolor 100, and Ektar 1000. If you think of these numbers as light-gathering receptors, you'll be able to appreciate the differences between high-speed films, medium-speed films, and slow-speed films. High-speed, or "fast," films have ISO ratings of 400, 800, and 1600 and contain that number of light-gathering receptors. Similarly, medium-speed films have ISO ratings of 100 and 200, which reflect their 100 and 200 receptors, respectively; and slow-speed, or just "slow," films with ISO ratings of 25, 50, and 64 contain equivalent numbers of receptors.

To clarify the importance of film speed, think about the following example. You load Fujichrome 50 in one camera and Fujichrome 400 in another after alerting the exposure meter in both cameras as to film choice by adjusting the film-speed dial. You want to photograph the weathered wood on the side of a barn with your 50mm lens. Because you have no real depth-of-field concerns, you set the aperture at f/8 on both lenses. Do you need the same shutter speed for the two exposures? Definitely not. If you think of the film's speed as its receptivity to light, one film will require less time and the other, more. Because Fujichrome 50 has only fifty light-gathering receptors, it will require a longer exposure time than Fujichrome 400.

To determine how much longer, you should know that film speeds, like apertures and shutter speeds, can be linked to the halving-and-doubling principle. For example, an ISO 50 film offers half as many light-gathering receptors as an ISO 100 film, an ISO 100 film offers half as many receptors as an ISO 200 film, and an ISO 200 film offers half as many receptors as an ISO 400 film. Conversely, of course, an ISO 400 film has twice as many receptors as an ISO 200 film. In effect, each halving or doubling of these light-gathering receptors is considered a stop. So if the correct exposure for the film with 400 light-gathering receptors is f/8 for 1/500 sec., what is the correct exposure for the film with 50 light-gathering receptors? By counting back from 400 to 200 to 100 to 50, you can determine the correct exposure via the number of stops. In this example, there is a three-stop difference: 400 to 200 (one stop), 200 to 100 (one stop), and 100 to 50 (one stop), for a total of three stops. Therefore, if f/8 for 1/500 sec. is the "right" exposure for 400 light-gathering receptors, then f/8 for 1/60 sec. is the correct exposure for 50 receptors.

How did I arrive at this exposure? Because the aperture is f/8 for both types of film, the correct exposure must be determined by shutter speed. Accordingly, the first camera's exposure meter, which you fed the pivotal information regarding film speed, dictates that the camera with ISO 400 film and an aperture of f/8 requires a shutter speed of 1/500 sec. The other camera's exposure meter, which you fed the sum of 50 receptors to, then indicates a different shutter speed; 1/60 sec. is correct because it reflects the three-stop difference in film speed. Moving from 1/500 sec. to 1/250 sec. (one stop), and from 1/250 sec. to 1/125 sec. (one stop), and then from 1/125 sec. to 1/60 sec. (one stop) comes to a total of three stops.

Because I believe that this is such an important part of understanding your exposure options, I want you to take out your camera and get a piece of paper and a pencil. First, set the film-speed dial to 100. Now set the lens opening to f/8 and with the camera pointed at a plant or tree outside, adjust the shutter speed until a correct exposure is indicated. Write down this shutter speed on your piece of paper. Next, move the film-speed dial to 200, leave the aperture at f/8, and adjust the shutter speed until a correct exposure is indicated. Once again, write down this shutter speed. Finally, turn the film-speed dial to 50 and complete the process the exact same way. What have you learned? When you double the number of light-gathering receptors from 100

to 200, the exposure meter indicates a different shutter speed—one that calls for half as much time as the shutter speed needed for 100 receptors. When you cut the number of receptors in half from 100 to 50, the exposure meter indicates yet another shutter speed; this one calls for twice as much time as the shutter speed needed for 100 receptors.

You can do this exercise just as easily by leaving the shutter speed constant and adjusting the aperture. For example, with the film speed set at 100 and the shutter-speed dial set at 1/125 sec., adjust the aperture until a correct exposure is indicated. Then increase the film-speed setting to 200 and readjust the exposure. Finally, turn the film-speed dial to 50 and readjust your exposure once again. This simple exercise shows that with 200 receptors, a one-stop decrease in aperture size is required, and that with 50 receptors, a one-stop increase in aperture size is necessary.

So why all of the fuss about fast, medium, and slow films? Why not just select one and stay with it? In fact, most people do. Also, the most popular of all film-speeds continues to be the medium speeds of ISO 100 and ISO 200. With these films, you seldom have to worry about using slow shutter speeds or freezing action—such as at a soccer game—on days of average brightness. However, there are numerous times, especially in terms of creative exposure, when one film will do the job better than any other. And if that is not ISO 100 or ISO 200 film, would you be opposed to switching film? Surprisingly, many of my students protest when they have to give up their "old faithful" ISO 100 or ISO 200 film—even if it means missing creative opportunities.

To understand this point, refer to the "Exposure Settings" chart shown below. Assume that the exposure information listed for each film refers to a scene in which an old fence borders a field of wildflowers. The day is overcast, which eliminates any concerns about sharp contrasts caused by strong highlights and shadows. In effect, the scene is evenly illuminated, so making meter readings is easy. This chart is helpful for several reasons. As you go across it, you'll see that with each one-stop increase in a film's speed, the constant aperture, such as $f/2.8$, is paired with a one-stop increase in the shutter speed. I want to emphasize that each of the aperture-and-shutter-speed combinations indicated under each film will produce a correct exposure. However—and this is just as important—each exposure combination will record a different creative effect.

Suppose that for one composition, you decide to use a 200mm lens to isolate a couple of flowers that are about 7 feet from you. Choosing a low viewpoint, you can selectively focus through the foreground flowers, thereby creating a beautiful wash of color around the two flowers that you want to isolate. Directly behind these two in-focus flowers, the sea of out-of-focus color continues. To keep the depth of field limited, you have to set the lens to wide open, which is $f/2.8$ in this case.

Now refer to the chart again. What do you notice about approaching this scene with an ISO 400 film at $f/2.8$? According to the chart, you need a shutter speed of 1/8000 sec. But suppose your camera, like most others, can't shoot at this exceptionally fast speed of 1/8000 sec.; you certainly won't be able to use the creative aperture of $f/2.8$. In fact, most photographers shooting ISO 400 film would need an aperture of at least $f/8$ because most cameras have 1/1000 sec. as their fastest shutter speed. But at $f/8$, the depth of field is too great and ruins the selective-focus technique.

EXPOSURE SETTINGS

Kodachrome 25	Fujichrome 50	Kodacolor 100	Fujicolor 400
$f/2.8$, $1/500$ sec.	$f/2.8$, $1/1000$ sec.	$f/2.8$, $1/2000$ sec.	$f/2.8$, $1/8000$ sec.
$f/4$, $1/250$ sec.	$f/4$, $1/500$ sec.	$f/4$, $1/1000$ sec.	$f/4$, $1/4000$ sec.
$f/5.6$, $1/125$ sec.	$f/5.6$, $1/250$ sec.	$f/5.6$, $1/500$ sec.	$f/5.6$, $1/2000$ sec.
$f/8$, $1/60$ sec.	$f/8$, $1/125$ sec.	$f/8$, $1/250$ sec.	$f/8$, $1/1000$ sec.
$f/11$, $1/30$ sec.	$f/11$, $1/60$ sec.	$f/11$, $1/125$ sec.	$f/11$, $1/500$ sec.
$f/16$, $1/15$ sec.	$f/16$, $1/30$ sec.	$f/16$, $1/60$ sec.	$f/16$, $1/250$ sec.

This chart shows four popular films along with their assigned film speeds. In addition, I have listed the possible exposure combinations for the scene of a field of wildflowers under an overcast sky.

So what can you do? In order to use *f*/2.8 (the aperture that limits the depth of field), you have to determine which film speed will enable you to selectively focus. Refer once again to the chart. You will see that at *f*/2.8, either an ISO 25 or an ISO 50 film will produce the desired effect. Don't let the fact that both of these films are available only in slide form trouble you. Why not take this opportunity to try your hand at shooting slides? (More experienced photographers might be wondering why I don't suggest a neutral-density filter to people who prefer print film in situations like this. Why spend money on a filter when there is such an array of film choices to experiment with? All too often, photographers miss out on new and exciting discoveries because they are opposed to change.) Finally, with an ISO 50 film loaded in your camera, you can set your 200mm lens at *f*/2.8 and shoot away as the meter indicates a correct exposure of a 1/1000 sec.

Next, you decide to shoot the scene differently: with a 28mm wide-angle lens to achieve a storytelling composition that utilizes maximum depth of field. With your camera loaded with Kodachrome 25 and the lens opening set at *f*/16, you discover that the effective shutter speed is 1/15 sec. Unfortunately, you didn't bring your tripod. Because you aren't feeling too steady today, you're forced to open up the aperture a bit; now you can shoot at a faster shutter speed. So you set the aperture at *f*/8, which results in a shutter speed of 1/60 sec. Although this is a correct exposure, the creative effect you want—maximum sharpness throughout—is adversely affected. In fact, the fence post in the foreground that leads the viewer's eye into the scene looks a bit fuzzy and strikes a jarring note in an otherwise harmonious scene. You then ask yourself if Kodachrome 25 is the wrong film for this composition. The answer is no. Both seasoned professionals and serious amateurs alike favor such slow films as ISO 25 and ISO 50 because of their rich colors and vivid sharpness. But keep in mind that slow films almost always require the use of a tripod or some other firm support.

A final note about film speed: Once a film is processed at a lab, its light-gathering receptors turn into grainy specks. Of course, the more light-gathering receptors a film has, the grainier the finished slides or prints. Slow- and medium-speed films are noted for their lack of grain. They are well-suited for photographing landscapes and people and for showcasing fine details in closeups. In addition, images made on these films often grace the covers of calendars, cards, and books. On the other hand, fast films, with their harsh and rough grain pattern, are equally effective for freezing action and for creating impressionistic landscapes, romantic fashion and beauty shots, and even closeups of flowers. There has been a recent surge in the use of high-speed films by experienced professionals, including myself, despite the finer grain of many of the new high-speed films. Experiment with them to find out if you like the results.

Before you begin shooting, you should think about what subjects you plan to capture on film. Do you anticipate photographing images that center around the creative use of depth of field—selective focus, blurred backgrounds, or storytelling compositions? Do you expect to shoot mostly images that center around the creative use of shutter speed—freezing action, implying motion, deliberately blur-

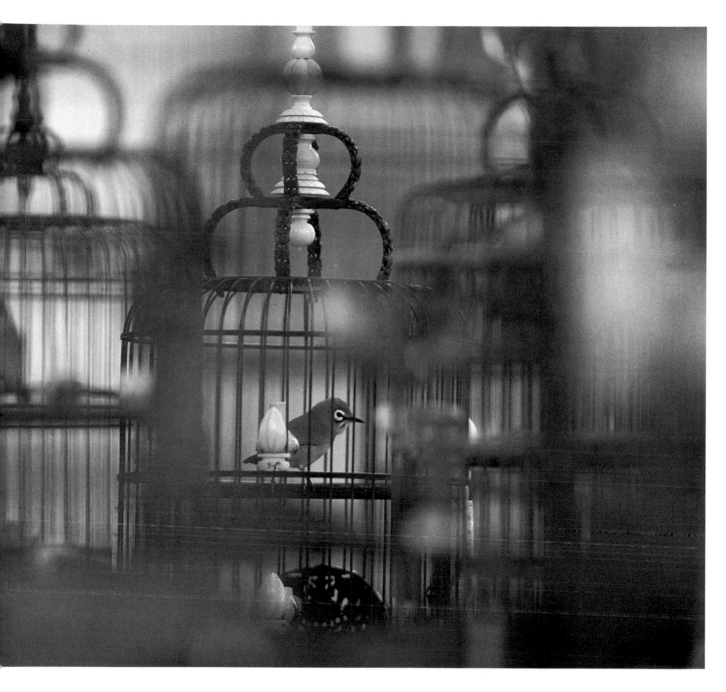

ring, or panning? Such films as ISO 25, ISO 50, ISO 64, and ISO 100 enable you to record both creative depth-of-field images and motion-filled scenes without freezing the action. However, these slow films often require you to use a tripod. On the other hand, faster films, such as ISO 400 and ISO 1000, freeze action-filled subjects, but even more important allow you to use smaller lens openings.

This provides additional depth of field, which often means the difference between a tack-sharp end-zone touchdown and one that is a bit fuzzy. ◆ As I left my hotel room and headed for Singapore's busy streets, I knew exactly where I was headed: to the Sunday bird-singing contest at Tiong Bahru. More than 100 natives and their caged songbirds provide a morning of melodious if noisy chatter.

The bird cages are hung from a wooden framework that rests above an open-air coffee shop. With my camera and 400mm lens mounted on a tripod, I chose to focus selectively through the cages in the foreground on one specific cage; the background cages were a soft blur as well. With the aperture set to $f/5.6$, I adjusted the shutter speed until a correct exposure of 1/500 sec. was indi-

cated. ◆ Because I knew that I would have only selective-focus shooting opportunities that day, I had decided to use ISO 50 film. Had I used ISO 400 film, I never would have been able to selectively focus. At the fastest shutter speed, 1/1000 sec., the aperture would have been $f/11$ for a correct exposure. The resulting depth of field would have rendered this a busy, confusing image.

TUNGSTEN-BALANCED FILM

Up to this point, I've discussed only films that are *daylight-balanced*. This means they render the proper ranges of light and tone under natural-light conditions. *Tungsten-balanced* film, on the other hand, is balanced not for daylight but for the artificial light provided by light bulbs. So if you've ever taken a picture inside your home (most homes are artificially illuminated by tungsten light) with daylight-balanced film, you have undoubtedly recorded a strong yellow-orange cast on film. This effect is particularly noticeable in shots taken at night when ceiling lights and table lamps are the sole source of illumination.

Don't confuse tungsten and fluorescent light. Although fluorescent light is also artificial, it has a completely different effect on film. If you've ever taken pictures with daylight-balanced film of interiors illuminated by fluorescent light, you've seen the "green monster," an apt name for the sickly green cast that permeates such photographs. Unfortunately, no film can compensate for its color wavelength. However, if you use an *FLD filter* when shooting daylight film, you can expect to achieve acceptable results on film. "FLD" means shooting fluorescent light on daylight film.

You can also rely on filters when you shoot daylight-balanced film in tungsten-lighting conditions. For example, you can use an 80A filter to "correct" an otherwise orange-red cast on film; keep in mind, however, that a dark blue 80A filter results in the loss of two stops of light. Correct exposures are possible, but the exposure times may be so long that any action may be rendered on film as a blur.

For this reason, you must explore other options. The most common is to use an electronic-flash unit when shooting indoors. Because the light that the flash puts out is daylight-balanced, you must choose daylight-balanced film. When you combine this film with your flash's *sync shutter speed*, the existing tungsten light in the room doesn't have an opportunity to record on film. The type of camera you own determines what the flash sync speed is. It could be 1/60 sec., 1/125 sec., or 1/250 sec. You can use any slower shutter speed, but you would never use a shutter speed faster than the sync speed when shooting with flash. Perhaps you've already

discovered what can happen. For example, if you use the next fastest shutter speed above the sync speed, half of the picture will be black. This happens because the shutter curtains already begin to close before the flash unit has time to fire.

But flash photography is not desirable or even permitted in such shooting situations as operas, plays, and church interiors, as well as during indoor parties where you might not want to be noticed as you shoot candids. Obviously, in these situations the bright burst of light from your flash unit would call a great deal of attention to you. Here, then, tungsten film is a solution. Until recently, Ektachrome 160 was the only choice in tungsten film. Still popular with many photographers, it can be "pushed" to ISO 320, which makes it ideal for indoor scenes (see page 112 for more about pushing film). On a recent assignment in London, I was asked to create natural-looking interiors and to shoot candids of the patrons of London's pubs for a magazine story. I photographed the entire assignment using Ektachrome 160 pushed to 320. Although the images were grainy, the effect enhanced my subjects and everything turned out fine. However, perhaps in response to the grainy quality of Ektachrome 160, both Kodak and Fuji now offer a finer-grain tungsten film: Ektachrome 50 and Fujichrome 64. Because of their slow speeds, they almost always require the use of a tripod or other support. Tungsten films are primarily popular with architectural photographers, who often shoot building interiors. But all three tungsten films also perform well for night scenes because many city lights are tungsten-balanced.

Although tungsten film is designed for use with tungsten lighting, I recommend that you shoot at least one roll in natural lighting conditions. When tungsten film is exposed to daylight, it records an excessive amount of blue light. This overall bluish cast can evoke feelings of coldness, distance, and detachment. Although this effect is seldom successful with portrait photography, landscapes and even some closeups take on a new meaning when shot in daylight with tungsten film. Once again, don't let the fact that these tungsten films are intended for slides rather than prints stop you from using them to create better photographs.

Homes, churches, and office-building lobbies are often illuminated artificially by tungsten light. Although the term might not sound familiar, this is the type of illumination ordinary light bulbs provide. ✦ Assigned to shoot a story on London's pubs, I was given the option to use either electronic strobes or tungsten-balanced film. Keeping in mind the crowds at most pubs, I decided to shoot the available, though artificial, light with tungsten film. One of my favorite pubs, the Black-friars Pub, is noted for its unique marbled walls and tiled mosaics. With my 20mm lens and my camera loaded with tungsten ISO 160 film pushed to ISO 320, I mounted my equipment on a tripod. I then chose a seat in the corner of this small room. I was immediately struck by the sharp contrast between the relaxed demeanor of the elderly man closest to me and the concerned look on the faces of the two younger men to my left. I set the aperture to wide open, $f/2.8$, and the exposure meter indicated a correct exposure at 1/8 sec. I carefully pressed the shutter release, hoping that movement in the room would be limited. I shot more than three rolls of film at both the indicated reading as well as at one- and two-stops overexposed. ✦ The tungsten film enabled me to accurately record the colors of the pub's interior as well as of the patrons' clothing and skin. If I had used daylight-balanced film without a flash unit or an 80A filter in this situation, an orange-red tone would have permeated the images.

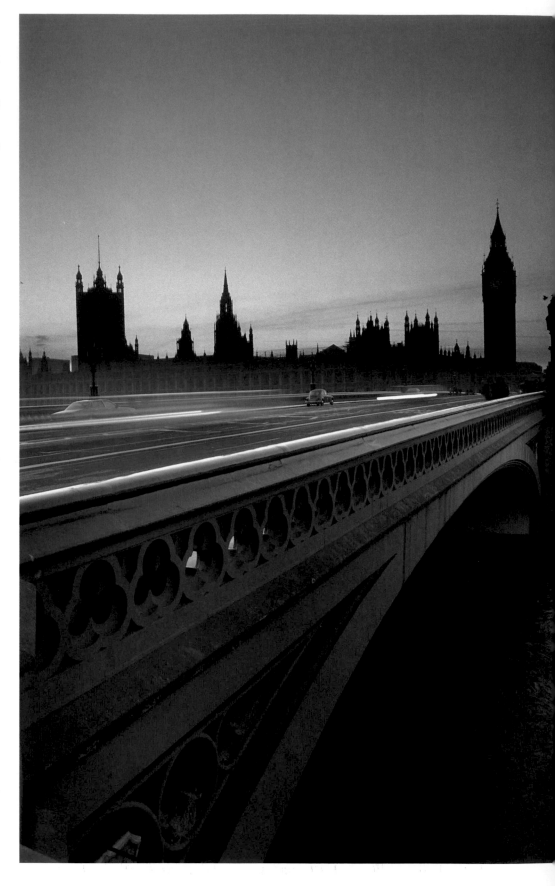

This photograph of the Westminster Bridge is the indirect result of an accident that happened a long time ago. The night before, I had shot all but seven exposures of a 20-exposure roll of tungsten film inside a church. When I woke up the following morning, I chased after the sunrise and finished the remaining seven exposures. As I took the film out of the camera, I realized what I had done and believed that I had wasted those seven shots, thereby missing that morning's sunrise. But the final images were a pleasant surprise. The buildings were blue instead of their usual silver gray, and although I didn't record the red-orange sunrise, I did get an appealing pinkish-purple shade. ◆ For this shot, I loaded my camera with ISO 50 tungsten film, chose a 28mm lens, and mounted both on a tripod. Next, I composed from the west end of the bridge. From this vantage point, I was able to shoot into the sky and capture a sweeping vista because of the 75-degree angle of view my 28mm lens provided. My starting exposure, metered for the sky, was *f*/8 for 1/8 sec. ◆ But I wanted to record a detailed exposure of the bridge and roadway. So I pointed my camera at the bridge only. Now the meter indicated an exposure of *f*/8 for 1 sec., a difference of three stops. Since I didn't want the sky to be overexposed by three stops, I placed a graduated neutral-density filter on my lens. I then aligned the filter in its holder so that it extended only into the distant but brighter sky. The filter reduced the light transmission by two stops. When I received the processed film, I was pleased to see the much-anticipated "blue" bridge.

Following a clear yet cold night, I woke up to a landscape covered with a thick layer of frost. I quickly mounted my camera and 55mm macro lens on a tripod and rushed out the door. I knew that I would find an abundance of picture-taking opportunities. Both frost and snow impart a newness to the landscape that is exciting to shoot. ◆ Coming upon a window in my barn, I was soon mesmerized by the intricate and delicate frost patterns. With the aperture set to *f*/8 and the shutter speed to 1/60 sec., I shot frame after frame until I was rudely awakened: I couldn't advance the film any further. The top picture is one of the images on this roll. Reaching into the small bag that sat at the base of the tripod, I searched for a new roll of daylight film to find that I had only one roll of ISO 50 tungsten film. Rather than run back to the house, I decided to experiment once again. I eagerly awaited the developed film. I knew that this frost would record on film as blue, enhancing its beauty, as you can see in the bottom shot.

PUSHING AND PULLING FILM

As the tour bus pulls into the parking area, your heart begins to race. Looking out the bus window, you see your eagerly awaited destination: majestic, imposing Salisbury Cathedral in Salisbury, England. As you walk around the grounds, you decide to frame the cathedral with tree limbs in the foreground. Later, you move into the nearby flower garden and use flowers as foreground interest to bring depth and perspective to the composition. Next, as you enter the cathedral through its heavy, solid-wood doors, you are immediately taken by the immensity and beauty of the architecture. Stained glass surrounds you, marble floors support you, and row upon row of church pews with finely detailed woodwork lay ahead of you. Getting ready to shoot this magnificent cathedral, you realize that your ISO 100 film isn't fast enough for a successful handheld shot and that your flash will not cover the church's interior. What can you do? You could switch to a faster film—if you have any with you. Your only other option is to *push* the film.

Pushing film is a simple technique. When you find yourself shooting in low-light situations and don't have your tripod or a fast film, you can "trick" your camera's exposure meter into thinking that you are using a fast film. How much faster? Most films can be pushed two stops. However, a one-stop push might be all you need. Here's how to decide. When you're photographing in low-light situations without a tripod, your major concern is arriving at a safely handholdable speed. Suppose, for example, that you're in the dimly illuminated cathedral. First, you must start with a fresh roll of film; it is impossible to push just one part of a roll and have the remaining part processed "normal." You then need to factor in your lens. Simply put, you have to be able to shoot at a shutter speed equivalent or close to your lens' focal length. Because most interiors are shot with a wide-angle lens, such as a 28mm, assume that this is the lens you are using here. Assume, too, that you have only ISO 100 film.

First, set the film-speed dial to 100 and the aperture to wide open at *f*/3.5. Now what shutter speed is required for a correct exposure? Your meter probably indicates a shutter speed that is slower than the focal length of your lens, such as 1/8 sec. But without a tripod, you need a safely handholdable shutter speed of at least 1/30 sec. You can achieve this two-stop increase by pushing the film. When you turn the film-speed dial to 200, the effective shutter speed becomes 1/15 sec.; then when you move the dial to ISO 400, the effective shutter speed becomes 1/30 sec. This exposure combination, *f*/3.5 for 1/30 sec., meets the criteria of a shutter speed that equals or comes close to the focal length of the lens in use. Remember, though, even if you shoot just a few exposures inside the cathedral, you must either finish the roll with the film speed set at ISO 400 or remove it once you are ready to move on. Mark the film cassette or the canister so that later you will know that this roll of film must be pushed to ISO 400.

Perhaps you are not a world traveler. Are you the official family photographer? If so, you, too, can benefit from pushing film but in a rather unique way. For example, imagine that you just finished shooting two rolls of film at your child's soccer game. Because you wanted to freeze the action, you chose an ISO 400 film and just as you had hoped, the shots turned out fine. Then several weeks pass and you receive an invitation to a neighbor's barbecue and decide to photograph the gathering with a fresh roll of ISO 100 film. Afterward, you return home, rewind the exposed roll of film, pop the camera back open, and then you remember you never changed the film speed from the 400 you used at the soccer game to the speed of the film, ISO 100. All you have to do is take the roll to a camera store and explain that you want the film pushed to ISO 400. While this mistake can be rectified, pushing the film will usually add to the price of processing. But this is immaterial compared to the trauma of missed shots.

As I stepped outside my studio, I noticed my son sitting alone in the pasture in what seemed to be a contemplative mood. The last few rays of the afternoon light casting their warm glow on him and the surrounding landscape. Not wanting to interrupt his solitude, I stayed low to the ground behind the large black-walnut tree. I purposely chose to use a 400mm lens in order to limit depth of field and to fill the frame—without my being spotted. ◆ However, as I began to determine the exposure, I realized that the ISO 50 film in my camera was preventing me from shooting at a fast shutter speed safe for handholding the camera. Since this was a fresh roll of film, I decided to push it to ISO 200. The additional two stops of exposure enabled the shutter speed to increase from 1/60 sec. to 1/250 sec. The result: a charming candid of my son.

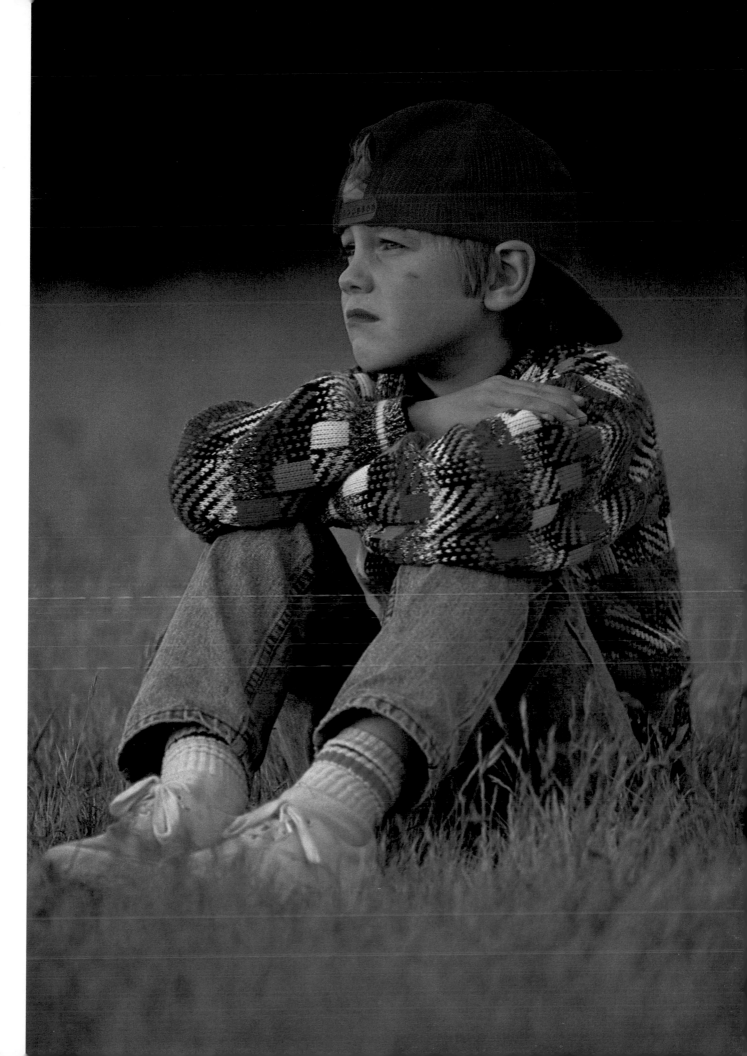

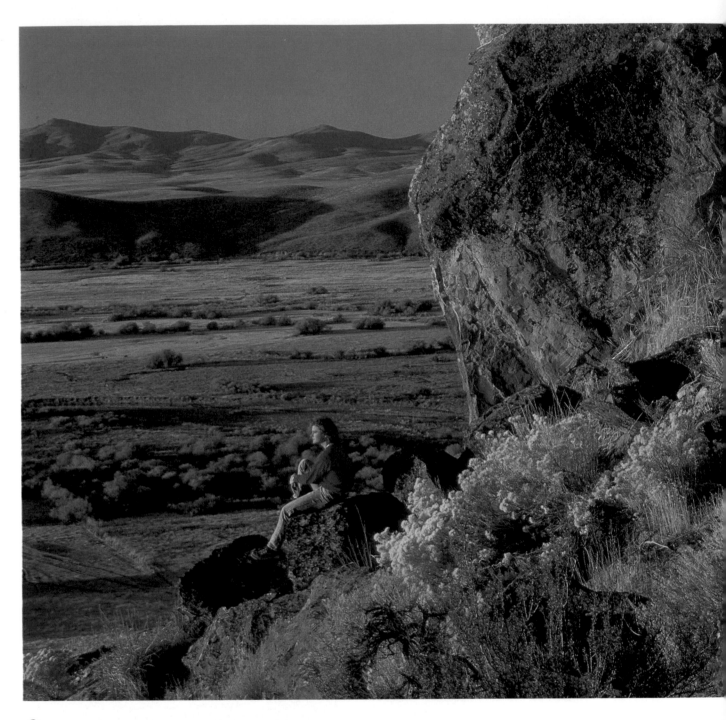

On very rare occasions, I either forget to set the right film speed, or I load the wrong film for my expected subject into my camera. One time, after photographing a rodeo in eastern Oregon for two days with ISO 400 film, I was ready to shoot stationary subjects again. I find that landscapes, which of course don't move, make composing success-fully much easier. ✦ For this shot, my friend Ken sat on a rocky outcropping as I mounted my camera, loaded with Fujichrome 100—or so I thought—and 50mm lens on a tripod. After shooting the entire roll, I rewound the film and was stunned when I realized that I had actually shot a roll of ISO 400 film. Somehow, a roll of ISO 400 film had managed to find its way into the com-partment reserved for ISO 100 film. In effect, then, the whole roll I had just shot would be two stops overex-posed if I were to have it developed "normal." By tell-ing the lab staff to pull the ISO 400 film to ISO 100 during developing, I was able to save this roll. As you can see, the pulled images turned out fine.

Although pushing film can often come to the rescue, there are some limits. You can't push a roll of film in midstream. For example, if you've already shot ten exposures on a roll of ISO 100-24 exposure film, you can't just move the film-speed dial to 200 and continue. You must start with a new roll of ISO 100 and shoot the entire roll at the desired pushed speed of 200. Because the actual pushing takes place during processing, it's impossible to separate exposures that require one developing time from those requiring a longer developing time. Also, after you shoot a roll at a pushed speed, mark the "new" speed on the film container.

Another limitation is that not all films can be pushed. Fujichrome, Ektachrome, Agfachrome, and Fujicolor films can be successfully pushed up to two stops past their assigned speed, while Kodacolor and Agfacolor films can be pushed successfully by only one stop. On the other hand, pushing Kodachrome film is out of the question. Finally, even though good exposures can result from pushing film, you must anticipate an increase in grain. For example, when you push an ISO 100 film to ISO 400, the film assumes the grain pattern of an ISO 400. I want to point out, however, that grainy pictures aren't necessarily bad. When you deliberately push film, such as Fujichrome ISO 400 to ISO 1600, the grainy effect that results can be truly satisfying, especially if used for the right subjects: nudes, flower closeups, still lifes, or even some landscapes. Try pushing a roll of ISO 400 film to ISO 1600; you just might get hooked on "going against the grain."

Pulling film is the opposite of pushing film. However, this technique is rarely a deliberate choice. It usually results from an incorrect film-speed setting. Suppose that just after finishing a roll of ISO 400, you notice that the film-speed dial is set at ISO 100. In effect, then, all of the pictures on this roll would be two stops overexposed if it were processed "normal." But because you caught your mistake before having the film processed, you can simply explain the problem to the salesperson at the camera store. He or she would then write on the photofinishing envelope "pull to ISO 100." The lab would then know to develop the roll as if it were ISO 100. This will correct the problem of the two-stop overexposure.

EDITING YOUR IMAGES

In all honesty, most if not all photographers average about three really strong images per roll. As a result, ruthless editing is a must. Like me, you have probably sat through a slide show or flipped through the pages of a neighbor's photo album, only to witness countless variations on the same theme. For example, after looking at seven different viewpoints and exposures of your neighbor's family standing near the North Rim of the Grand Canyon, you are treated to nine different postures of the much-talked about rainbow that arched across the deep crevices and plateaus. Out of all these photographs, you might remember the one outstanding rainbow shot—if you haven't become too restless.

When you consider why you love photography, I seriously doubt it is because a neighbor was anxious to share his or her vacation photos with you. Odds are that your passion resulted from seeing one or two truly outstanding pictures at a poster gallery or many different photography books. My point is that "good" photography doesn't have to be explained, nor does it require a cast of characters, such as bad exposures or various points of view. If necessary, ask your local camera retailer to assist you in picking out the best two or three shots from each roll. Include only these images in your photo album or slide show. Even though your "inventory" might appear to be sparse, I guarantee that you'll leave a positive and lasting impression on those who view your pictures.

Like so many other working professionals, I ruthlessly edit my work. Do you think I want to share my "gremlins" with anyone else? I get a certain amount of pleasure when I show my work to groups outside the photographic community. Almost everyone comments on its "beauty," "drama," "vivid colors," and "striking and graphic compositions." Little do most of these people know how many slides I took and later threw away in order to show that one great image.

STORING YOUR WORK

Storing slides or color negatives doesn't have to be a complex, laborious task that spoils your enjoyment of photography. You have several options. You can keep slides in a carousel slide tray or leave them in the slide boxes; all you have to do is mark each tray or box with identifying information, such as subject and date. I pre-fer to keep my slides in clear-plastic pages of archival quality. Each page holds twenty slides, and by simply holding a page up to a light source, I can quickly locate a particular image. When purchasing plastic pages, don't buy ones made of polyvinyl chloride (PVC). PVC pages have a tendency to trap moisture between the slide pocket and the slide, which is the fastest way to ruin slides. (Also, overexposure to light, either natural sunlight or light from a projection bulb, can be damaging. If you frequently project your slides, I recommend that you make *duplicates*, or *dupes*, of your slides. This is an easy process that a camera store's lab can do.)

Once you store your edited slides in plastic pages, place them in a three-ring binder according to subject. When you first start out, such simple categories as people, landscapes, recreation, and closeups make locating images easy. However, as your number of slides increases, you'll find it advantageous to expand your category descriptions, making them more specific: children, adolescents, adults, seniors, mountain landscapes, coastal landscapes, desert landscapes, cityscapes, boating, swimming, skiing, tennis, soccer, flowers, butterflies, insects, and so on.

If you shoot color-print film, perhaps you've had the unpleasant, time-consuming experience of trying to track down a negative of a family outing to Devil's Tower in Wyoming. Your sense of frustration was probably at an all-time high, especially when you found the somewhat battered and bruised negative in the silverware drawer after a long search. The principles of ruthless editing apply to color negatives as well. Take those negative strips that contain your best images to your local camera store and have a *color contact sheet* made. This is an 8 × 10 piece of paper that records all of the images on the negative strips at the same size as the negative, but in a positive form. Next, place the color negatives into sleeves in archival-quality negative pages and attach the corresponding contact sheet to it, and then put them both in a three-ring binder. The visual aid of the color contact sheet makes finding the right negative much easier later.

In spite of what you might have heard at your local camera shop or camera club, or even what you have just seen and read here, I don't want you to settle on any absolute formulas. Being willing to experiment with slow, medium, and fast films will lead you to creative discoveries that you would otherwise miss. Trying new films and new ways to use your favorite films is one of the best ways to improve your photography.

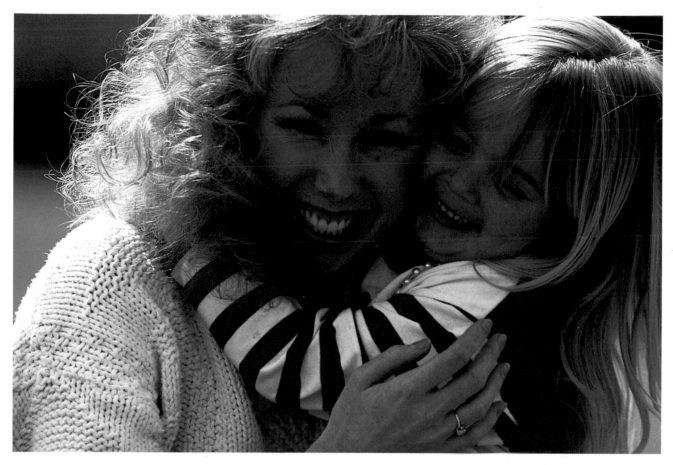

How many zingers—strong photographs—do you average per roll of 36-exposure film? Different students have told me that they get about 9, 11, 17, 26, and 31 great shots per roll. These figures are too high. By the end of a workshop, students agree that they need to be more ruthless when editing their work. I average three zingers per roll. The problem may be the exposure, the lens, the light, or any number of possibilities. Rare is the photographer who can produce more than five zingers per roll. ◆ Photographing Chris and her daughter Katie is always a delight. When Katie is in a playful mood, she keeps her mother occupied and the resulting images are spontaneous. During the editing process, I eliminated 33 out of 36 exposures. Either the exposures were a bit off, Chris and Katie's gestures weren't quite right, or their expressions weren't in sync. Of the three remaining shots, I think that the top photograph is the best. The only problem with the others is the location of Chris's hand. In the center shot, she appears to be looking at it, and in the bottom shot, her hand is cut out of the frame a bit too much.

SPECIAL
TECHNIQUES

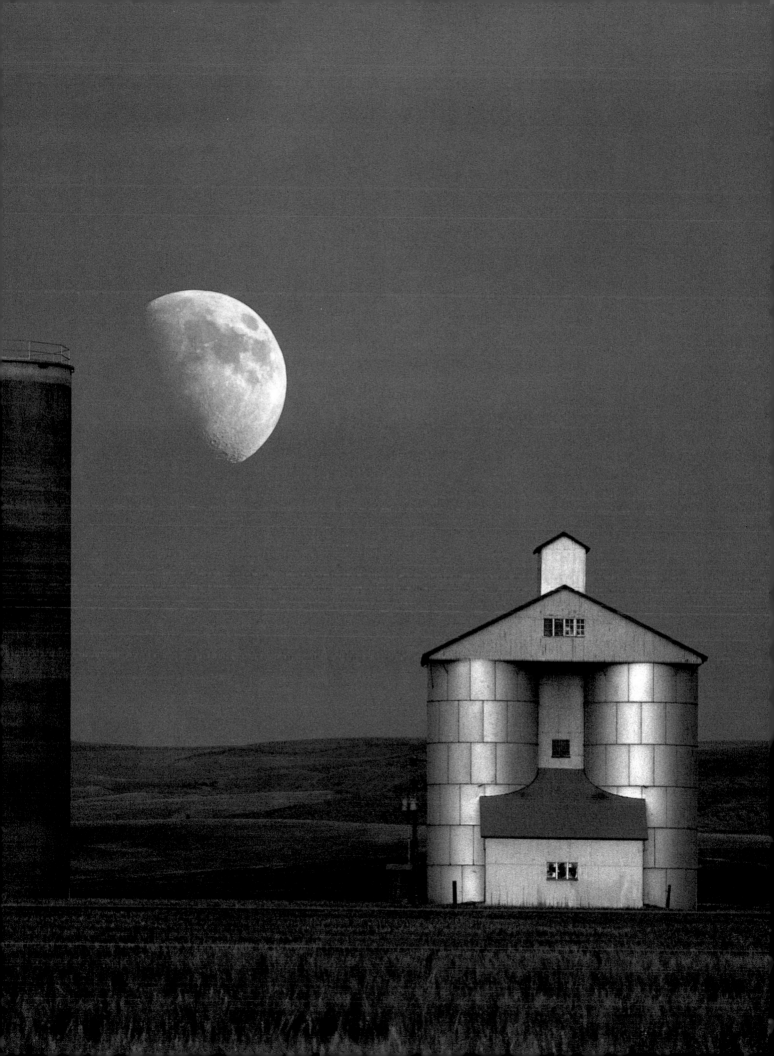

Some people are quite content with the basic car. You know which car I mean: the stripped-down model that always shows up in Saturday's paper for a ridiculously low price. When I responded to just such an ad several years ago, the salesperson told me that the basic car "will get you where you want to go and back again." He was right. I looked at the car but couldn't find a radio, carpets, side mirrors, side mouldings, a cigarette lighter, or even wheel covers. If I wanted any of these "extras," I would have to pay extra for them. You can compare what I have said about exposure to this stripped-down model of a car. Everything that I have shared with you up to this point is solid, yet basic information.

Now I want to show you how to add some "extras" to your understanding of exposure. These include deliberate underexposure, overexposure, double exposures, and multiple exposures. To add "wheel covers, pinstriping, and special paint" to your compositions, you need to use the moon and stars as well as colored filters. If you explore and master these creative options, your compositions will have the extra edge that garners additional attention.

Whenever you shoot, you should ask yourself, "What if . . . ?" This will lead you to exciting discoveries and new approaches. As I focused on this bright yellow lily, I thought to myself, "What if I shoot this single flower in focus and then shoot it again on the same frame out-of-focus?" I thought that the resulting image would be a zinger. ✦ With my camera and 300mm lens mounted securely on a tripod, I set the aperture to f/5.6. Next, I adjusted the shutter speed to 1/250 sec. as the meter indicated. After I fired the shutter, I pressed the double-exposure button and reset the aperture to wide open, f/4. ✦ This one-stop increase in aperture size required a one-stop increase in shutter speed to keep the exposure constant. Therefore, the second exposure was f/4 for 1/500 sec. With a simple turn of the lens' focusing barrel, I threw the flower out-of-focus. The last step was, of course, to fire the shutter. I was quite pleased with the soft quality of this deliberate double exposure.

While weeding in my flower garden, I noticed this shasta daisy illuminated by a single shaft of light from the midday sun. Surrounding the petals were large expanses of open shade. Once again I seized the opportunity to shoot a lone, highlighted flower against a sea of black. ✦ With my camera and 55mm macro lens mounted on a tripod, I set the aperture to f/32 to achieve maximum depth of field. I then adjusted the shutter speed until 1/60 sec. was indicated. But I wanted to shoot a one-stop underexposure, so I changed the shutter speed to 1/125 sec. This deliberate one-stop underexposure enabled me to correctly expose for the flower and at the same time, to render the areas of open shade even darker. This technique produced a background that contrasted sharply with the subject.

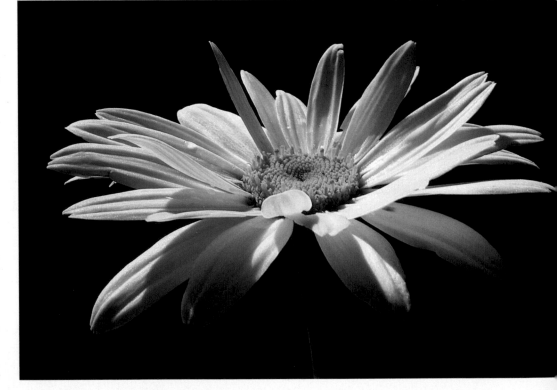

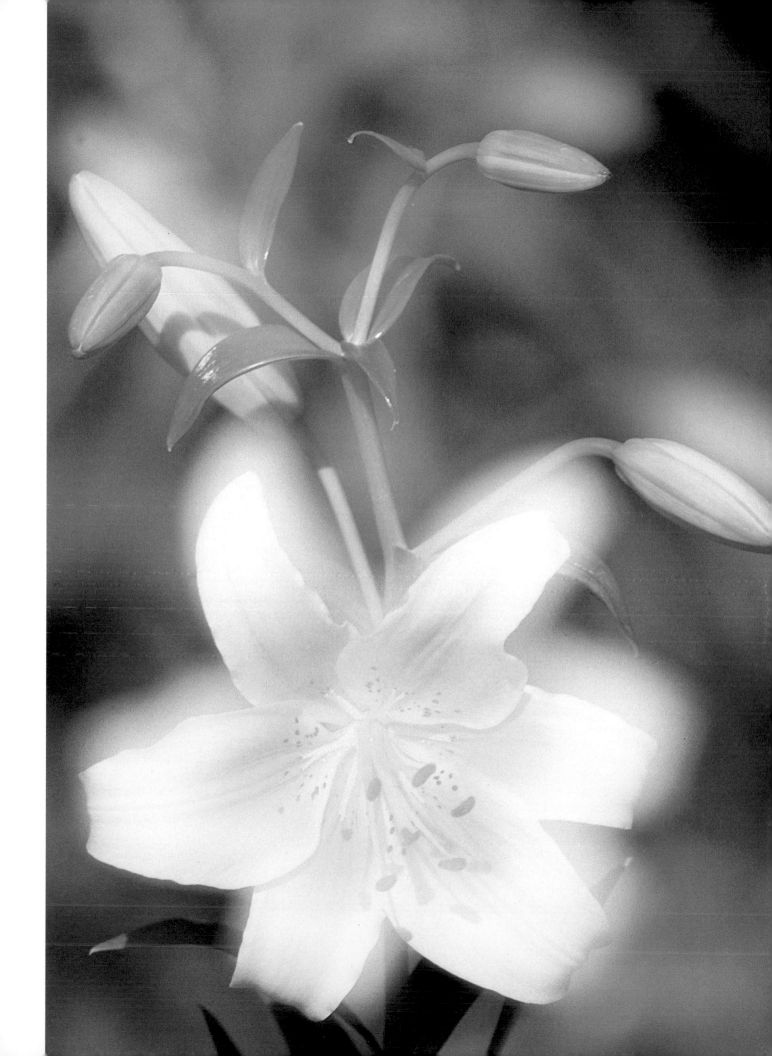

DELIBERATE OVER-
AND UNDEREXPOSURE

This exposure technique is seldom practiced by slide shooters with much enthusiasm. But the effect can be arresting. Several years ago, I came across a book written by New York photographer Robin Perry. Although I don't remember the title, I do remember that it was amply illustrated with "tricks" and techniques to which I am indebted. One such technique was overexposure. Perry included variations of an image of a model: intentionally thrown out-of-focus, intentionally shot at $f/26$, and intentionally overexposed by four or five stops. The overexposed result showed the model as a striking stick figure that reminded me of old pencil drawings of fashion models. Nudes, busy and colorful street scenes, and fields of flowers look wonderful when overexposed by four or five stops, whether they are in-focus or out-of-focus. It is important to note when shooting deliberate overexposures that you must choose a subject or subjects that are sidelit. The combination of light and shadow that sidelighting provides enhances the effect because of the different tones.

Unlike deliberate overexposure, this technique is practiced by experienced slide shooters worldwide. The purpose behind deliberate underexposure is to increase color saturation of the overall scene. Both backlighting and sidelighting provide opportunities for deliberate underexposure. One of the most common scenes—used without fail by two well-known nature-calendar companies—is a backlit autumn leaf against a pitch black background. Amateur photographers often think that the darkness of the background is an effect achieved with electronic flash. Although this is possible, nothing compares with natural light and deliberate underexposure.

When you see photographs like that of the leaf, do you ask yourself how they were shot? Here is another example of how your vision can actually impede your progress toward making creative exposures. If you had been there when the photograph of the leaf was taken, would you have seen anything that resembled a black background? Most likely, you would have seen only open shade, branches, leaves, and twigs behind the much brighter, backlit leaf. You might have advised the photographer to change viewpoints to prevent ending up with a busy composition. But the photographer didn't switch positions, as the finished picture proves. So what happened to the open shade and the busy background? They never had a chance to record on film because the exposure was set for the much brighter highlight. When an exposure for a highlight is at least three stops greater than that for surrounding open shade or shadows, these areas fade to black.

Consider another example. Suppose you come upon a cotton-candy stand at a local fair. As you face the vendor and his colorful display of pink "clouds," you notice that he is illuminated by sidelighting. Directly to his left is a large circus tent that casts a large area of shadow behind him. With a telephoto lens and a "who cares?" aperture, you move in close and take a meter reading off the vendor's sunlit clothing or skin tones. (If you want to shoot a candid, place the back of your hand in front of the lens so that the sunlight falls on it and take a meter reading off your hand. It doesn't have to be in focus.) Make several exposures at the indicated reading as well as several others underexposed by one stop. Even though you can see behind the vendor and into the area of open shade, the underexposed film will record it as very dark or black. To ensure that the scene will contain a dark or black background, take two separate readings: one from the highlight area and the other from the area of open shade. How far apart are these stops? If there's a difference of three or more stops, the final image will contain the darker background.

You are probably wondering, "If I can record bright, vivid subjects in front of black backgrounds, can I also record them behind black foregrounds?" Sure! For example, suppose that you're on vacation in Paris. From inside your hotel room, frame the Eiffel Tower with the window. Move up to the window and set the exposure for the much brighter light outside. Next, scoot back a bit from the window and frame it around the tower. The result: a black shape in the form of a window in the foreground frames the distant tower. Now suppose that you're vacationing near Rapid City, South Dakota, and want to shoot Mount Rushmore, one of the most-photographed monuments in the United States. Unfortunately, most amateur photographers pull into the main parking lot, raise the camera to their eye, and shoot the "postcard" image. To achieve an inventive shot, you can move away from the crowds. As you continue driving on the main road heading south, you pass through one of the area's many tunnels and notice the mountain in your rearview mirror. You pull over and take a meter reading of the mountain. With your exposure set, you walk a few feet into the tunnel until its oval shape frames the mountain. Your photograph of Mount Rushmore reveals a new and exciting point of view, complete with a black foreground.

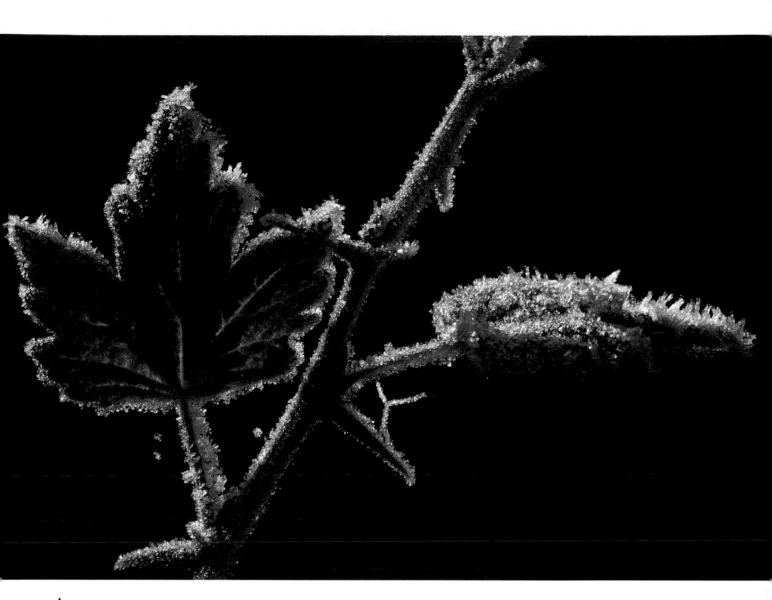

Although I'm not a fan of typical Oregon winters with all of their rain and rather mild temperatures, I rush out the door when I see a heavy frost on the land-scape. Several years ago, I woke up to such a morning and without any hesitation, I meandered across several fields near my farm and pho-tographed more than seven rolls of film over a few hours. The strong backlight that fell on the field pro-duced some wonderful com-positions as well as some great opportunities for crea-tive exposure. ◆ This photograph of a blackberry vine is one example. I fo-cused my macro lens on just several leaves on the vine. What intrigued me most was the area of open shade be-hind the leaves. As I moved in close to fill the frame with only these two backlit leaves, I adjusted the shut-ter speed until 1/30 sec. was indicated as correct. ◆ To further emphasize the dark background, I changed the shutter speed to 1/60 sec. to underexpose the scene by one stop. I then recomposed and fired the shutter, assured that the background would re-cord as black.

BRACKETING

If you have any doubt about determining a correct exposure, bracket. *Bracketing* is the practice of photographing a subject at exposures other than the exposure recommended by the meter, such as two stops overexposed, one stop underexposed, and two stops underexposed. However, you might be wondering, "Should I bracket with the shutter speed or the aperture?" This valid question is often the source of confusion.

The first question you should ask yourself is, "What creative effect do I want to achieve?" Do you want extensive depth of field (for storytelling imagery), limited depth of field (for singular-theme shots), or "who cares?" apertures? Do you want to freeze action, pan a moving subject, intentionally blur a subject, or imply a subject's motion by shooting with your camera secured to a tripod? Obviously, if you want a great deal of depth of field, you use an aperture of either $f/16$ or $f/22$, so the shutter speed plays the primary role in completing the exposure. Conversely, if you want to use the shutter speed creatively, such as by panning, you set the shutter speed and rely on the aperture to bring the exposure to a close. In the first example, bracketing is performed by the shutter speed: shooting at the indicated exposure, as well as at one or two shutter speeds faster and one or two shutter speeds slower than that exposure. In the second example, bracketing is performed by the aperture. Here, you shoot at the indicated exposure, as well as at one and two f-stops larger and one and two f-stops smaller than the indicated f-stop.

Not every scene, though, needs to be bracketed to such extremes. For the most part, extreme bracketing is reserved for compositions of sharp contrast, such as bright sunlight filtering through trees in a forest. Because the scene is composed of bright shafts of light and deep shade and all of the tones in between, bracketing in this situation enables you to record a range of exposures. Then, after you have the film processed, you can better decide which exposure is best. Don't feel discouraged because you had to bracket. It takes many months, if not years, of experience to know which single exposure is correct in a case like this. Even so, many experienced professionals still bracket around the indicated reading just to be safe. The old saying that film is cheap in comparison to the trauma of a missed shot is never more true than in such shooting situations.

More conservative bracketing is reserved for scenes that are fairly evenly illuminated. Just think of the beauty and softness of the light created by a bright, overcast sky. Whether you are shooting portraits, flowers in your garden, or candids of your children at a local park, no harsh shadows or areas of bright sunlight exist. Under these conditions, slide shooters can photograph at the indicated exposure as well as at one stop under if they want a bit more color saturation. Print shooters, on the other hand, can shoot at one-stop overexposure in addition to the correct exposure indicated by the exposure meter. The overexposed negative is then custom-printed, which results in a greater saturation of color on the finished print. Because deliberately underexposing color-print film produces a "thick," or dense, negative, which is difficult to print, this is seldom done. Like an unusually dark pair of sunglasses, a thick negative doesn't permit enough light penetration to all areas of the image when it is printed in a color enlarger at the lab.

Bracketing simply means shooting a scene at various exposures. First, you determine the indicated exposure and then shoot several exposures above it to overexpose the scene, and then several below the indicated reading to underexpose the scene. While people suggest bracketing whenever you're in doubt, I don't agree wholeheartedly with this advice. I believe that you should bracket only when extreme contrast exists. ◆ While on assignment in Cancún, Mexico, I noticed that the swimming pool at my hotel was designed in such a way that when viewed from the west looking to the east, it seems to merge with the distant ocean. One morning, I decided to shoot a pleasing composition with a 35mm lens. I chose a low viewpoint from the west end of the pool and composed the rising sun. This ensured that the pool and its mirror image would reflect the various colors of the early-morning sky. But because of the wide range of tones in the sky, as well as the reflection in the pool, I decided to bracket the exposure. After shooting at the indicated exposure of $f/16$ for 1/125 sec. (bottom left picture), I shot at $f/16$ for 1/60 sec. for a one-stop overexposure (top right picture), at $f/16$ for 1/30 sec. for a two-stop overexposure (top left picture), and at $f/16$ for 1/250 for a one-stop underexposure (bottom right picture). I prefer the image that was overexposed by two stops.

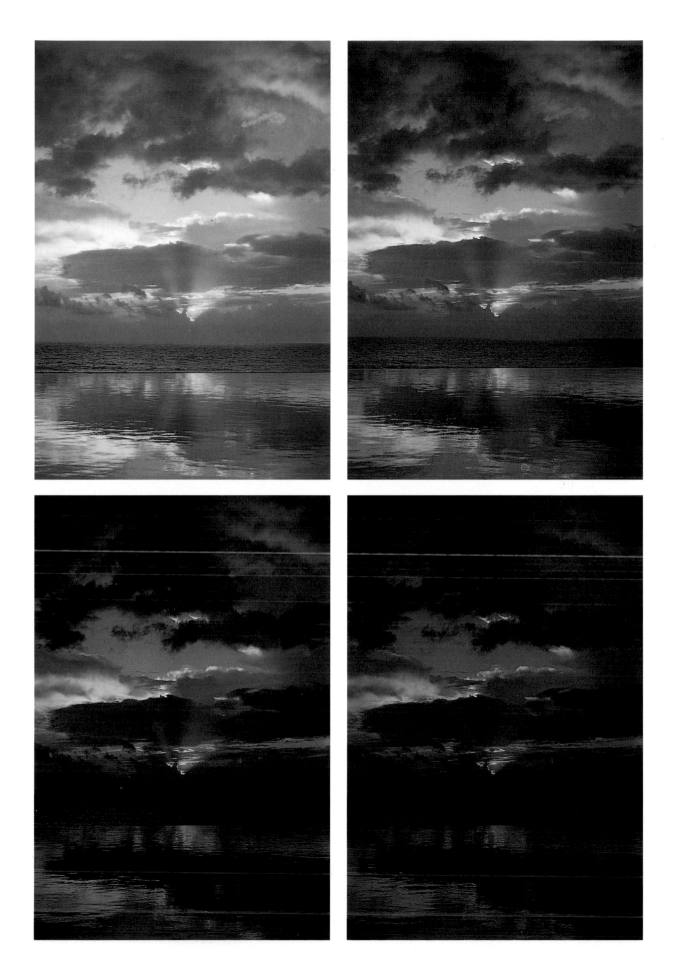

Like forests bathed in sunlight, street scenes at night are filled with contrast. As a result, both subjects can benefit greatly from bracketing. Evening cityscapes contain a range of tones, from the bright neon signs to the dark sidewalks. Shooting just one exposure under these conditions is hardly the norm for any serious photographer. This is one time when it is essential to remind yourself that film is cheap compared to the trauma of a missed shot.

◆ With my 80–200mm zoom lens set at 200mm and my camera mounted on a tripod, I composed this street scene in London's theater district. Regardless of what my exposure meter indicates in lighting conditions of extreme contrast, I always bracket; I underexpose several shots by one and two stops, as well as shoot several exposures one and two stops over the indicated reading. Here, with the aperture set to $f/11$, the meter indicated a correct exposure at 1 sec. So I first photographed this scene at $f/11$ for 1 sec., and then at $f/11$ for 1/2 sec. for a one-stop underexposure, at $f/11$ for 1/4 sec. for a two-stop underexposure, at $f/11$ for 2 sec. for a one-stop overexposure, and finally at $f/11$ for 4 sec. for a two-stop overexposure. The darker image on the opposite page, exposed at $f/11$ for 1 sec., is the "correct" reading. The lighter image on the right is the two-stop overexposure, $f/11$ for 4 sec., and is the shot I prefer because it reveals more detail.

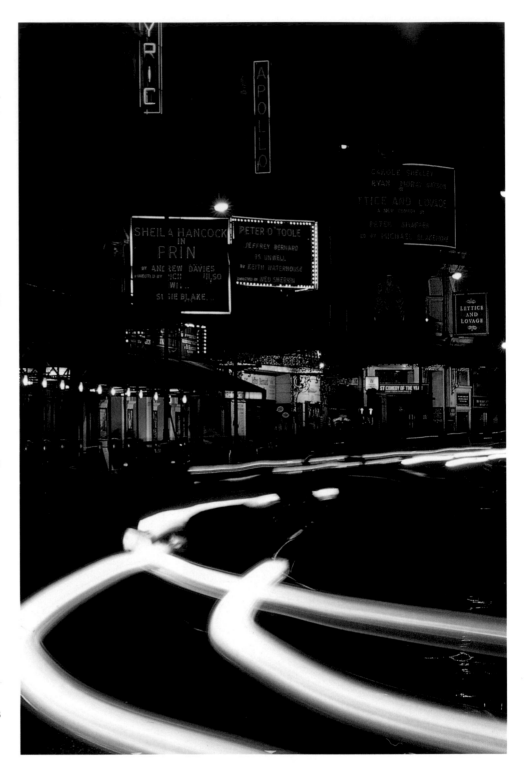

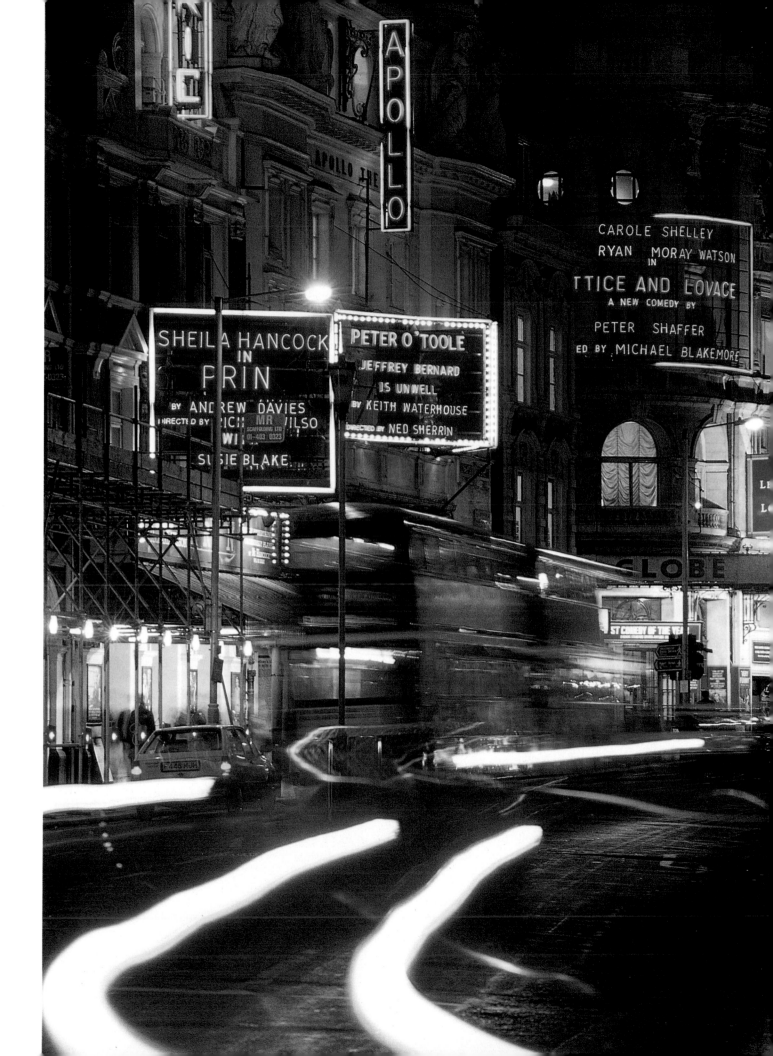

SHOOTING THE MOON

Have you ever been driving at dusk and out of nowhere appears a giant, yellow-orange full moon over the eastern horizon? The first time this happened to me, about fifteen years ago, I was on an outing in Eastern Oregon. I was heading west on a typical, lonely desert road, satisfied with the photographs I had just shot including the ones of the sunset. Suddenly, my eyes darted to the rearview mirror where I saw a large, yellow-orange globe. At first, I thought it was a UFO, but then I realized that it was the moon—a huge moon like I had never seen before. I immediately slammed on the brakes, jumped out of the car, and hurriedly set up my camera and tripod. And then it hit me: what exposure should I use? I knew that I should bracket the exposure (see page 132), so I shot more than twenty frames, all at different exposure times.

But the processed film proved that these were all the wrong exposure times. I was under the impression that shooting the moonrise called for long exposures using shutter speeds of 15, 20, 30 seconds and more. But I didn't know that when exposures are this long, the moon records on film not only as a gross overexposure but also as an egg-shaped object because the earth moves continuously. After doing extensive research on lunar-landscape exposures, I learned that they should be treated no differently from a frontlit landscape without a moon. Because lunar landscapes are bathed in the light remaining in the western sky, they are frontlit. And, during the first fifteen minutes immediately following the sunset, the light in the eastern sky has the same value as the landscape below. As a result, lunar landscapes can be metered the same way frontlit landscapes are. When shooting a frontlit landscape, I usually take my meter reading from the blue sky overhead. Because its reflected-light value is very similar to that of a gray card, I'm certain that the indicated meter reading is as close to correct as I can achieve. (If I choose, I can use this reading as a starting exposure and then bracket as well.)

Several other tips can also make shooting lunar landscapes easier and more rewarding. To get a large enough moon on film, you have to use a telephoto lens, preferably 200mm or longer. When you shoot the moon with a normal or wide-angle lens, it looks like a white or yellow-orange speck of dust. When using a telephoto lens, take the meter reading off the sky to the left, to the right, or above the full moon—just as you do when metering a sunset. Also, don't get caught off guard— buy a calendar that indicates the date of each month's full moon. If weather and time permit, scout out your location several days before the moon is full to see if the barn, oak tree, or city skyline you want to include is effectively aligned with the moonrise. I recommend shooting the lunar landscape the day before the full moon. Keep in mind that the landscape below and the sky above require the same exposure time the day before a full moon as they do on the actual day. Finally, you can increase your inventory of lunar landscapes if you have the energy and discipline to wake up early and shoot an hour before sunrise. Compose the moonset against the front-lit landscape, metering the light just as you would for a moonrise.

Exposing for the moon is easy. Once you determine which night has a full moon and select the composition, you need only to know what the exposure for the moon should be. (I'm assuming that you have already read about and understand how to take a meter reading for night cityscapes.) Using an ISO 50 film, adjust the aperture to $f/8$ and the shutter speed to 1/125 sec. With an ISO 100 film, set the aperture at $f/8$ and the shutter speed at 1/250 sec. With an ISO 200 film, set the aperture at $f/8$ and the shutter speed at 1/500 sec. Finally, if you use an ISO 400 film, set the aperture at $f/8$ and the shutter speed at 1/1000 sec. When you use these settings, the exposure meter indicates a severe underexposure because the great expanse of dark sky surrounding the moon influences the meter. Even though the meter might make you think that these exposure settings are wrong, just ignore its warning and press the shutter-release button. This will produce a full-moon exposure. Obviously, this idea is not limited to cityscapes. I have successfully made double exposures of the moon with farm scenes, as well as images of the moon suspended above the tops of snowcapped peaks.

Another popular idea for double exposure is combining an out-of-focus image of a flower with an in-focus image of it. This technique results in an almost dreamlike effect. It is important to work with subjects that are in full sun, preferably of high contrast. Again, set both exposures one stop under the indicated meter reading.

Here's another visual technique for shooting great double exposures at Christmas time. As already discussed, any out-of-focus spot of light assumes the shape of the aperture, so take out your closeup lens, put it in the close-focus position, and from a distance of 10 feet, point it at the Christmas tree. With all lights in the room off except the tree lights you will see wonderful out-of-focus spots of color. With the aperture set to wide open, fire off one exposure at one stop under the indicated reading. Next, turn on the room lights, switch to a wide-angle lens, mount the camera on a tripod, and shoot a one-stop underexposure of the in-focus tree. The result will be a magical Christmas-tree picture you'll be proud to send out as your annual greeting card the following year.

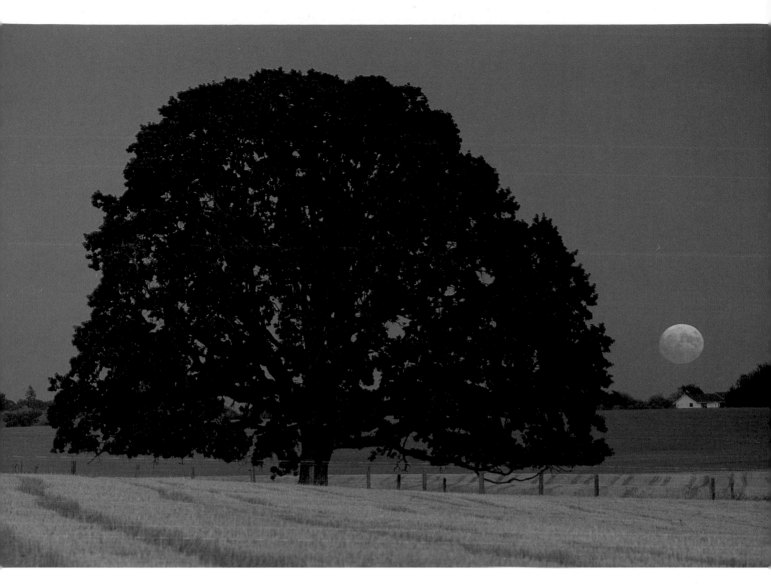

While many photographers watch the full moon as it rises, few photograph it because they aren't sure how to meter the scene. Surprisingly, however, moonrises are easy to expose for. They are actually just front-lit scenes, and the low-angled light following sunset evenly illuminates both the sky and the landscape. This lighting condition is similar to overcast conditions. The only possible difference is that the exposure times for a moonrise might be a little longer because the light levels after the sunset are relatively low. ◆ Having checked the date of this moonrise and selected this location, I headed out the door determined to photograph the moon (the day before it was full, of course).

Upon arriving, I set up my camera and 300mm lens on a tripod. I set the aperture to *f*/8 as I composed this large oak tree. Depth of field wasn't a concern because both the tree and the house rested at infinity. ◆ Once the sun had set behind me, the moon began to come over the horizon, almost like clockwork. As soon as the moon was high enough above the horizon, I needed only to calculate the exposure. With my aperture set to *f*/8, I pointed the lens at the part of the sky above the tree and adjusted the shutter speed until 1/8 sec. was indicated as the correct exposure. I then recomposed the scene and, using the camera's self-timer, fired the shutter-release button.

While on assignment in the Caribbean, I had another opportunity to photograph a moonrise—the day before the moon was actually full. After I finished shooting the sunset on the small island I was staying on, I raced about 300 yards to the eastern shore and immediately decided to include this house in the composition.

✦ As I set up my camera and 105mm lens on a tripod, I patiently waited for the moon to peak over the horizon. The moon rose within a few minutes. With the aperture set to *f*/16 and the depth-of-field scale preset to ensure maximum sharpness, I tilted the camera toward the sky and adjusted the shutter speed until 1/2 sec. was indicated. I then recomposed and with the camera's self-timer, recorded this tranquil scene.

After completing an assignment for a mining company in Oregon's Jordan Valley, I decided to stay a few extra days to photograph some stock shots of the desert landscape. I drove to a large outcrop about half an hour before sunset. I wanted to have plenty of time to compose using my camera and 35mm wide-angle lens mounted on a tripod. Once the sun had set behind me, the moon appeared above the horizon. Within minutes, it rose far enough so that I could include the moon, the sky, the rocks in the immediate foreground, and the town in the picture. With the aperture set to *f*/16, I preset the focus via the depth-of-field scale. I wanted to expose for the sky, so I tilted my camera above the horizon line and adjusted the shutter speed until 1/8 sec. was indicated.

Next, I tilted the camera below the horizon line; this filled the viewfinder with the foreground rocks and the town, as you can see on the right. Here, the exposure was *f*/16 for 1/2 sec., a difference of two stops. ◆

For the shot below, I placed a filter holder in front of the lens, slid a Cokin G-2 graduated filter in the holder, and pressed the depth-of-field preview button while aligning the filter. This kept the area of density at and above the horizon line. Because using the filter produced a 2-stop reduction in light transmission from the sky, I was sure that when photographed at *f*/16 for 1/2 sec., the sky and the ground would record on film as equal exposures. The picture below is far more compelling than the top shot, in which the sky is overexposed by two stops.

DELIBERATE DOUBLE EXPOSURES

Shooting double exposures can be fun and rewarding. To achieve this effect, you photograph two separate scenes or subjects on the same piece of film. Keep in mind that double exposures often shock and surprise viewers; also, too many double exposures can make each one less dramatic. One of my first attempts at making a double exposure included the American flag. In one composition, an elderly man was sitting on his front porch directly under a flag. I photographed the man and his dog, lying at the side of his chair, first and then made another exposure of the flag alone on the same piece of film. I could have shot a single exposure of the man, his dog, and the flag, but the man's patriotism seemed so intense that I thought it was appropriate to "drape" the flag over the entire frame.

Another double exposure I remember fondly is of a friend. Although this woman lived in the city, she spent almost every waking moment dreaming about the ocean. Her apartment was decorated with sea shells and driftwood, and paintings and photographs of the sea covered the walls. One day when my friend and I were at the beach, I decided to photograph her at sunset. I positioned her so that I could shoot a profile of her head and neck against the much brighter, backlit sky. By using a 200mm lens, I was able to completely fill the frame with her silhouetted profile. I quickly switched to a wide-angle lens and shot the surf, surrounding rocks, and sun so that this image fit inside her profile. When the processed film came back, the photograph showed my friend with the ocean filling her head. We both loved it.

Check your camera right now to see if it has double-exposure capabilities. Unfortunately, not all cameras do. The purpose of the double-exposure feature is to enable you to shoot two (or more) exposures on the same piece of film. Remember, however, that when you shoot a double exposure, you must pay attention to how the images will overlap. Many compositions are ruined by the misalignment of the two exposures. For example, when I made the double exposure of the elderly gentleman and his dog, I was careful not to cover his face with the stars on the flag.

Despite the need to be careful and precise, you will find that creating a double exposure is easy. You shoot the two compositions at one stop under the indicated reading; this is true for both print- and slide-film shooters. The list of subject matter is endless, but I encourage you to consider several of the following ideas. Cityscapes are popular with the amateur and professional photographer alike. If you are fortunate enough to live near a city that faces east, and if you plan ahead, you can be out shooting the skyline at night with the full moon rising between or above the many skyscrapers. Some ideal cities for this once-a-month event (weather permitting) are Seattle, Dallas, and Houston. You might be wondering how there can be so many shots of American cities including a full moon when most buildings are too tall for a natural moonrise over the city skyline. The answer is simple: the magic of double exposure. I prefer this treatment because I can then decide exactly where I want the moon to be in my compositions.

As I reached the top of an incline on the highway, I saw this brightly illuminated nightscape. I quickly pulled over and mounted my camera and 300mm lens on a tripod. With my aperture set wide open to f/4, I adjusted the shutter speed until 1/4 sec. was indicated as correct. Then I engaged the camera's self-timer and tripped the shutter release. This first exposure is above on the left. ◆ Next, while pressing the double-exposure button, I advanced the shutter without advancing the film. I was ready to take the second exposure, using the same f-stop and shutter speed. But for this shot, I deliberately close-focused the 300mm lens; the photograph above on the left shows the resulting out-of-focus circles of light. ◆ For the bottom shot, I tripped the shutter again using the self-timer. The out-of-focus circles were then recorded on the same piece of film as the in-focus buildings. The effect of this double exposure is a city that promises glittering riches.

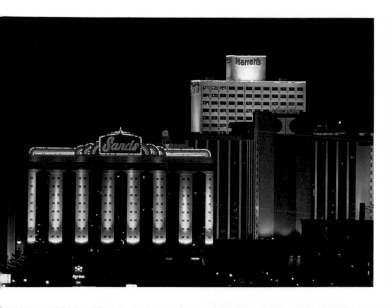

DELIBERATE MULTIPLE EXPOSURES

If taking two exposures on the same piece of film doesn't quite do it for you, how about taking eight, sixteen, thirty-two, or even sixty-four exposures? As long as you press the double-exposure button after each exposure, you can keep placing exposure upon exposure on the same piece of film, thus creating any number of multiple exposures. This sounds interesting, right? For deliberate multiple exposures, which are less common than deliberate double exposures, the same scene or subject is photographed over and over and the camera is moved slightly between shots. First, quickly review the basis for any exposure. This is simply allowing the "right" volume of light (the aperture) to remain on film for the "right" amount of time (the shutter speed); what influences the choice of both of these "rights" is the film speed in use. This speed, in turn, enables the exposure meter to calculate an indicated exposure.

Suppose, for example, that you want to fill the frame with a large display of fruits and vegetables at a country produce stand. The sky is overcast, so making the exposure is easy. Because you are shooting straight down with a wide-angle lens and filling the frame with about a dozen baskets of fruits and vegetables, depth of field is not a deciding factor. Using the "who cares?" aperture of *f*/8, you then merely have to adjust the shutter speed until a correct exposure is indicated. In this situation, the exposure reads *f*/8 for 1/60 sec. on ISO 50 film. Now I have the "right" combination of aperture and shutter speed to make a full exposure.

I'm purposely using the word "full" to make my next point. Assume that *f*/8 represents a volume of water flowing out of a faucet into a one-gallon bucket. In order to fill the bucket with one gallon of water, the shutter speed permits the flow of water to continue for 1/125 sec. So the bucket is filled, or a full exposure is recorded, at *f*/8 for 1/125 sec. You can think of film much the same way you do this one-gallon bucket. Because your goal is to record a correct exposure, (in comparison, to fill the one-gallon bucket with water), does it really matter if the film (or bucket) is exposed (filled) all at once or over the course of many shorter bursts of light (two cups of water at a time)? In other words, if *f*/8 for 1/125 sec. "fills the bucket" all at once, how many exposures are required to "fill the bucket" if you shoot at *f*/11 for 1/125 sec.? Because switching from *f*/8 to *f*/11 divides the light flow in half (the bucket is filled with only a half not a whole gallon of water), you need to take two exposures at *f*/11 for 1/125 sec. to fill the bucket. Shooting at *f*/16, then, requires four exposures to fill the bucket; at *f*/22, eight exposures.

Now you are ready to shoot a multiple exposure. With your camera's double-exposure button engaged, photograph your subject at *f*/22 for 1/125 sec. eight times, with each exposure falling on the same piece of film. To make the final image even more interesting, move the camera before each shot ever so slightly up, down, or diagonally. When making double exposures, keep in mind that lighting does not seem to be a primary concern. I've been successful shooting multiple exposures on overcast days as well as on sunny days when subjects are frontlit or sidelit. Finally, bold colors and patterns are great subjects for multiple exposures.

Why make only double exposures when you can shoot multiple exposures—if your camera has double-exposure capability and a motor drive. A word of warning: deliberate multiple exposures are addictive. ◆ Here, I mounted my camera and 300mm lens securely on a tripod, set the aperture to *f*/32, and composed the graphic shot of row houses in Daly City, California. I then adjusted the shutter speed until 1/15 sec. was indicated as correct. The top photograph is the result. ◆ To create the striking multiple exposure shown directly opposite, I shot eight exposures of the scene on the same piece of film. Realizing that if I were to shoot all eight exposures at *f*/32 for 1/15 sec. the scene would be overexposed by seven stops, I knew that I had to change the shutter speed. So if every correct exposure can be compared to filling up a one-gallon bucket with water, exposing this scene at *f*/32 for 1/15 sec. is like filling the bucket all at once. If I were to fill the bucket with eight separate pints of water, I would have to repeat the process eight times, or shoot eight exposures. Shooting for 1/30 sec. would require two exposures, shooting for 1/60 sec. would require four, and shooting for 1/125 sec. would require eight. For the bottom shot then, I exposed at *f*/32 for 1/125 sec. eight times with my camera in the multiple-exposure mode while moving the camera in a somewhat circular motion.

FILTERS

During the past five years, the camera industry has unveiled literally 101 different filters. Until then, filter choices were limited. Some filters, such as an 80A, are used for color correcting. Similarly, a deep blue filter is used when you shoot daylight-balanced film under tungsten light, and an FLD filter is a magenta filter used when you shoot daylight-balanced film under fluorescent light. Black-and-white photographers call upon red or yellow filters to increase the contrast between the whites and blacks in a scene. And occasionally when they shoot portraits, they use green filters to bring out facial texture. Of course, when color and black-and-white photographers shoot sidelit landscapes that include large cumulus clouds, they prize their polarizing filters. By simply turning this filter, you can make puffy white clouds appear almost three-dimensional and turn the lighter blue patches of sky into a much deeper blue.

Today it is quite common to walk into a camera shop and learn about another "new and exciting, you just have to buy it" filter. In fact, there is a filter that can actually make a rainbow magically appear in your composition. While some photographers think that such filters are just gimmicks, I believe in using whatever filter effects make you happy. So if creating a cross on every highlight, framing a heart around a subject, making a stationary object appear to be moving at 90 miles per hour, or even making a rainbow appear out of nowhere, why not? I only caution you to use the many different special-effects filters with some reserve. You can easily become almost fixated by them, so much so that you pass up many opportunities to compose and expose the natural world. This might surprise some of you, but I don't have thirty or forty filters at my disposal. I have only five, three of which I feel no photographer should be without.

When faced with a backlit landscape, you don't have to lose the area below the horizon to underexposure. Using a graduated neutral-density filter eliminates this problem. ◆ I photographed this wine-country scene while on an assignment designed to promote Oregon tourism. I used a Cokin G-2 graduated gray filter. While it isn't a true graduated neutral-density filter, it is close—and you

don't have to resort to gels. The G-2 filter reduces strong backlight above the horizon by two stops, thereby bringing its required exposure time closer to the shorter time needed for the landscape below the horizon. As a result, you can render the spectacular colors of a sunset or sunrise sky and can still record color and detail in the landscape below. ◆ I arrived at this vineyard an hour before sunrise and set up my equipment under the pre-dawn sky. With my camera and 24mm lens securely mounted on a tripod, I composed the scene to include one-third of the sky and two-thirds of the vineyard. As soon as the first hint of light broke over the horizon, I began taking meter readings. Because I wanted extensive depth of field, I set the aperture to *f*/22 and pre-set the focus via the depth-of-field scale. Then with my camera pointed toward the sky, I adjusted the shutter speed until 1/30 sec. was indicated. Next, I pointed my camera below the horizon toward the vineyard foliage; here, the meter indicated a shutter speed of 1/2 sec.

◆ To compensate for this four-stop difference in exposure between the sky and the foliage, I placed the G-2 filter in front of the lens. Then I pressed the depth-of-field preview button in order to properly align the filter's density at and above the horizon. This produced a two-stop reduction in light transmission from the sky, still leaving a two-stop difference. I then decided to split this difference by shooting at *f*/22 for 1/4 sec. As you can see in the final image, the sky is one-stop overexposed and the landscape is one-stop underexposed—quite acceptable.

Both open shade on a sunny day and overcast skies provide ideal lighting conditions for shooting portraits, whether they are candid or posed. Because the illumination is even, metering is a snap. In addition, the softness of the light flatters most faces. The only drawback to these two lighting conditions is the color of the light. Film "sees" the light as blue and records it that way. This cool blue cast is seldom complimentary and produces a sense of emotional distance—exactly opposite to the effect you're trying to achieve. ◆ Warming filters are designed to reduce or eliminate this blue cast. They come in three densities: 81A (the lightest), 81B, and 81C (the darkest). I prefer the 81B middle-density filter and use it almost without fail every time I shoot in open shade or on overcast days. ◆ I had just completed shooting a story for a travel magazine when I met this London police officer who willingly posed for me. After mounting my camera and 300mm lens securely on a tripod, I asked him to stand in front of an etched-glass window. I had no depth-of-field concerns, so I was able to set the aperture to *f*/8 to take advantage of critical sharpness. In the photograph on the left, the bobby seems a bit cold and distant; this unflattering effect is a result of the slight bluish cast of the overcast sky. To achieve the warmer, more inviting shot, shown on the right, I used an 81B filter.

Although I think filter use is often excessive and unnecessary, I occasionally shoot with soft-focus filters. Used with restraint to enhance appropriate subjects—such as people and closeups of flowers—these filters can effectively add to your creative-exposure repertoire. The softness they impart not only makes portraits more flattering but also creates a dreamlike mood. ✦ While Ranette Hastie gathered cut flowers in my garden, I composed this scene using 180mm lens and an aperture of f/5.6; I had mounted my camera and lens on a tripod. Once I focused on her, I adjusted the shutter speed to the indicated setting of 1/250 sec. I then asked her to look into the camera and smile. Not completely satisfied with the top image, I decided to place a soft-focus filter on the lens to create an ethereal mood. Still shooting at f/5.6 for 1/250 sec., I once again asked my "model" to look into the lens and smile. The bottom photograph more closely captures the calm, peaceful mood of this garden scene.

POLARIZING FILTERS

Of the many filters on the market, every photographer should have a polarizing filter, or polarizer. Its primary purposes are to reduce haze and to eliminate or severely reduce glare from reflective surfaces, such as glass, metal, and water. On sunny days, a polarizer is most effective when you shoot at a 90-degree angle to the sun. For this reason, sidelit landscapes are popular subjects for photographing with a polarizing filter.

Shooting in bright sunlight at midday (not a favored time because the light is so harsh) can benefit from the effect of a polarizer. Whether your shooting angle around noon is north, south, east, or west, the sun is at a 90-degree angle to the polarizing filter—its best shooting angle. Either several hours after sunrise or several hours before sunset, point your camera and lens toward the blue sky and puffy white clouds to the north or south. This will put the polarizing filter at a 90-degree angle to the position of the sun. Then as you rotate the filter on the front of your lens, you'll clearly see a large reduction in harshness and glare. You'll also see a much more vivid blue sky come into view; this makes the contrast between it and the clouds sharper. If you were to shift your camera and lens so that the polarizer was at a 30- or a 45-degree angle to the sun, the polarizing effect would cover only one-half or one-third of the composition. Perhaps you already have several landscape shots in which half of the sky is a much darker blue than the other. Now you know why.

Even though a polarizer has absolutely no effect on exposure when you shoot frontlit or backlit scenes—landscapes, portraits, or closeups—many photographers seem to be under a different impression. So, is using a polarizer restricted to only sunny days? Definitely not! On rainy and cloudy days, a polarizer effectively reduces surface reflections from wet streets, wet car finishes and windows, and wet foliage in the woods and forests. Because the sky on a cloudy or rainy day is a giant umbrella, sunlight is scattered and evenly distributed. As a result, gray glare can be found on most everything. But a polarizer can minimize this glare no matter what angle you are shooting the subject from.

NEUTRAL-DENSITY FILTERS

Until now, you might have believed that when faced with a backlit landscape, you couldn't get a good exposure of both the area below the horizon and the brighter sky. But with the aid of a graduated neutral-density filter, anything is possible. A neutral-density (ND) filter is simply a noncolored, tinted filter available in various degrees of density, similar to the tint on a pair of standard sunglasses. The tint reduces light transmission, which in effect enables you to use slower shutter speeds or larger lens openings without worrying about overexposure. The density of the tint determines how many stops of light transmission the filter can reduce.

The most common ND filters offer a two-stop or four-stop light reduction. Suppose you have ISO 400 film in your camera and you come upon a waterfall that you want to shoot at 1/4 sec. With the aperture stopped down all the way to f/22, you discover that the meter indicates 1/15 sec. for a correct exposure. If you were to set the shutter speed at 1/4 sec. anyway, you would end up with a two-stop overexposure. But if you were to place a two-stop ND filter on your lens, you would be able to shoot at 1/4 sec. because the filter would reduce the light transmission by two stops.

Consider another example. One morning at sunrise, looking for a subject to shoot, you find yourself crawling around on your hands and knees in a meadow. With your macro lens in hand, you come upon a dewy spider web backlit by the bright orange sun. You immediately focus close on several strands of dew. The composition also includes the bright orange ball of out-of-focus light in the distance. To ensure that you capture this ball on film, you set the aperture at wide open. But as you adjust the shutter speed, you discover that even at 1/1000 sec. the image is overexposed. You could stop down the lens, but then the final photograph will show an out-of-focus hexagon of light. Knowing that this isn't the effect you want to achieve, you reach for a four-stop ND filter, thread it on to your lens, and after making a final adjustment to the shutter speed, find a correct exposure at wide open at 1/500 sec.

A graduated neutral-density filter, on the other hand, contains an area of density that merges with an area of no density. Rather than reduce the light transmission throughout a scene, as an ordinary ND filter does, a graduated ND filter reduces it in only certain areas. Suppose you are at the beach waiting to shoot the sunset. You want to include both the small rocks and sand in the foreground and the sky at their respective correct exposures. Exposing solely for the sand can cause the sky to be washed out. Exposing for the sky can underexpose the foreground making it too dark and lacking in detail. To solve this problem, first you must take a reading of the bright sky. For example, let's say you're shooting with a wide-angle lens and an aperture of f/16. As you point the camera into the sky above the sun, the meter indicates a correct exposure at f/16 for 1/60 sec. Next, take a meter reading of the wet reflecting sand; the meter indicates a reading of f/16 for 1/8 sec. Between the sky and wet sand, you have a three-stop difference.

For both black-and-white and color photography, no filter gets a greater workout than the polarizing filter. Polarizers can reduce reflections and haze, intensify blue sky, and act as neutral-density filters. Although polarizing filters are popular because they can be used so many ways, they are seldom used properly. For example, they shouldn't be left on the lens all the time; they serve no purpose whatsoever when you shoot a frontlit or backlit landscape or a portrait. ◆ But polarizing filters are perfect for shooting sidelit scenes when you want to intensify the blue sky and cut through the haze—which were my goals when I photographed San

Francisco's Golden Gate Bridge from Marin County. With my camera and 180mm lens mounted on a tripod, I framed the foreground cables and the distant city, set the aperture to *f*/22, preset the depth of field via the depth-of-field scale, and adjusted the shutter speed until a correct exposure was indicated. I didn't use a polarizer for the photograph on the right. But by placing a polarizer on my lens for the shot below, I was able to reduce the haze considerably, and the color of the sky was rendered more vividly. And because the sun was at about a 90-degree angle to my right, I was able to achieve maximum polarization here.

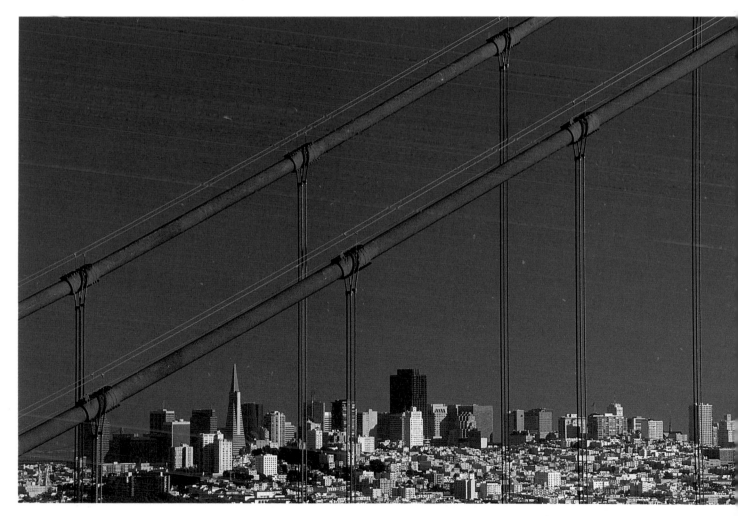

Place a two-stop graduated ND filter in front of your lens, aligning it so that the dense portion stays at and above the horizon. Use the depth-of-field preview button to check the alignment as you look through your stopped-down lens. Now set the exposure given for the wet sand: f/16 for 1/8 sec. Because of the two-stop reduction of light transmission, the final image will render a correct exposure of the foreground and a one-stop overexposure of the sky. A one-stop overexposed sky at sunset is far more pleasing than a three-stop overexposed sky.

Graduated-color filters work much the same way graduated ND filters do. But they also impart additional color or a completely different color to the subject. The variety of color filters is quite extensive. One of my favorites is a pinkish-rose filter: it gives the clouds at sunset a wonderful pink color when the sun does not. And without my 81B warming filter, the skin tones in many of my people shots would have recorded on film as an ugly blue. When either a heavily overcast sky or open shade exists, a great deal of blue light also exists. This bluish cast is seldom flattering to most subjects. The only possible exceptions are snow scenes and frost closeups photographed in open shade when the resulting bluish cast intensifies the coldness of these subjects. To reduce this bluish cast and impart a warmer tone to the subject, use a warming filter, such as an 81A. Warming filters produce more inviting and appealing compositions. These filters are available in three densities: 81A, 81B, and 81C. I find that the 81A filter is a bit too light, the 81C a bit too dark, but the 81B ideal.

Whether it is an elegant Sunday brunch at a fine hotel or a tempting buffet at a local restaurant, many different aromas coupled with the artistic display of fruit, vegetable, and meat dishes are enough to make any empty stomach growl. In much the same way, I've attempted to create a buffet of creative exposure options for you. How many of these options you decide to sample depends in large part on how "hungry" you are. Will you go up to the buffet just once, sampling only a few dishes, or will you return after sampling a little bit of everything and fill up on those dishes that really excited your tastebuds? As is true of every picture-taking opportunity, you have many exposure choices to make. What happens now depends on you and your appetite. Just how hungry are you?

With my camera and 200mm lens mounted on a tripod, I framed the incoming surf between two small rocks. After stopping all the way down to f/32, I swung the camera and lens toward the brighter part of sky to the left of the setting sun and adjusted the shutter speed until 1/15 sec. was indicated. ✦ Knowing that this exposure time wasn't long enough to render the surf as relatively calm, still water, I reached into my accessories bag and pulled out a two-stop neutral-density filter. The resulting "loss" of two stops of exposure "forced" me to shoot for 1/4 sec. using the same aperture of f/32. As you can see, the slower shutter speed enabled me to achieve the desired effect.

After spending a spectacular autumn day in the North Cascades of Washington, several friends and I decided to end the day at the top of Hart Pass, a narrow, winding road. We arrived at this spectacular spot several minutes past sunset. ✦ With my camera and 105mm lens securely mounted on a tripod, I set the aperture to *f*/8. Then I adjusted the shutter speed until 1/60 sec. was indicated. But while this exposure would result in a correctly exposed sky, it would render the snow-capped peaks too dark. How did I know this? I had also exposed for the mountain peaks and according to the meter, an exposure of *f*/8 for 1/8 sec. was required. As you can see in the photograph on the right, the sky is fine but the mountains are too dark. ✦ To reduce the three-stop difference in exposure, I used a Cokin G-2 filter to "recover" two stops. With the filter in its holder in front of the lens, I pressed the depth-of-field preview button. I was then able to see that the density of the filter was limited to the sky. With the exposure now set for the snowcapped peaks, *f*/8 for 1/8 sec., I fired the shutter and effectively exposed for both the peaks and the sunset sky as shown below.

INDEX